REDISCOVER THIS GREAT CITY,
JUST AS I HAVE

MIKE CHADWICK

vancouver

infocus

the city's built form

mike chadwick

Library and Archives Canada Cataloguing in Publication

Chadwick, Mike, 1976 —
Vancouver in focus: the city's built form / Mike Chadwick.

Includes bibliographical references and index.

ISBN 978-1-894694-44-5
ISBN 1-894694-44-9

1. Vancouver (B.C.) — Buildings, structures, etc. — Pictorial works.
2. Vancouver (B.C.) — Buildings, structures, etc. — Guidebooks.
3. Vancouver (B.C.) — Guidebooks. I. Title.

FC3847.7.C53 2006 917.11'33045 C2006-904055-9

Editor: Bernard Shalka
Copy Editor: Neall Calvert
Indexer: Mike Chadwick
Cover and Book Designer: Mike Chadwick
Printed in Hong Kong

Granville Island
Publishing

Suite 212 — 1656 Duranleau
Vancouver, BC V6H 3S4
Tel: 604.688.0320
info@granvilleislandpublishing.com
www.granvilleislandpublishing.com

contents

prologue

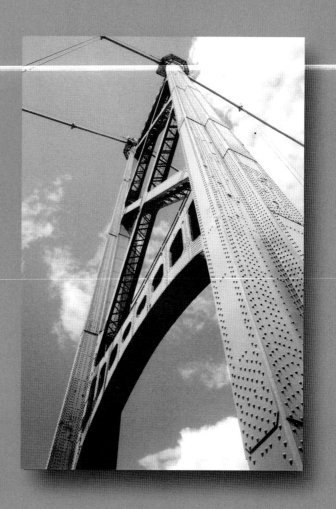

FOREWORD by James KM Cheng

Mike Chadwick's book comes from a rather unique perspective, as he is not an architect, an urban planner, or even a professional photographer. He started his project because something in the downtown core struck a chord with him. Mike spent his life in the Lower Mainland, mostly in North Vancouver, yet he really discovered downtown in the last few years, and fell in love with what he found there. It is always refreshing when passion, rather than finance, drives somebody.

This book intrigues me. It blends art, design and photography along with text that nicely summarizes the changes that Vancouver has gone through. Obviously the architectural content caught my interest but the photographic content did as well, as I have always enjoyed photography, especially black-and-white. Many years ago, I did some freelance photography to help finance the completion of my bachelor's degree in architecture.

Several years ago, my firm [James KM Cheng Architects Inc.] was designing a commercial tower and shopping centre in Shanghai. Before we started, I spent months wandering China's countryside, taking photos of the land and its people — partly to gain insight into my client's needs and to understand China's aesthetics, and partly for the sheer love of the craft. Mike's choice to use black-and-white for his photos is a wise one. By foregoing colour, one tends to focus more on form, content and details.

For my part, I have been privileged to be able to contribute to the shape of Vancouver's skyline. We, as a firm, seek to integrate architectural and urban design with interior design and landscape. When you create an environment for people, you can't miss any of these elements. Architecture is half art and half science. It is not just about the building. It is also about the spaces between the buildings and the area surrounding the site. You have to look at the big picture if you want the whole area to succeed.

Vancouver has been an exciting place to work, especially because of the tremendous changes the city has gone through in the last 25 years. The transformation has been quite remarkable. I have always felt it is important to be sensitive to the cultural, social and environmental needs of the particular site and its eventual users. Architecture that embodies these qualities has put Vancouver on the map as one of the most liveable cities in the world.

The timing of Mike's book works well — we are on the verge of another transformation with the 2010 Olympics. In the immediate future lie the redevelopment of False Creek South and the SkyTrain extension to Richmond. Like Expo 86, these will undoubtedly lead to a new chapter in the city's evolution.

Vancouver is a dynamic place, and we're doing things right. People with passion — the planners, architects, developers, marketing people and the public have become used to working together. That is what builds a great city. *Vancouver In Focus* nicely captures that greatness at a particular point in the city's history.

James Cheng started his architectural company after working with Arthur Erickson from 1973 to 1976 and graduating from Harvard in 1978. James KM Cheng Architects is among the top firms in Vancouver. His work on over 35 towers has helped define the Vancouver skyline. Some of his most significant buildings include the 42-storey Shaw Tower, the Residences on Georgia, Palisades, One Harbour Green, and Marina Crescent's nine towers in the False Creek Development. The honour of designing the city's tallest building — the 61-storey (646-foot) Living Shangri-La tower, to be completed in 2008 — belongs to Cheng.

PREFACE

A camera is a wonderful thing. As I created this project, strolling around downtown Vancouver with camera in hand, I discovered what a great city this is. A camera makes you look at what you are seeing. It makes you walk around looking at details that you would otherwise miss when you are en route to your destination. It takes you into the nooks and crannies of the city, makes you look up and down, lets you see the diverse architecture, scenes and surroundings. It is the camera that got me exploring, searching for interesting subject material and perspectives. It is the camera that made me discover my city.

It was never my intent to produce a tourist-oriented collection, though tourists may well enjoy my perspective on the city. The evolution of this project has produced a unique series of images that I believe residents of the city will enjoy seeing. I have foregone the stereotypical photos of Lions Gate Bridge, the skyline at night, the mountains, and so on — other books do a fine job of showcasing the city in this way. My collection is focused more on individual scenes and the details within them.

One question I have asked myself repeatedly is, "How will I know when this project is finished?" There always seems to be a few more photos to take, a few more shots from different angles in different light, especially since the city is in a constant state of change. I have resigned myself to the fact this venture will never truly be completed. There just has to be a point where it stops and the next one begins.

I mentioned that the project evolved. From the beginning, my motivation was to wander the city and let my eye judge what was interesting. That was my only criterion, therefore this collection should not be viewed as an inventory of Vancouver's buildings. Some I have featured with many photos, some I have foregone entirely. I also found some towers that are very interesting but a good vantage point for photos eluded me, despite my best efforts.

The area encompassed by *Vancouver In Focus* is the city's downtown core, from Stanley Park eastward to Main Street, and from Coal Harbour south to English Bay/False Creek. Maps are provided which show each featured sub-area.

One thing that surprised me is how people-friendly the downtown is. There are many public plazas, green areas and, to my delight, new developments which incorporate pedestrian walkways and waterfront access/seawalls. Planners obviously realize that people live as well as work here. It is not a concrete jungle but a livable space, and a truly remarkable one at that.

Vancouver is a growing and changing city with many interesting new buildings to look at — some with unusual design features, some just unusual. In among all the new skyscrapers are old heritage buildings that nicely balance the vibrant Vancouver of the present with the city of the past. These islands of history add contrast to the glass and concrete, provide variety and an anchor of familiarity for those lifelong residents who have lived through the changes. It is fascinating to see the ornate architectural details in these heritage buildings and wonder about the construction techniques, the craftsmanship and, of course, the cost.

As time goes on, Vancouver is becoming an even more incredible place to live. Progress is guided by what the people want their city to become — a livable place that stimulates the eye and the imagination, that complements its scenery but doesn't dominate it, where people want to be and choose to live. Vancouver, its citizens and planners having assessed where other cities have failed and risen to overcome those challenges, is its own place.

I embarked on *Vancouver In Focus* simply because I love being immersed in the creative process. Assembling this collection was a learning experience and a personal journey, one which I'm happy to be able to share.

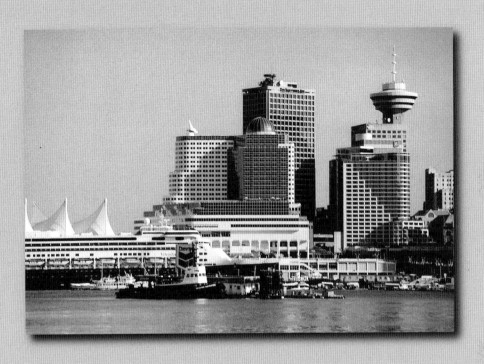

ABOUT THE AUTHOR

I am a lifelong resident of Greater Vancouver, raised in the community of North Vancouver on the north side of Burrard Inlet. Two bridges connect this area to Vancouver, and as a result, there is a feeling of separation from the larger city. Living there, it seemed that the problems associated with the big city were far away. Families live somewhat insulated lives, a benefit of having a body of water as a physical and psychological barrier. I always felt like a small-town boy whenever I ventured into the downtown area. One could say it was a sense of wonder, seeing the towers and experiencing the high energy. I never imagined that one day I might live there.

I had been to the downtown core many times, of course, but always with a purpose, a destination, a reason. Never just to wander and explore. Through discovering the area, I fell in love with it and finally made the move across the water. Now I call the West End my home.

This book gives some insight into how I view the city and my outlook on life. I chose to focus on Vancouver's positive aspects and the areas that evoke a response within me. A friend from Toronto told me that I have a child-like fascination with things as I walked him through parts of downtown, explaining the history of various buildings and pointing out interesting design features. I hope this enthusiasm is evident in the project.

Peter Meiszner

Regarding photography, I freely admit to having no formal training. It is my artistic side that guides me. As I walk down the streets, I am constantly looking for a potential photo in among the scenes. I know it when I see it. It is as simple as that. Sometimes my judgement is flawed and sometimes it is perfect — my first glance at the developed photo is the deciding factor. I use a Pentax SLR camera with standard, wide-angle and zoom lenses. At some point I will make the leap to digital technology, but for now I am quite happy with traditional equipment.

I enjoy being creative and I have a great appreciation for art and design, whether in the form of oil-on-canvas or steel-and-glass. For several years, my career was in the graphics industry, and the experience certainly helped in putting this book together. In pursuit of another goal, I enrolled in school for two years and received a technical diploma in forestry. Now working as a forest ranger in North Vancouver, I believe I have struck the perfect balance — I work in the forest and live in the heart of the city!

Vancouver In Focus has taken more than two years to complete. I have worked at my own pace without any kind of pressure — a rarity in today's times. Having said that, I am surprised at just how much time I have devoted to this endeavour. Rather than focus my attention on the end result, I enjoyed the step-by-step creative process, knowing in the back of my mind that I was moving towards something special.

Being a goal-oriented person, I know that as soon as this project is finished, I will be asking myself, "What's next?"

I present my work with hopes that it will make you look at our wonderful city in a different way, or inspire you to go downtown and walk around, seeing what I have seen and finding your own favourite buildings and places. If I have conveyed that Vancouver is a dynamic place and a leader in North American urban design, that Vancouver is a great place to live, and that the future holds even greater possibilities, then I have accomplished my goal.

ACKNOWLEDGEMENTS

During the development of *Vancouver In Focus* I received feedback from many people; their positive comments motivated me to keep going. There have been some key individuals who were pivotal, and to whom I would like to extend my heartfelt thanks:

- Peter Meiszner, who was there at the conceptual stage. He shares my passion for photography, and his idea for us to go to the downtown core to take photos is how *Vancouver In Focus* began.

- Kris Rogerson, who was an excellent sounding board and whose advice, patience and constructive criticism helped shape this book in the early stages.

- Jo Blackmore of Granville Island Publishing, whose knowledge and advice were extremely helpful in moving my idea forward from photo collection to published book.

- Bernard Shalka, editor and former Toronto urban planner, whose input expanded the scope of the text.

- Neall Calvert, editor and true professional, who worked closely with me to refine the text portion of this book. His attention to detail is remarkable.

- Greg Chadwick of Trax Web Design, whose technical support, website design skills and Internet marketing knowledge will help *Vancouver In Focus* reach a broad audience.

- James Cheng, master architect, who graciously agreed to write the Foreword.

urban planning

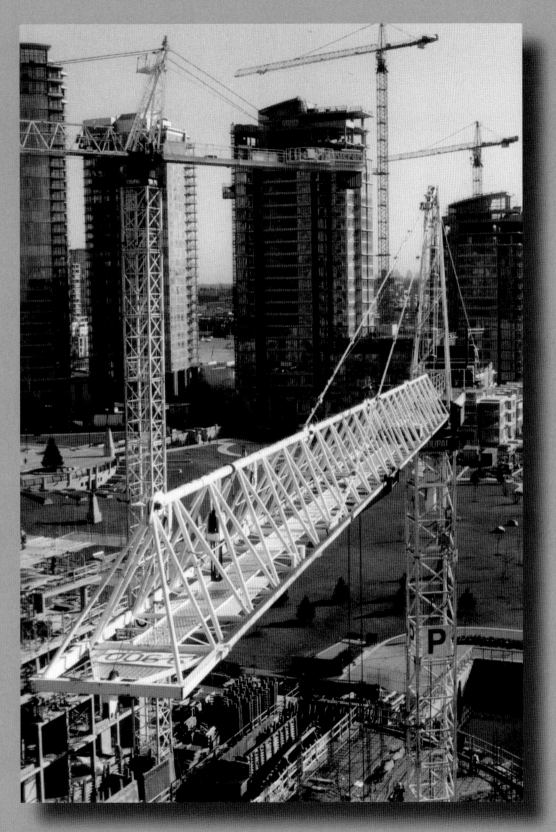

This has been the essence of Vancouver since the 1990s: construction cranes working furiously to erect new towers. This is the last neighbourhood of the False Creek development to be built, just east of the Granville Bridge.

URBAN PLANNING

Vancouverites are proud of their city, and rightly so. Lifelong residents or even those who have lived here for twenty years have seen a remarkable transformation. Vancouver has consistently been near the top of the rankings in terms of quality of life in major cities, and there are several reasons for this:

- The downtown core has been repopulated;
- There is a people-first development strategy;
- Transit and transit options are promoted;
- Air quality is good;
- Superb design exists in residential developments;
- There is a commitment to green spaces and parks;
- Existing neighbourhoods have been rejuvenated.

Vancouver is a city balanced with nature. Its inhabitants treasure the fact that the forest and ocean are only steps or a short drive away. One of the most wonderful smells is experienced when walking through the forest on a hot mid-summer's day, or along the beach as a gentle breeze carries salt air off the ocean.

The forest and ocean are keys to the physical, mental and spiritual well-being of those who live here. A respite from big-city life is always close at hand. On a greater scale, Vancouver's location assures quick getaways to places of incredible contrast. The true desert of the Okanagan, with its ranches and vineyards, is only four hours away. Lush farmlands are an hour's drive, and Whistler, a world-class ski resort, is perhaps double that. For the more ambitious, a hike on a glacier and lunch by an alpine lake is possible within the confines of a day trip. If one prefers to venture on the seas via BC Ferries, Vancouver Island is a tempting weekend jaunt.

The other natural aspect that has a profound yet subtle impact on shaping Vancouver is climate. With Canada's most mild weather, winters are warm and short (albeit wet), giving rise to extremely lush and rapidly growing vegetation. No matter how quickly Vancouver seems to grow, it is at a snail's pace compared to nature. The mild climate means that exotic species can thrive. A fine example can be found at the intersection of Davie and Denman Streets in the West End where palm trees, evoking a Miami-like ambience at the beach, do very well. There are still select spots in the forest where one can walk through true old growth, marvelling at 400-year-old sitka spruce or 600-year-old yellow cedars.

The subject of climate would not be complete without a few words about sun and rain. The former is eagerly anticipated and seemingly in short supply. The latter, grudgingly tolerated; always seeming to appear in greater quantities than one wants. It is this lopsided balance of sun and rain that makes possible the lush vegetation, the clean air, and the enjoyment of the city. Vancouver seems to be a different place when skies are clear. The very hint of sun brings people to parks, seawalls and streets — everyone eager to take advantage of the warmth and the beautiful outdoor environment.

What most people do not realize is that Vancouver is on the edge of the wilderness. It is the last large bastion of civilization before the rugged mountains begin immediately to the north. Flying overhead, this becomes evident as the towers of the city quickly give way to seemingly endless peaks, valleys and glaciers.

Urban planning has been respectful of the natural environment over the last three decades, and the cityscape is spectacularly set against the mountains and ocean. Having Canada's most mild climate has focused the city's residents on their surroundings, natural and man-made. The public gets involved and is very vocal if a proposed development is not suitable. Examples of citizen action include the rejection of a freeway into the downtown core and of the massive "Project 200" development at the waterfront, the preservation of heritage homes in the West End's Mole Hill neighbourhood, and the decision to not increase the capacity on Lions Gate Bridge when it was refurbished.

POLICY AND DEVELOPMENT

The city's downtown land has been fully developed for many years. New projects are the result of redevelopment of existing areas, such as Coal Harbour and False Creek. This has proven to be a huge advantage in that the urban waste of old industrial and commercial areas has given way to new, attractive, residential neighbourhoods. A testament to the success of this process lies in the fact that the population of the downtown area has quadrupled since 1981 and is expected to be 120,000 by 2025.

Vancouver's planning department advises City Council on policies that guide growth and change in the city, with an emphasis on land use and built form. The department considers the implications of a wide range of social, economic, physical and environmental issues for the livability of the city. A key guiding principle is the protection of mountain and water views, especially along north-south streets. Vancouver must continue to exist in harmony with its natural surroundings, rather than dominate them.

The Livable Region Strategic Plan (created by the GVRD in 1996) is the growth strategy applicable to the City of Vancouver. Its focus is to preserve and enhance the quality of life for the inhabitants and to protect the environment. The four principles it is based upon strive to:

- protect the green zones;
- build complete communities (False Creek, Coal Harbour);
- achieve a compact metropolitan region;
- increase transportation choices (bike lanes, SkyTrain extensions).

The downtown core is the centre of the region's commerce. It has the greatest concentration of the working and shopping public, and the well-being of these people requires more than the usual regulatory mechanisms. The buildings, open spaces, streets, transit and other components of the urban scene must be executed for maximum benefit to the public.

Vancouver's Official Development Plan, with regards to the downtown core, sets out to:

- improve the general environment as an attractive place to work, live, shop and visit;
- ensure that all buildings and developments meet the highest standards of design, and provide amenities for the benefit of all users;
- provide for flexibility and creativity in development proposals;
- encourage more people to live in the downtown core;
- improve transportation by encouraging greater transit usage;
- discourage automobile use;
- create distinctive public areas and streetscapes.

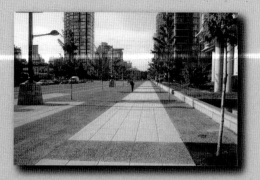

A public space that works well is the seawall at Coal Harbour, which separates pedestrian traffic from cyclists/rollerbladers. It features wide pathways for both, and has ample benches and landscaping.

The Residences On Georgia development features streetscape treatments that include extra-wide sidewalks with attractive surfacing, reflecting ponds, stylized street lights and landscaping.

Key urban design elements for Vancouver include:

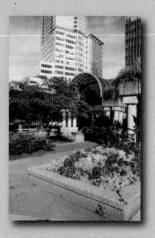

- the value of housing downtown as a key to Vancouver's success as a vibrant city;
- protection of view corridors;
- encouragement of unique developments with high design standards and architectural excellence;
- emphasis on point towers rather than slab towers;
- the importance of landscaping in high-density projects, and the creation of public spaces (plazas, greenways);
- satisfactory execution of simple urban design rules for townhousing treatments and heights of towers, and clear delineation between public and private spaces;
- sidewalk streetscape treatments (landscaping, public art, pavement designs).

A good example of a public plaza in the Waterfront area (Thurlow and West Cordova).

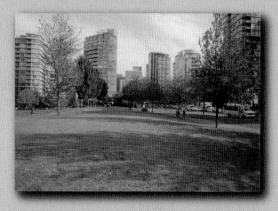

Ample green space exists in this transition area between Stanley Park and the Residences on Georgia. Busy West Georgia Street is to the right.

The separation of public and private spaces is used along the False Creek seawall. To keep the development to a human scale, and to prevent shadowing, the planners designed the buildings to be lower near the public areas.

The look and design of the city is largely a result of the zoning process. Industrial, commercial and residential areas have been rezoned to shape and continue the vision of Vancouver. There are pros and cons to this method, especially in a city as young as

Vancouver. Zoning has guided the city's growth from the earliest times. There has not been much "natural evolution," perhaps with the exception of the West End where the passage of time has given rise to a multitude of architectural styles.

Zoning is intended to enhance the good qualities of developments while ensuring that unfettered building does not occur. However, the process can also prevent innovative urban planning and architectural design. While it is an excellent tool to guide growth, there are intangible aspects to all great cities that cannot be achieved by zoning alone. Too much reliance on zoning may create sterile, boring communities that lack character. One may argue that False Creek, being a very new development, falls into that category. Perhaps zoning regulates what cannot be done rather than what can.

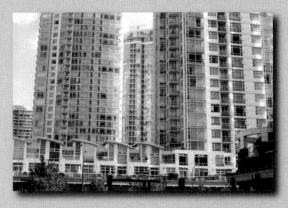

False Creek: Sterile and boring, or exciting and new?

SUCCESS STORIES

Vancouver itself is a success story, but a number of development initiatives that have been overwhelmingly successful are worth noting. Examples that are discussed in upcoming sections include the revitalization of Gastown, the restoration of a West End neighbourhood, the new Coal Harbour and False Creek communities, and the transformation of the shoreline where public access is now integrated with each new building project.

Granville Island

The name is a misnomer since the "island" is actually a peninsula. Designed to reflect the industrial heritage of False Creek, today's Granville Island has retained historic elements such as rail lines, industrial cranes, and some original warehouses. In 1973, a creative scheme by the federal government transformed the area into the most visited attraction in Vancouver, anchored by a public market — the most successful in North America. Tenants include the Emily Carr Institute of Art and Design, artisans, art galleries, restaurants, tourist shops and theatre companies. It is a tremendously successful public space,

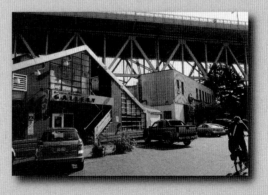

The Granville Bridge makes for an interesting background on Granville Island. Note the industrial-style buildings, many of which are renovated originals.

and several festivals are held on the island each year, including the Vancouver International Writers' Festival, the Fringe Festival, Comedy Festival, Vancouver International Jazz

Festival and the Festival of Lights. Interestingly, there is still a major industrial tenant, Ocean Concrete, on the north side of the island.

Originally a sandbar in the centre of False Creek, Granville Island was built up to become an island in 1916. It was soon home to industrial activities such as ironworks, shippers, roofing manufacturers and machine works. As the industrial heart of the city, it peaked during the Second World War, after which businesses began to leave in search of cheaper land. By this time the island was really a peninsula and its thriving character soon became an abandoned wasteland. The reclamation that followed may be credited to forward-thinking visionaries and a proactive public.

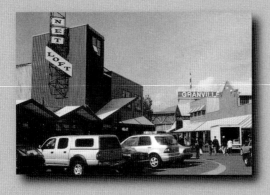
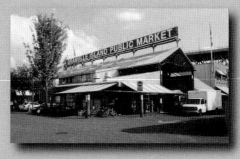

Above: The Public Market. Left: Some of the funky buildings that make the area lively.

QUESTIONABLE DECISIONS

It is easy to measure each building or development by today's standards of urban planning and design. We have become used to seeing public spaces, interesting architecture, the "people-first" approach, and community amenities incorporated into new projects. However, the urban planning processes of today are far different than those of the past. One must keep this in mind when analyzing structures that were built decades ago. One thing is certain: Vancouver has made some past urban planning decisions that do not fit in with its current philosophy.

Stadiums

In 1980 the provincial government announced plans to build BC Place Stadium as part of Expo 86. The problems with BC Place are its sheer bulk, the fact that it prevents streets from extending to False Creek and the splitting of Pacific Boulevard. The stadium does not integrate well into the area, and is not in keeping with the city's "less cars" philosophy. With a capacity of 60,000 people, it draws a huge influx of traffic into the city during events. To compound the impact of this superstructure, GM Place hockey stadium was built adjacent to BC Place in the 1990s. Fortunately, it is of a much smaller scale and doesn't dominate the city's eastern skyline.

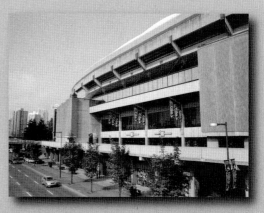

BC Place Stadium is not so much a tall structure as an enormous one. The sheer bulk of the stadium is shown here from the south aspect.

Granville Bridge

Granville Bridge is efficient, but some components make it out of place in today's Vancouver. It is not so much the six lanes, but the multiple off-ramps and cloverleafs that make this a freeway-type bridge. The cloverleafs are especially intrusive, taking up large spaces, protruding into new surrounding neighbourhoods and impeding pedestrian access. At street level, the masses of concrete supports, beams and roadways create a grey and unwelcoming atmosphere.

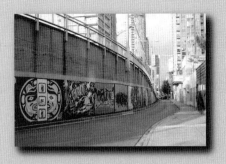

Despite the artwork, this is not an inviting pedestrian corridor, nor one which evokes a feeling of safety at night.

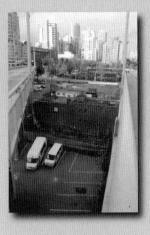

The junction of the main deck and an off-ramp is shown here, elevated above street level.

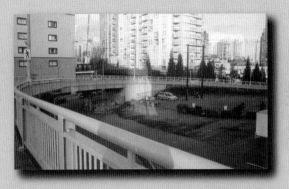

As well as taking up large amounts of land, areas encircled by cloverleafs are undesirable places to construct new buildings or residential units. Consequently, they easily become a place for unkempt buildings, parking lots and urban wasteland.

However, the design of the superstructure is attractive in a mechanical way. Built in 1954, the bridge looks as though a highrise building was laid on its side half-way through completion, with its iron skeleton exposed. From that perspective it blends well with the surrounding towers, and gives an interesting view to visitors of Granville Island directly underneath the south end.

Georgia/Dunsmuir Viaducts

During the 1960s, developers and City Council determined that a major freeway to downtown Vancouver would:

- decrease traffic congestion;
- increase land values;
- improve access to strategic areas;
- promote growth at False Creek and the North Shore;
- stimulate the local economy.

This ambitious plan was to include a third crossing to the North Shore, a link from that crossing to a new Georgia Viaduct, and a connector to the Trans Canada Highway. The proposed freeway was to go through Chinatown and the Strathcona neighbourhood, but intense public pressure made Council reconsider and they attempted to scale back the

project's scope. They abandoned the route through Chinatown, but still approved the construction of the Georgia and Dunsmuir Viaducts.

Today these structures are a reminder of what could have resulted had the freeway been built. At street level, the viaducts loom overhead, creating a less than desirable space. Typically, the areas underneath elevated roadways are a refuge for street people and illegal activity. This most likely would have occurred throughout the proposed freeway system, especially in areas lacking visibility. Fortunately this is not a characteristic of the viaducts.

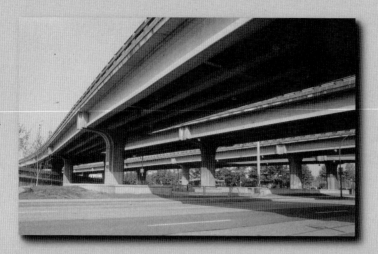

The masses of concrete are clearly evident as the viaducts cross over Quebec Street. Although it appears that there are four separate roadways, two are actually off-ramps. One could easily assume that this image portrays part of the Los Angeles freeway system.

In the lower centre, under the first roadway, an urban skateboard park makes excellent use of the marginalized land.

One positive use of a small area under the Georgia Viaduct is a skateboard park. It is an area isolated from the residential towers and a perfect place for urban boarders to go. The concrete structure overhead provides a good sound barrier for the nearby residents. As any apartment dweller will confirm, street noise travels upwards.

With regards to urban design, the viaducts are simply elevated concrete roadways. No attempts were made to help them blend into their environment and no stylistic features were incorporated. They will soon be lined with residential towers, creating difficult interface conditions.

It has already started: Residential towers are being constructed on the north side of the viaduct in the International Village development.

There is some irony in that the SkyTrain line, also elevated, runs parallel to the viaducts on the north side. It cuts a much slimmer profile through the area and does not stand so tall. Because its use is for transit, it is more accepted by the public.

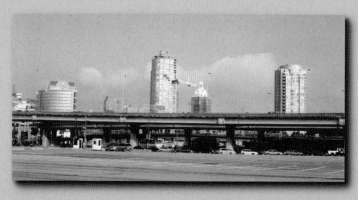

The original Georgia Viaduct was built in 1915 as a means to extend West Georgia Street over the rail yards of False Creek, and the more recent viaducts were to be part of the now defunct freeway system. Both reasons for the viaducts no longer exist. Perhaps the solution is to dismantle them and bring the traffic back down to street level.

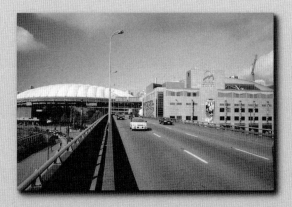

Three consequences of prior urban planning decisions, all evident in one photo: BC Place Stadium, GM Place and the Georgia Viaduct. GM Place (right) appears larger than BC Place because it is more in the foreground. Note the extremely narrow pedestrian/bicycle corridor on the viaduct, which seems to have been an afterthought when the structure was built.

Special Mention — Robson Square

Neither a great success nor a failure is Robson Square, designed by the city's pre-eminent architect, Arthur Erickson. The provincial government of the early 1970s wanted to tear down the existing courthouse (now the Vancouver Art Gallery) and build a 55-storey tower. The City objected, and also in 1973 there was a change of government. Arthur Erickson was brought in to find a better solution.

His approach was to lay the tower concept on its side, making it more accessible both physically and philosophically. The intent was to encourage the public into the building. Priority was given to creating public space in the heart of the city.

The project encompasses an area of three city blocks by one city block and contains waterfalls, reflecting ponds, terraces and lavish landscaping. The public space varies in elevation, from below grade to one storey above, giving great views of the surrounding buildings, particularly the Hotel Vancouver. One notable feature is the overwhelming use of concrete. By design, this concrete turns a rosebuff colour when wet, due to its special mixture.

In the centre of the photo, on the opposite side of Robson Street, Roman-style columns and a domed roof highlight the former courthouse.

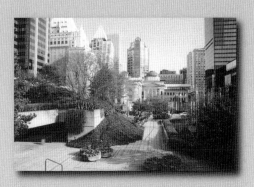

The existing courthouse was retained and converted to the Vancouver Art Gallery, and a concourse with an outdoor skating rink was incorporated underneath Robson Street.

The Law Courts is a very modern structure, with a huge angled glass roof atop a tubular superstructure, all over a terraced atrium. The design of the courts is landmark to be sure, but critics have said that Robson Square does not work as a public gathering place. It is too disconnected — the courts are separated from the terraced concrete plaza, which in turn dips via more steps under Robson Street to the skating rink (no longer used), and more steps ascend to the Vancouver Art Gallery. Proof that the area is not successful as a

gathering place may be observed on any day; few people are found there and it is not a venue for special events. Although never the intent, Robson Square is a semi-private space in the middle of the city where one can escape the hustle and bustle.

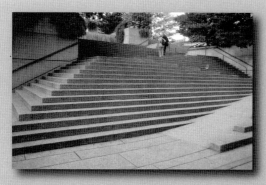 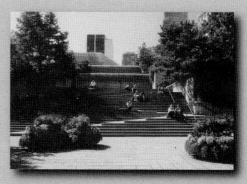

The concrete and many steps of Robson Square. This photo, taken during the late morning hours of a weekday, illustrates that the area is not heavily used.

Robson Square from another angle, shot during lunchtime. The glass roof of the courts can be seen in the background, along with the terraces and waterfalls.

TRANSPORTATION

The Vancouver public is more vocal over transportation issues than any other area of civic debate; transportation decisions impact people's daily lives. This dates back to the 1960s when the downtown freeway proposal was rejected. Transportation choices and planning are especially relevant in current times with the influx of so many new residents.

A good example of public involvement is the refurbishment of Lions Gate Bridge, the major access point to the North Shore. Several public consultations were held and many alternatives to the status quo of a three-lane bridge were presented, including adding a fourth lane, building a second bridge, constructing a tunnel and double-decking the current bridge.

In the end it was decided that the status quo should be maintained so that traffic in the downtown area would not be increased and livability would not be compromised. This approach places a limit on the amount of vehicles that can enter the downtown core in a given time and makes people look at alternatives to single-car occupancy.

The examples cited may lead one to believe that a paranoid public has stifled growth and progress. This is not the case. In fact, the public and their elected officials have been remarkably forward-thinking and progressive, especially by rejecting a downtown freeway system and encouraging transportation alternatives. Vancouver is a beautiful place to live and it is the responsibility of the public to ensure it stays that way.

City planners, architects and developers have adopted this mindset and the result is that Vancouver has become the city that the people wanted, and that residents in other cities admire. Encouraging public transit goes hand-in-hand with restricting the number of cars downtown. Limiting auto capacity by not building new roads leads to congestion — a prime motivator for people to explore different modes of transportation. Vancouver offers several.

The city has one of the largest electric trolley-bus fleets in the world, following the routes of the old streetcars they replaced. These buses are silent, pollutant-free and of course, environmentally friendly.

Two SeaBus ferries have been plying the waters of Burrard Inlet between downtown Vancouver and the North Shore since the mid-1970s as an alternative to a third crossing. This has been a runaway success story for the transit system. In addition, there are two private mini-ferry companies that serve False Creek.

Another success story is SkyTrain, the elevated light rail system that transports users quickly while providing them with stunning vistas. The first phase was completed for Expo 86, and SkyTrain has since become one of the World Fair's great legacies. An additional line has been added, and construction is about to begin on an extension of the system to the airport and the suburb of Richmond.

The city has completed 180 km (110 miles) of bikeways on public streets in the last ten years. The bike is recognized and encouraged as a viable form of environmentally friendly transportation, and one can see bicycle commuters throughout the year. In 2005, City Council made a proposal to dedicate two of the Burrard Bridge's six lanes to bike usage. Many concerns were raised and this experiment did not come to pass, but it shows that elected officials are looking for alternatives to the automobile.

CONCLUDING COMMENTS

Urban planning has played a major role in shaping the city. But credit must also go to the vocal residents and the civic politicians who have made their wishes clear. Planners have listened to the residents and have learned from the mistakes of the city's past and those of other cities. They have been true visionaries in creating an attractive, functional place where people want to live. Developers too, have had to accommodate many conditions set by the City and have been challenged to design better buildings and developments. The tone has been set for all groups to work together to produce what is best for Vancouver.

Planners, government and residents have come to realize that living downtown is very desirable. The lifestyle is attractive, the local economy has been booming as a result of new tower construction and the city feels rejuvenated. The key to success is for people to be able to live *and* work in the downtown core.

Condos have been built at a furious pace, and it may seem that new commercial/office space has not. Adding to this perception is the conversion of some office towers to residential use. In fact, 400,000 square feet (net) of new office space has been constructed each year since 2001. This will go a long way towards preventing a mass daily reverse commute of city residents to workplaces in the suburbs.

It is important for urban planners to achieve a careful balance. For the last decade, the emphasis has been on attracting people to live downtown and building condominiums. New businesses must also be encouraged to the area and existing ones must be motivated to stay.

Vancouver has definitely been a city in transition for over twenty years. No doubt, the improvements have been astonishing and it is a far more attractive place to live than ever before. All have come to expect the highest standards in urban design, planning and architecture. And people are very cognizant of the reality that they can make a difference in the process. Vancouver has had many successes and some failures, but no one can argue that the future is truly bright for this great city.

west georgia

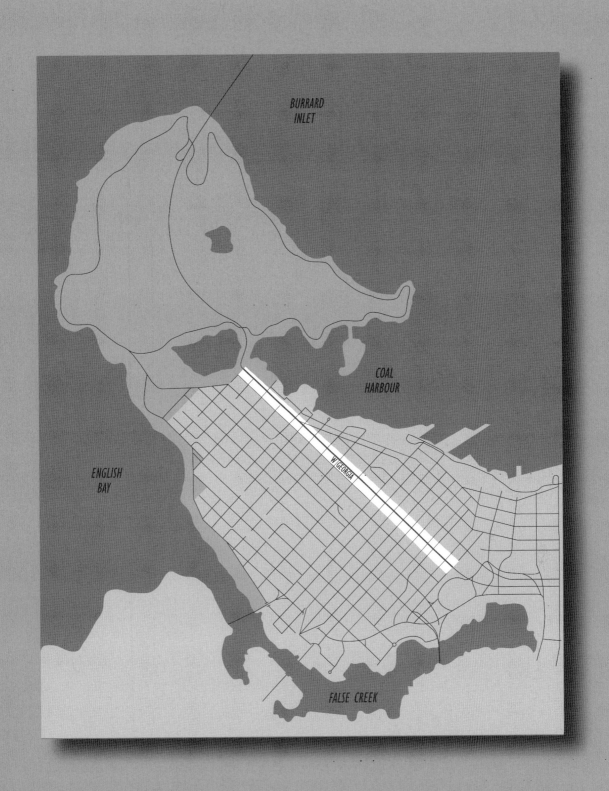

BURRARD
INLET

COAL
HARBOUR

ENGLISH
BAY

W.GEORGIA

FALSE CREEK

WEST GEORGIA

When driving across Lions Gate Bridge from North Vancouver, one is treated to spectacular previews of what is to come. Stanley Park obscures much of the view of the downtown area, however parts of Coal Harbour and the waterfront are just visible. Driving through the park on the causeway, one feels far removed from the city. The canopy of the conifers closes in, dimming the sunlight and creating a peaceful environment. After a few minutes, the tall old cedars and hemlocks yield to the towers of the West End, seen from across the serenity of Lost Lagoon. The road curves to the left and becomes West Georgia, the gateway to the downtown core from the North Shore.

West Georgia is a vehicle-oriented thoroughfare, bringing people in and out of the downtown core. Still, there is much for pedestrians to see and accommodations for foot traffic increases with each new development. Sidewalks become wider, landscaping more liberal and public plazas more abundant.

It is clearly evident that this is a well-planned area, part of the greater vision of putting people first when it comes to new developments. Public spaces are incorporated and scenic views are preserved. It is a welcoming place. One observes the urban oasis of wide sidewalks, reflecting pools and generous green spaces on the north side, with the towers of the Residences On Georgia giving a hint of what is to come. This is a transition area between the park and the dense towers just ahead. Construction is taking place on part of the south side of the street as this book is being written.

The view looking towards Stanley Park, about two blocks west of Denman Street. One can hardly see West Georgia's heavy traffic as cars line up (across the top third of the photo) to cross Lions Gate Bridge. The pond was created to make the area a continuation of Lost Lagoon on the other side of the street.

Especially on a sunny day, the textures and architectural styles of the towers that line West Georgia are striking. Glass, concrete and steel in subtle hues draw one further into the downtown area. And yet there are reminders of the past. At the Bute Street intersection are the beautifully restored Banff Apartments, built in 1909. The Hudson's Bay department store at Granville Street is another heritage building that has survived.

Progressing east along West Georgia, the towers gradually become taller and denser. Still, the sidewalks are wide and people abundant. Along with office buildings and hotels, there is ample shopping, at and below street level. Looking down the streets, one sees the North Shore mountains at the end of tower-lined view corridors.

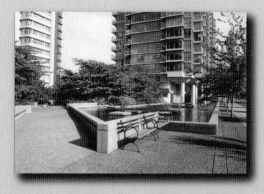
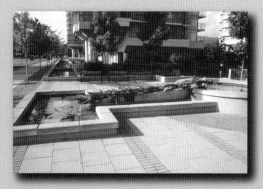

Some of the public amenities that were incorporated into the Residences On Georgia development: reflecting pools, benches, interesting sidewalk surfaces, landscaping and small plazas (as illustrated on the right). As time goes on, the landscaping will mature and the sidewalks will become more shaded.

Towards the east end of West Georgia, the wonderful Roman-style library comes into view. An architectural competition was held for the new design. Although the building was an instant classic, its design has not been without controversy. Some call it imaginative, dramatic, stunning. Others say the design is reminiscent of a theme park. In any event, it has been tremendously successful, most likely because its design is so different and unexpected.

Library Square on West Georgia.

Nearby is the unusual CBC Building, designed by local architect Paul Merrick. Many suggest that this structure from the 1970s is Vancouver's least attractive, resembling either a factory or a concrete bunker. However, the design won a Governor-General's award and a major facelift is planned for the 2010 Winter Olympics. It does succeed in evoking a response from passersby.

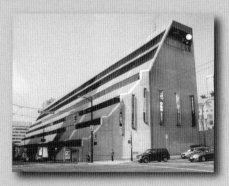

CBC Building, two blocks away.

Completing the view at the east end is BC Place Stadium with its massive white fabric roof. One exits the downtown core along the elevated Georgia Viaduct.

After travelling a short distance, one has seen Vancouver's past, present and future; it's successes and works in progress; and its evolution of urban design.

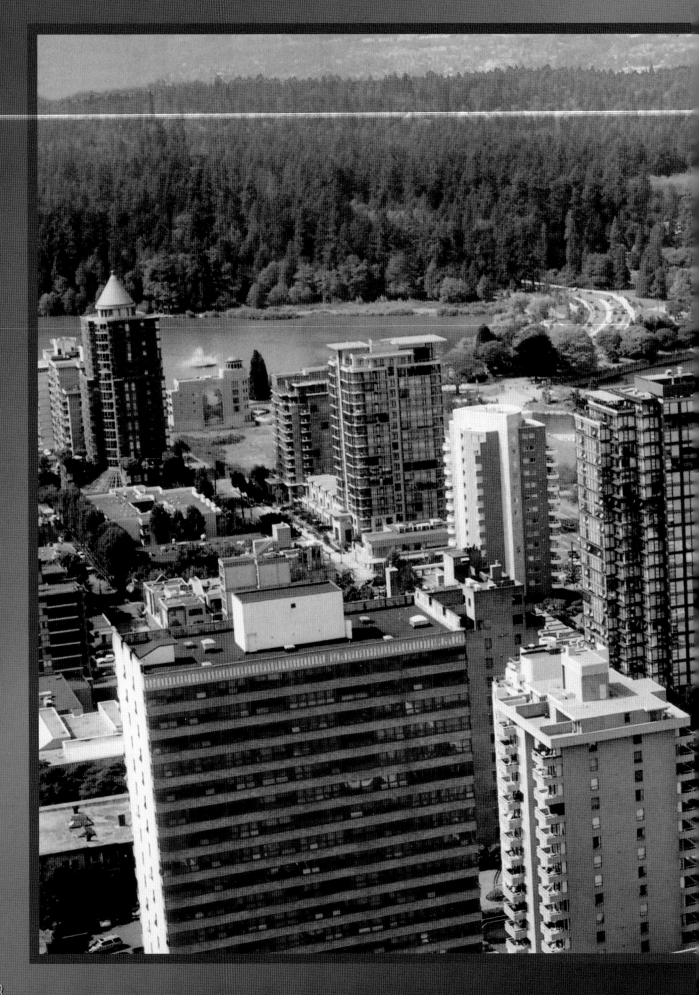

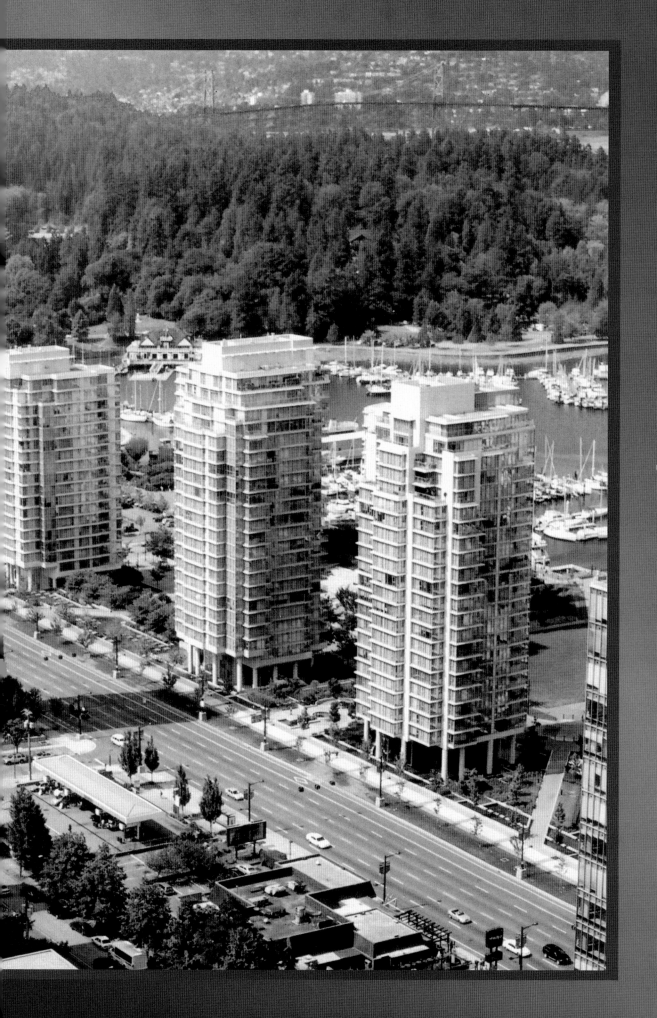

residences on georgia

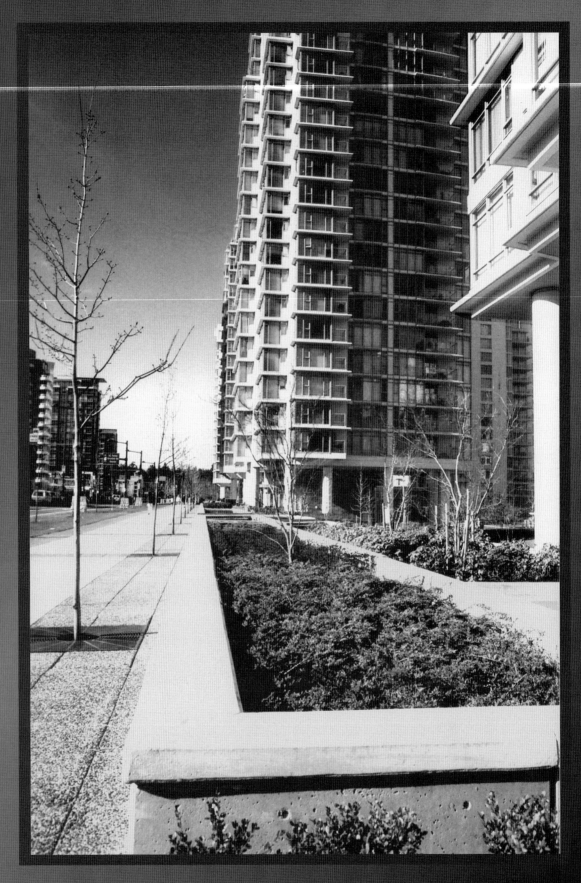

Address: 1200 West Georgia Use: Residential Floors: 36
 1288 West Georgia Architect: James KM Cheng Height: 108 metres (354 feet)
Completed: 1998

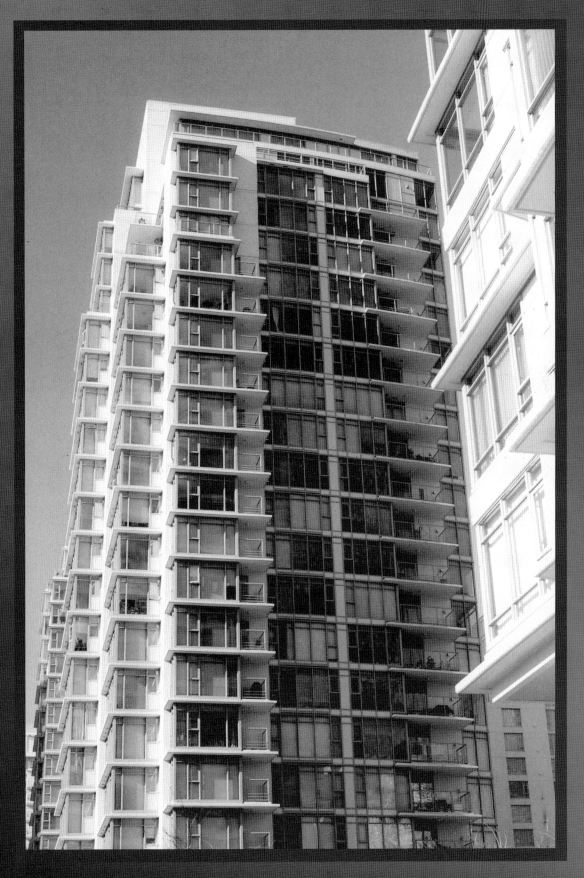

These towers on Georgia Street have generous spacing between them, allowing ample public spaces while gradually drawing one into the denser downtown core. This spacing also preserves the treasured view corridors to the mountains of the North Shore.

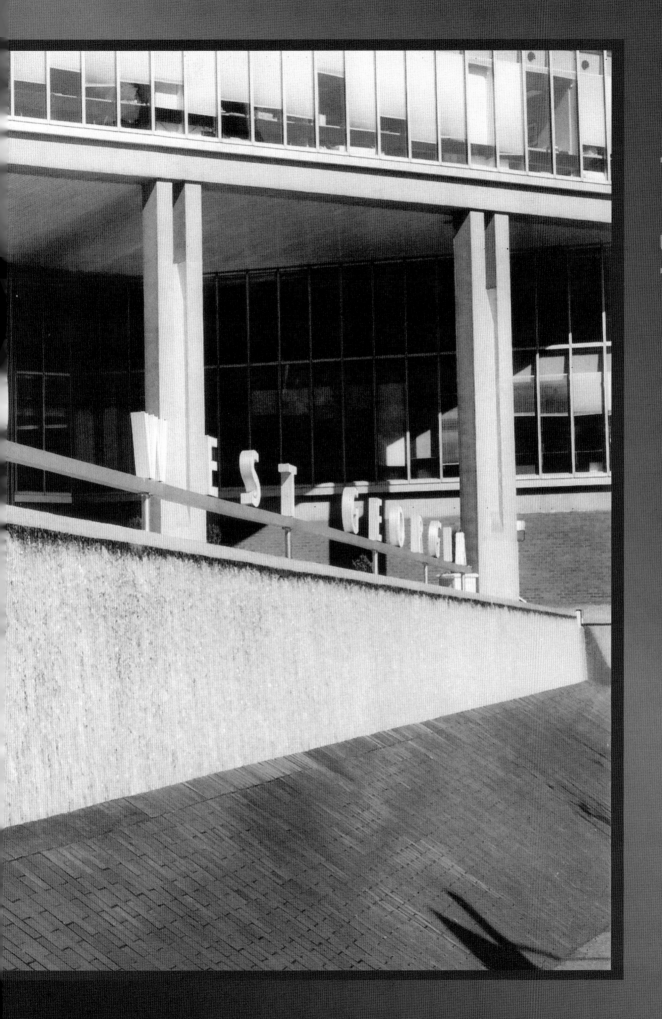

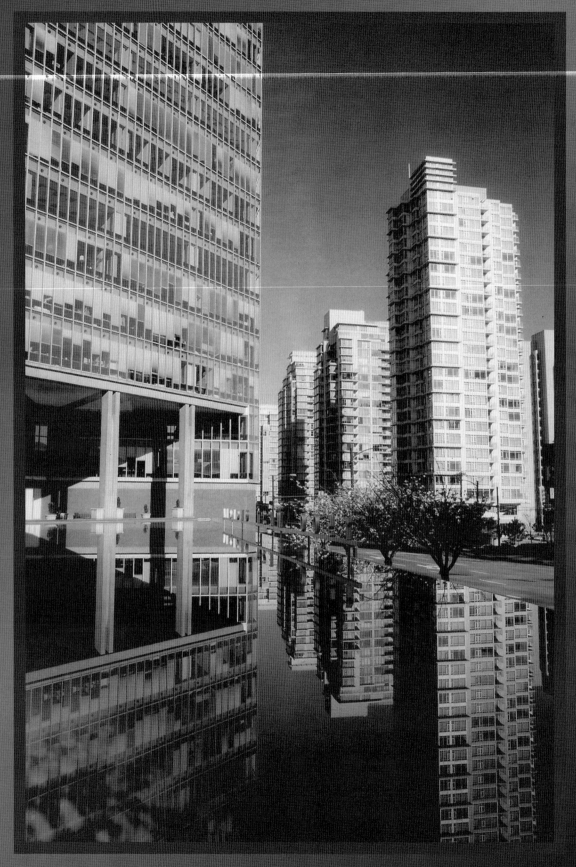

| Address: 1500 West Georgia | Use: Offices | Floors: 19 |
| Completed: 1977 | Architect: Rhone & Iredale | Height: 85 metres (279 feet) |

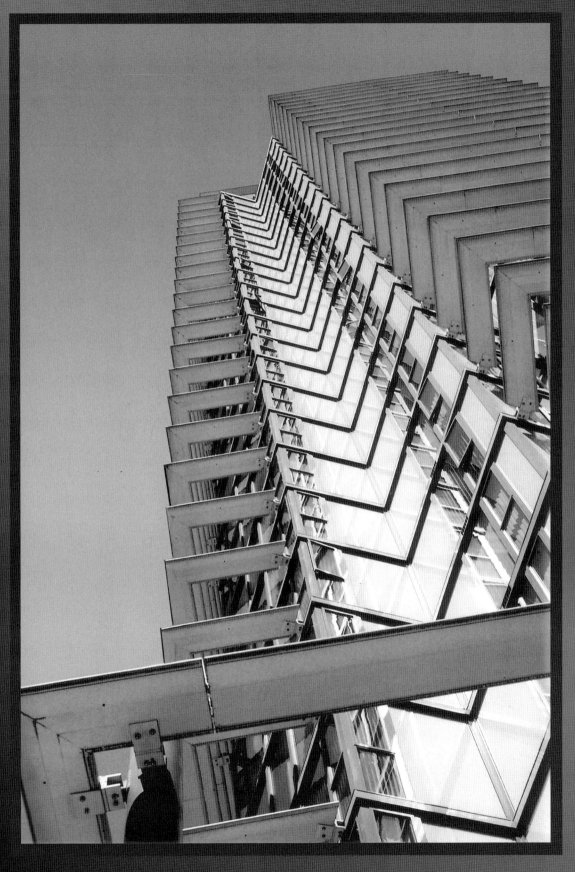

Address: 1331 West Georgia Use: Residential Floors: 29
Completed: 1999 Architect: Bing Thom Architects Height: 84 metres (275 feet)

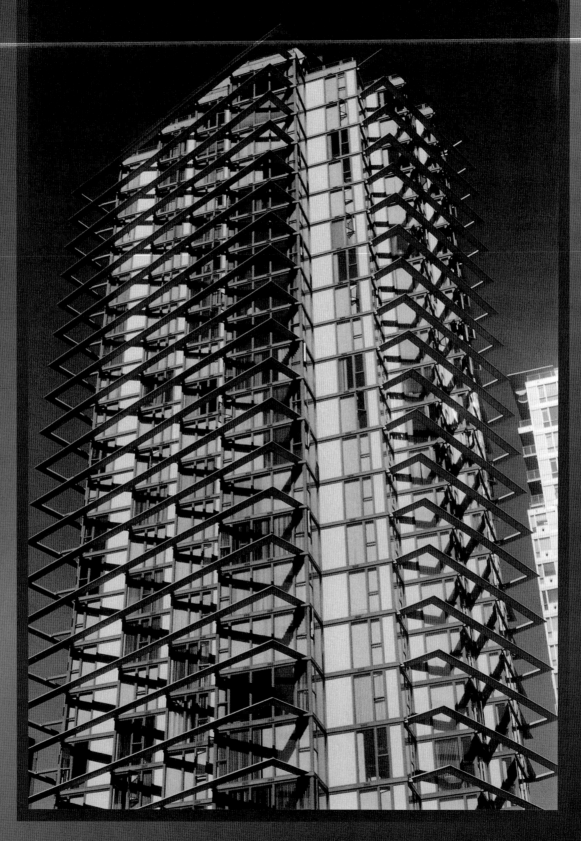

This building is representative of the new generation of towers in Vancouver – tall, slim and finished in gleaming glass. Landscaping, waterfalls and reflecting pools finish the site, as do improvements to the public accessways.

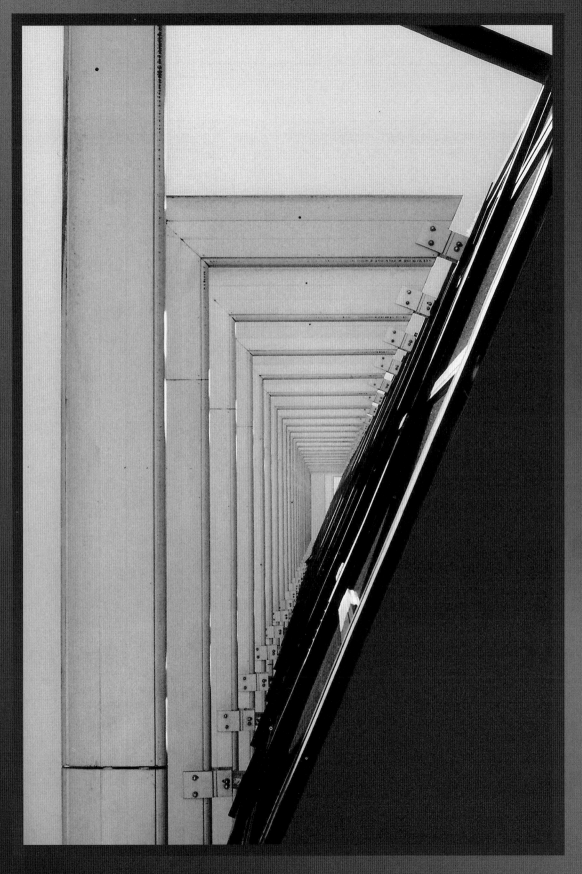

The Point's defining feature is the decorative exterior exo-skeleton (aluminum brise-soleil fins) that acts as solar controls and also aligns the building with the street, though it is rotated on its site to give suites maximum views. There is no other building in the city with this feature.

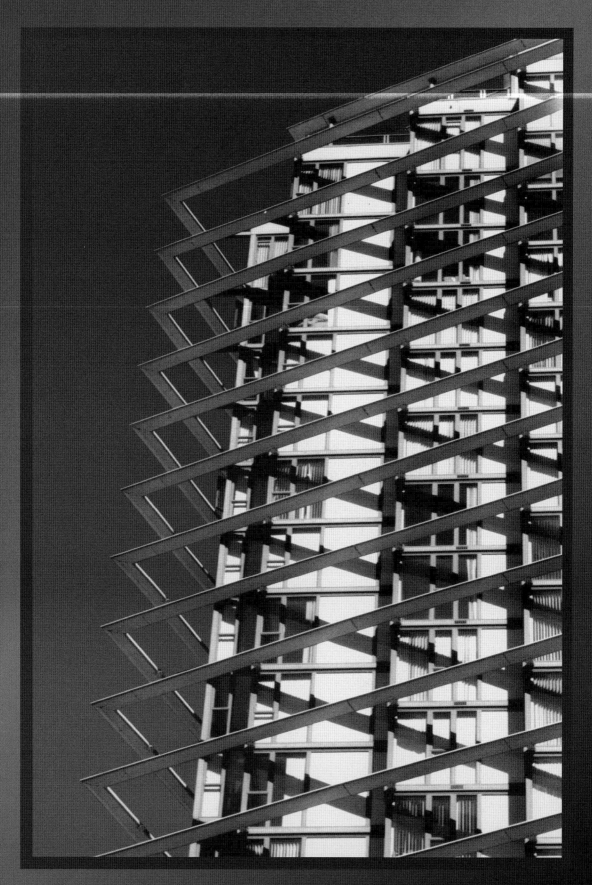

This building is part of a trend towards residential towers replacing commercial office space in the downtown core of Vancouver, particularly on West Georgia Street. It was also one of the first to be designed and equipped to support home-based businesses.

Address: 1383 West Georgia Use: Residential (conversion) Floors: 13
Completed: 1969 Architect: Rhone & Iredale Height: 82 metres (269 feet)

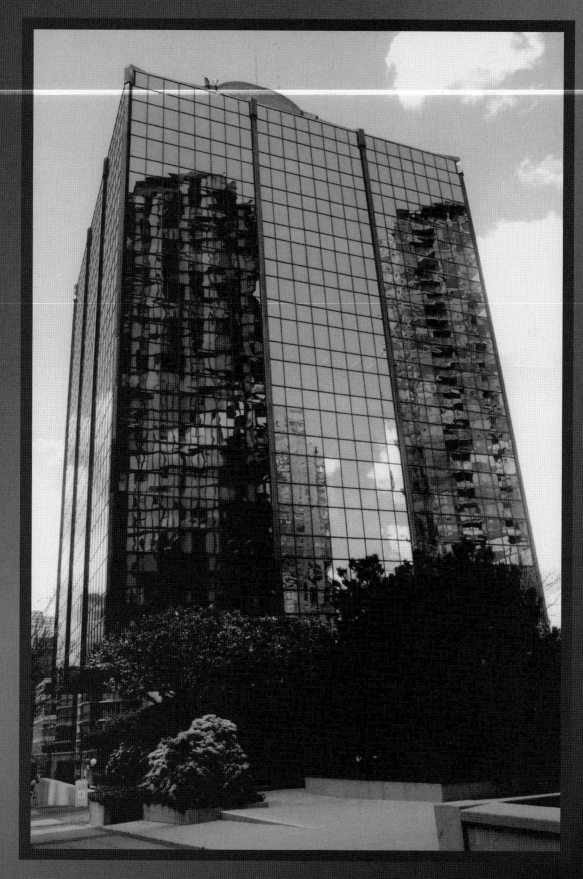

Known as the Westcoast Transmission Building for 31 years, this Vancouver icon is unique in that it was built from the top down. The floors were hung off the central pillar using suspension bridge technology, the design intent being to make the building earthquake-proof.

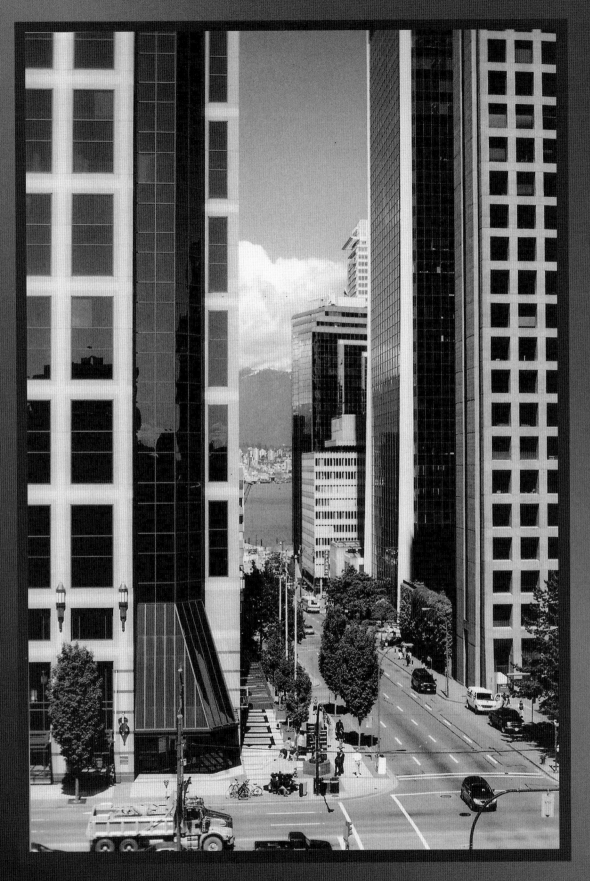

The intersection of West Georgia and Thurlow demonstrates a Vancouver urban planning priority: view corridors. The water and mountains are clearly visible as one travels northbound on Thurlow Street. Terasen Centre is on the left, and the MacMillan Bloedel Building is to the right.

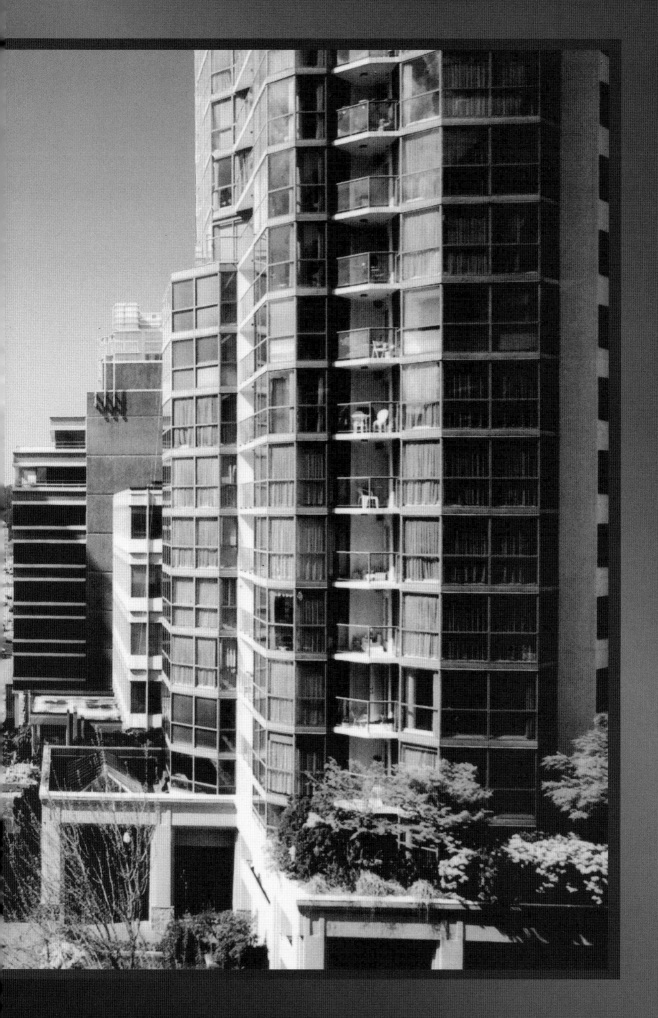

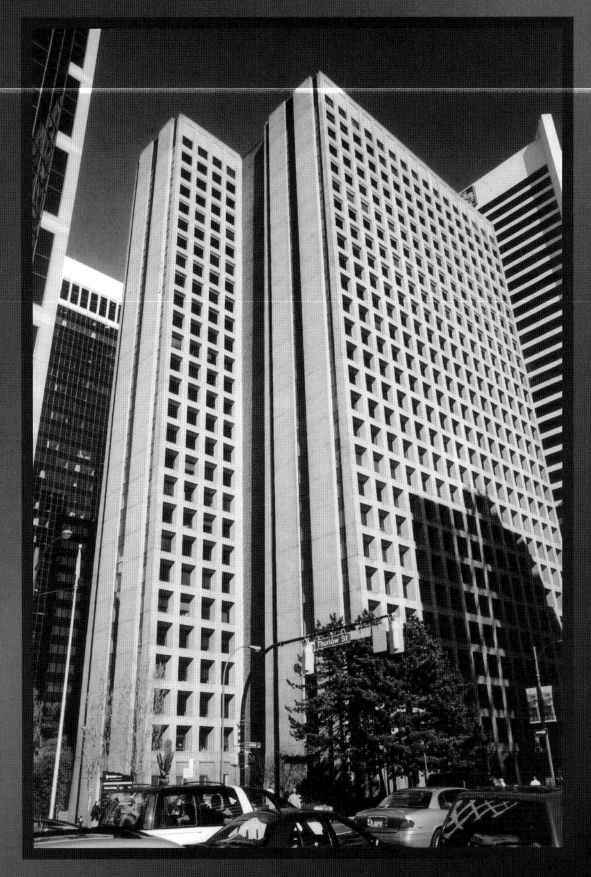

macmillan bloedel

Address: 1075 West Georgia Use: Offices Floors: 27
Completed: 1968 Architect: Arthur Erickson Height: 104 metres (340 feet)

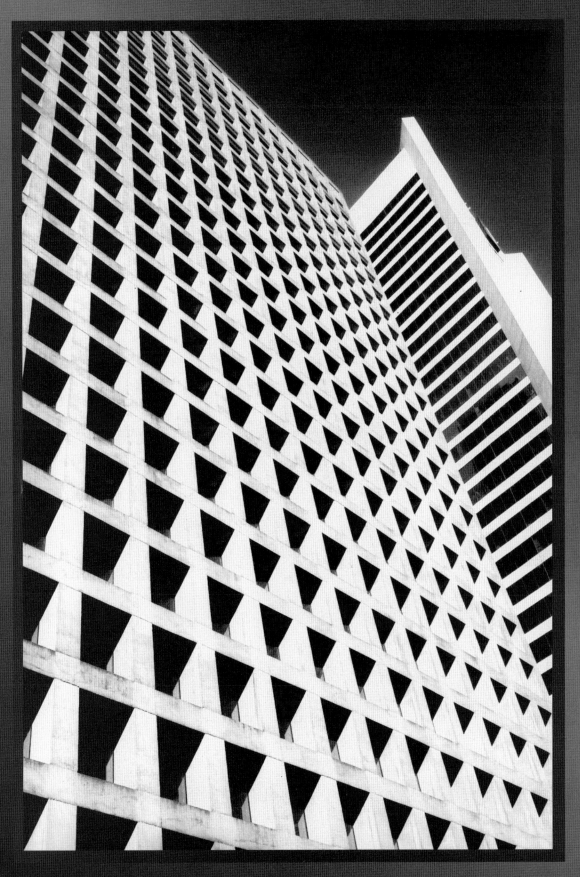

This signature Vancouver building is actually two connected towers. The exterior walls are load-bearing, cast-in-place concrete. As a result, the interior is column-free. Constructed in 1968 at a cost of $9.5 million, it was occupied by forestry giant MacMillan Bloedel until 1999.

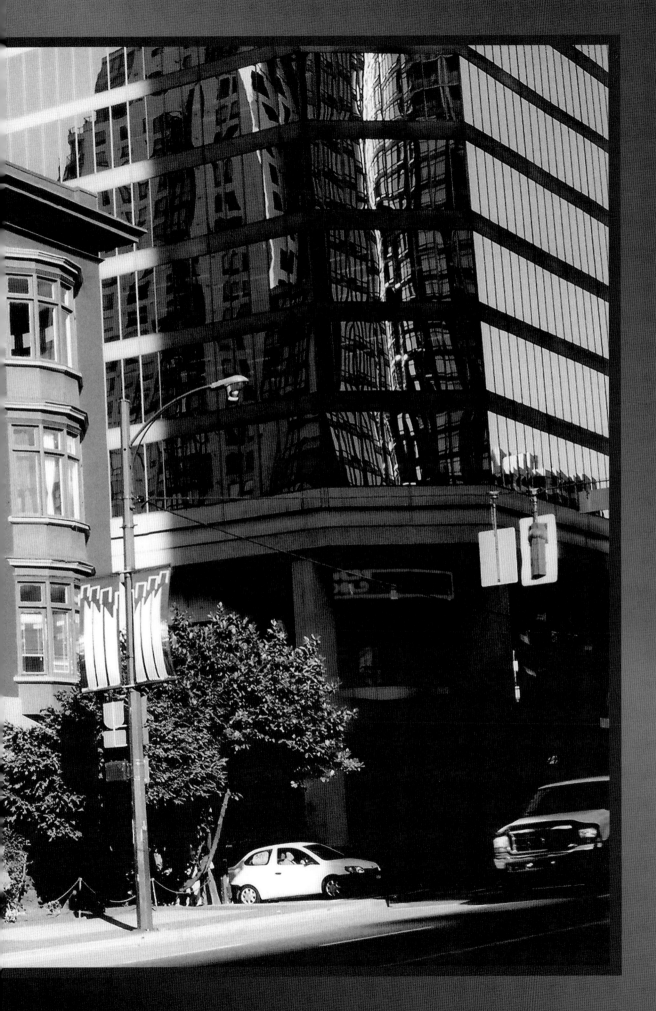

banff apartments

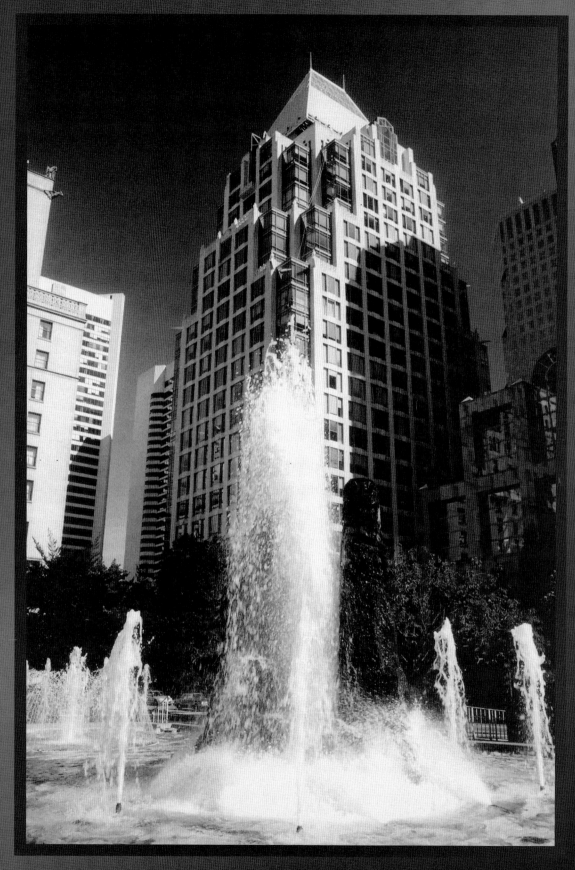

Address: 925 West Georgia
Completed: 1991

Use: Offices
Architect: Merrick Architecture

Floors: 23
Height: 116 metres (382 feet)

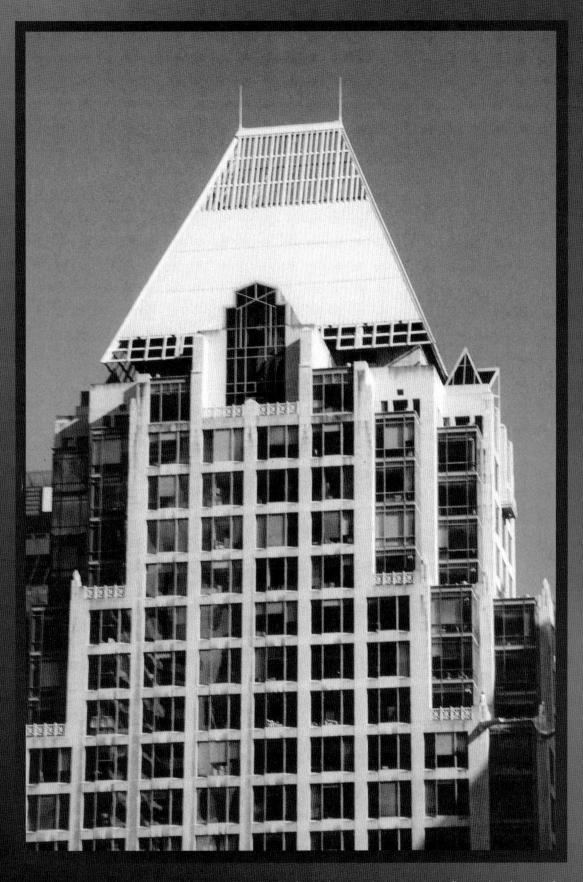

Like a respectful neighbour, this building across from the Hotel Vancouver reflects the design of the landmark hotel, updated to a more modern look. This is a grand postmodern structure that integrates art deco styling cues from the past and fits well into its environment.

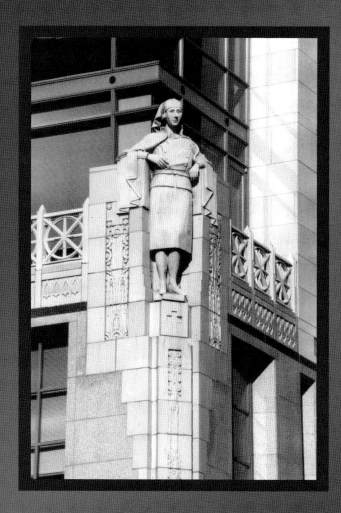

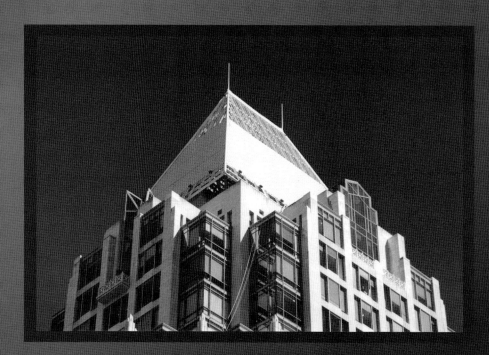

Cathedral Place occupies the site of the former Georgia Medical Dental Building. Many of the original art deco mouldings and fixtures were reproduced and incorporated into the new design.

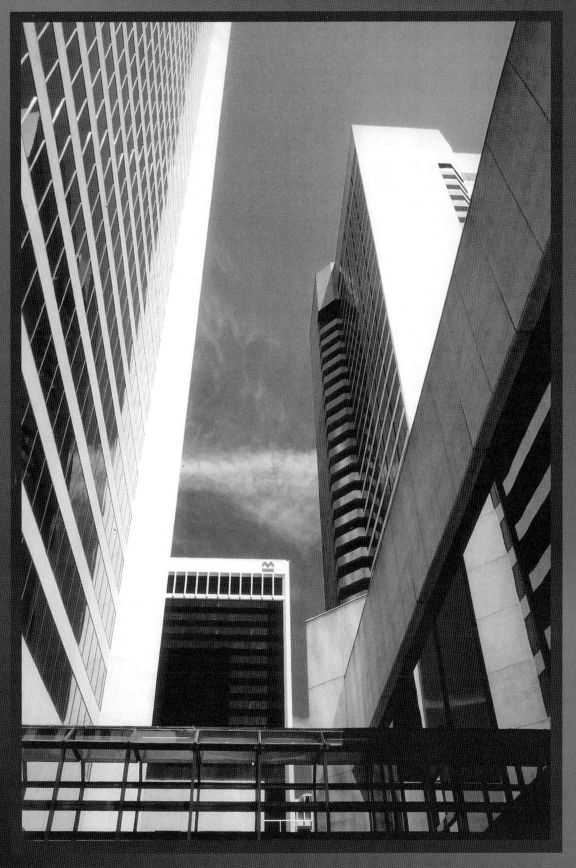

Address: 655 Burrard Use: Hotel Floors: 35
Completed: 1973 Architect: Dirasser, James Height: 109 metres (359 feet)
 Jorgenson & Davis

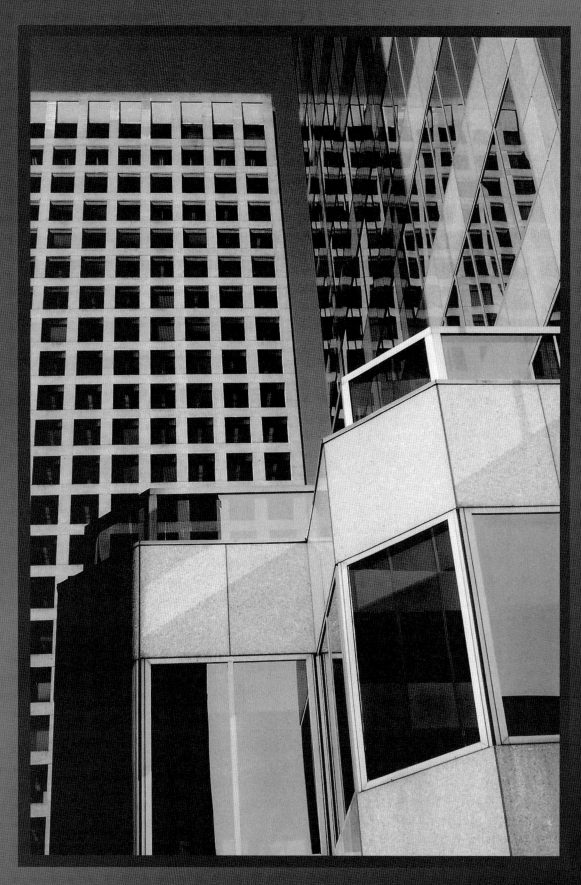

The MacMillan Bloedel Building is reflected in the gold glass of the Grosvenor Building, completed in 1985. Each floor has 12 corner offices as a result of the tower's unique design.

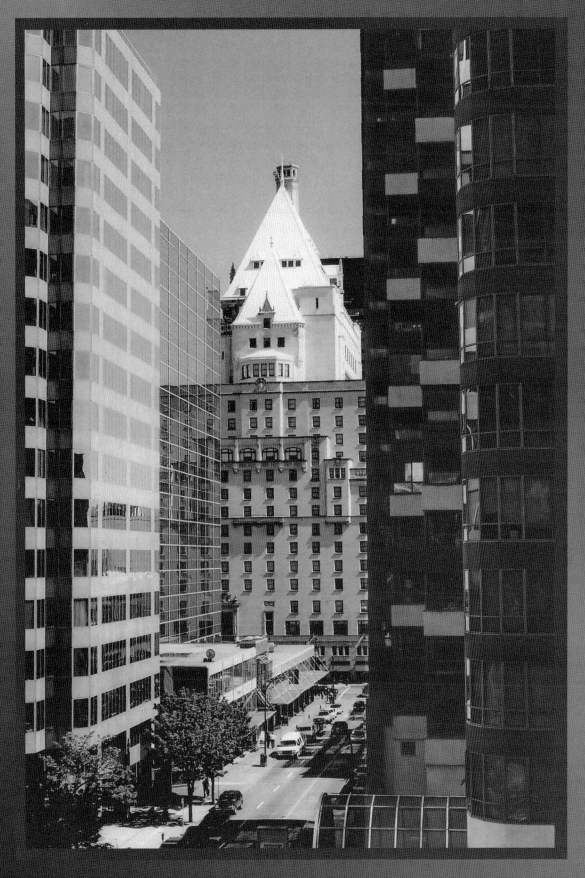

Alberni Street terminates at Burrard Street and the Hotel Vancouver. Although not a natural view corridor, it gives a perspective of the old hotel that makes the building look impressive.

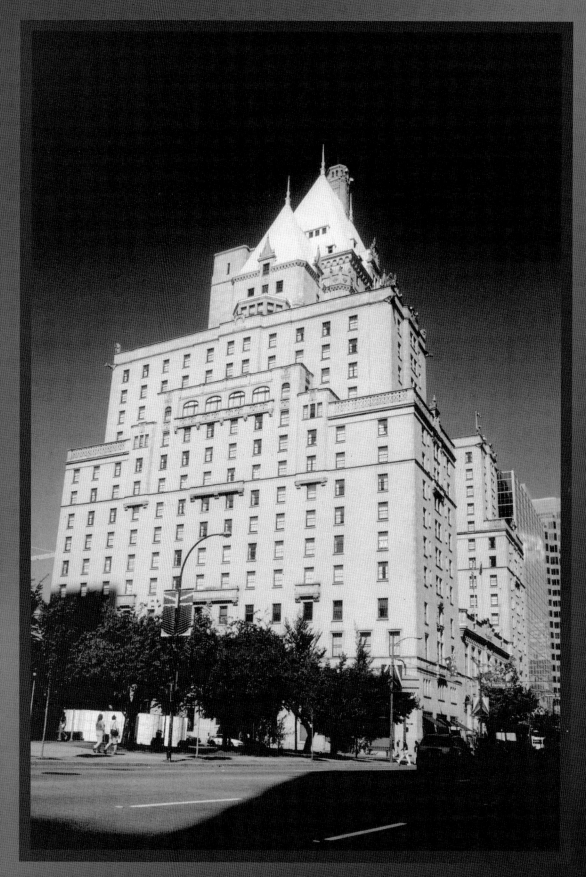

hotel vancouver

Address: 199 West Georgia Use: Hotel Floors: 17
Completed: 1939 Architect: Archibald & Schofield Height: 111 metres (363 feet)

44

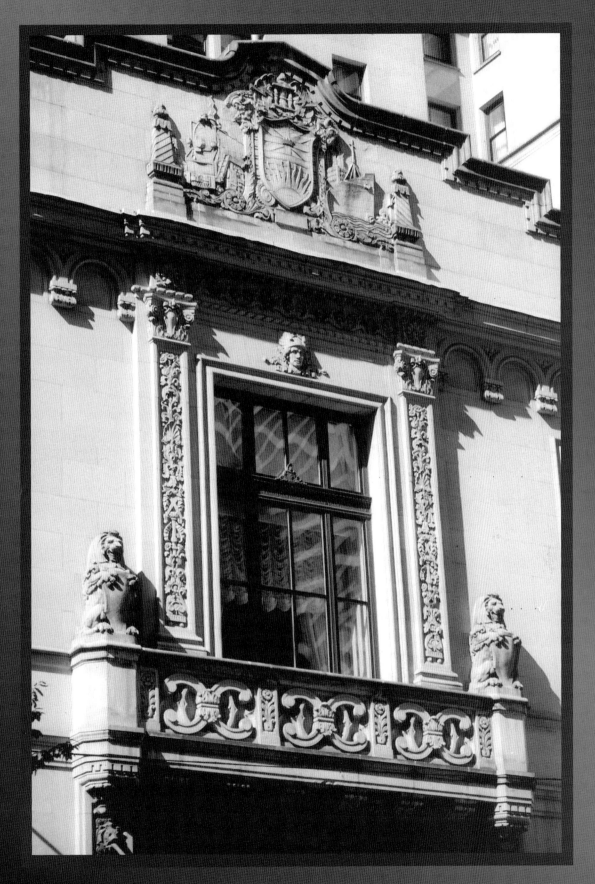

The Hotel Vancouver is one of Vancouver's most recognizable landmarks, and this photo shows the wonderful detail and craftsmanship that is characteristic of this building. Construction took 11 years to complete, but was halted for five years during the Depression. The final cost was $12 million.

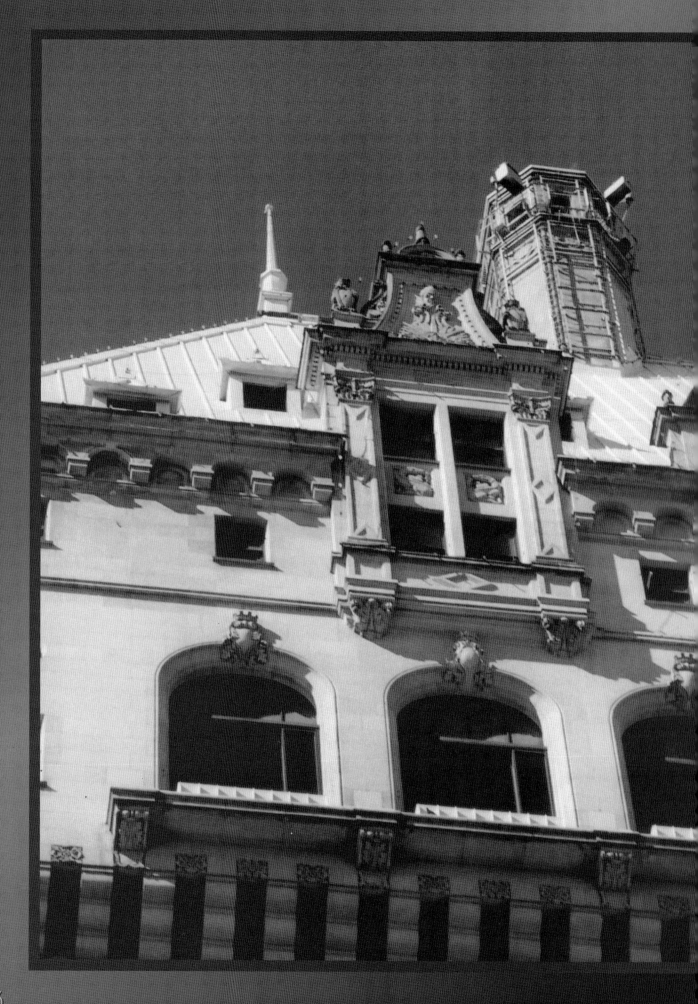

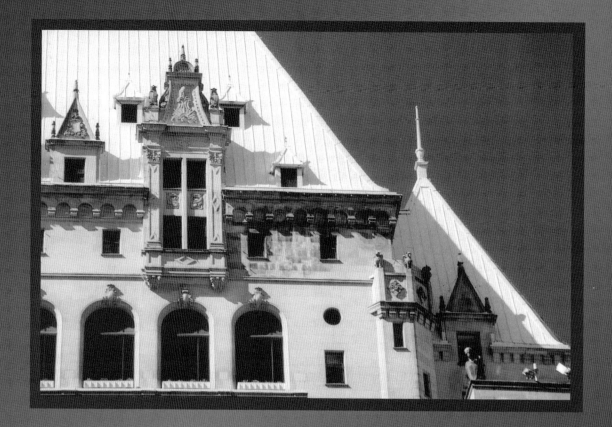

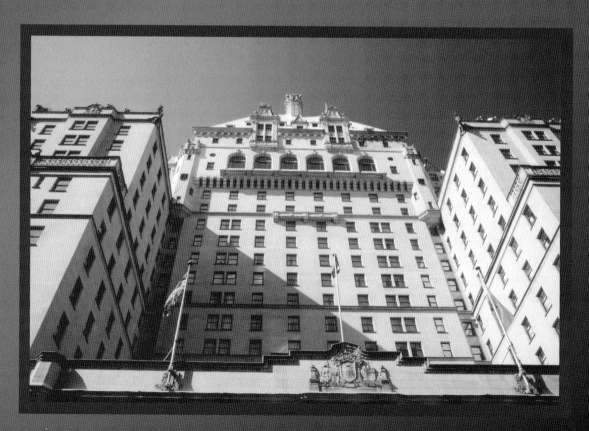

The top photo shows the detail of the oxidized copper roof. This was the final CPR hotel to be built in the chateau style and was Vancouver's tallest building until 1972. During the mid-1990s, it received a $70 million restoration.

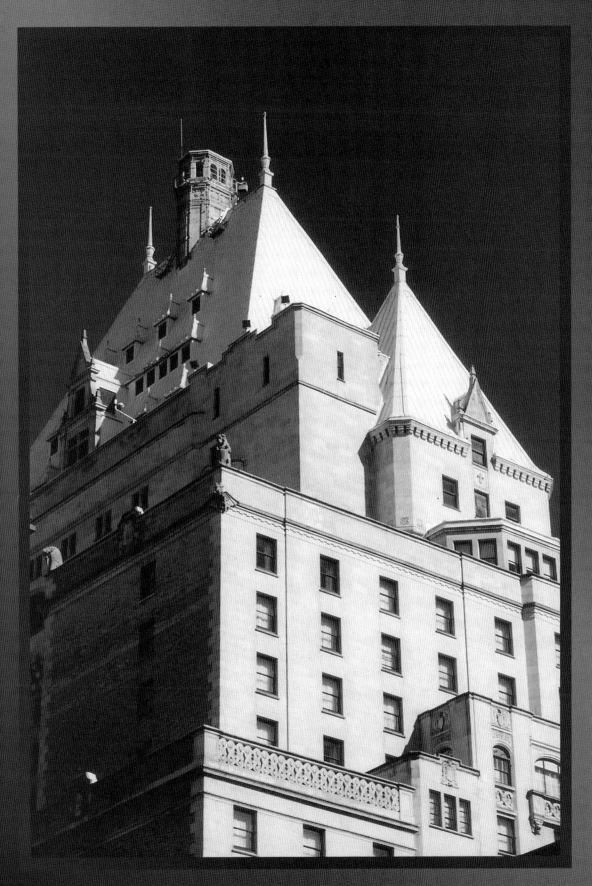

This is the third building to bear the name "Hotel Vancouver." The first, built by the CPR in 1887, was a five-storey brick structure that resembled a farmhouse. The second was completed in 1916 and became a government administration building during the Second World War.

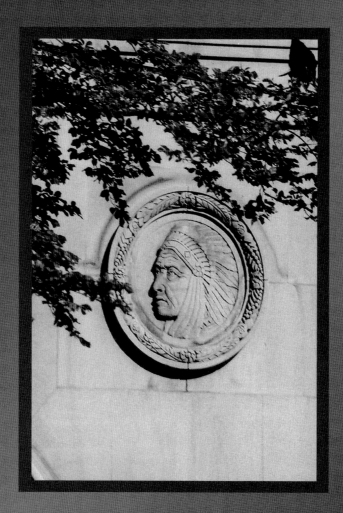

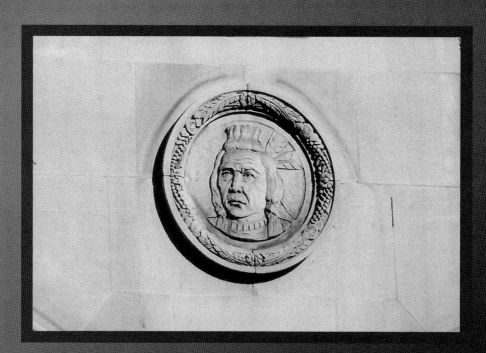

Here are wonderful examples of the architectural details on the hotel. The Indian heads, which pay homage to First Nations history, can be found at street-level on the building's east side.

Address: 300 West Georgia Use: Public Asset Floors: 21
Completed: 1995 Architect: Moshe Safdie & Height: 84 metres (276 feet)
 Associates

The integrated tower at the northeast corner is occupied by the federal government. The architect for the project was chosen by competition, with the public voting on the submissions. The total cost of Library Square was $157 million.

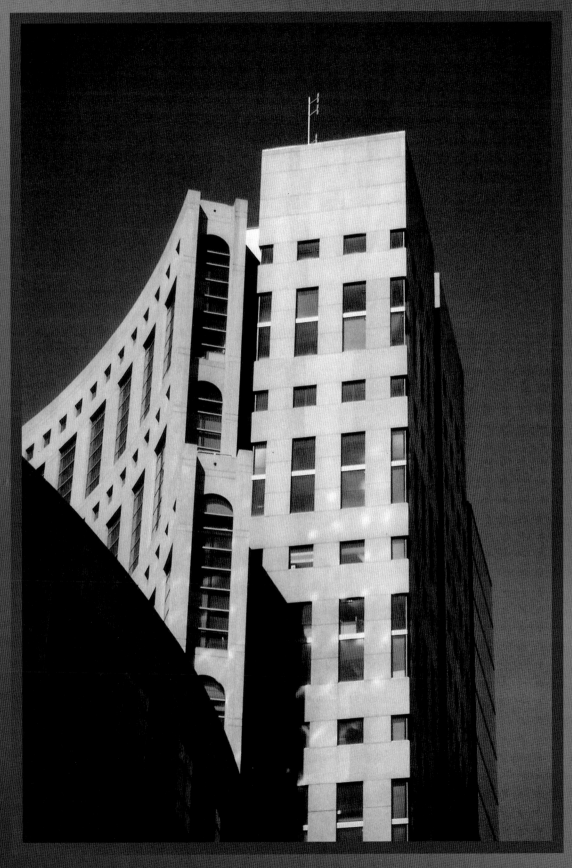

This building is enormously successful and is loved by the residents of the city. Many see it as an architectural triumph, breaking away from the typical right angles and embracing gently sweeping curves. Interestingly, the actual structure is a rectangle within an ellipse.

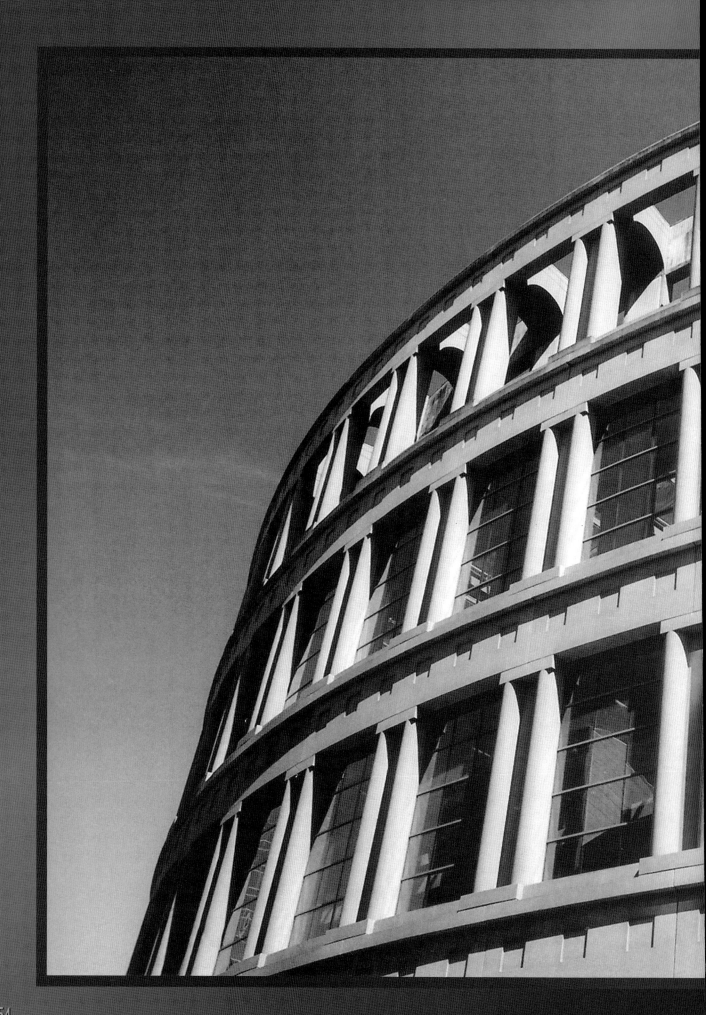

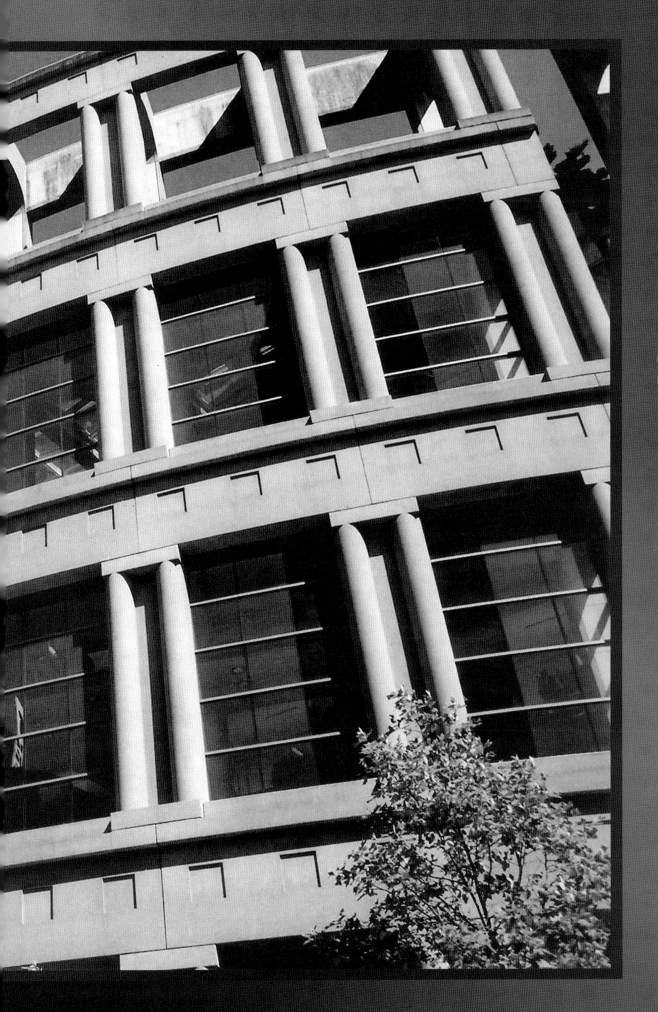

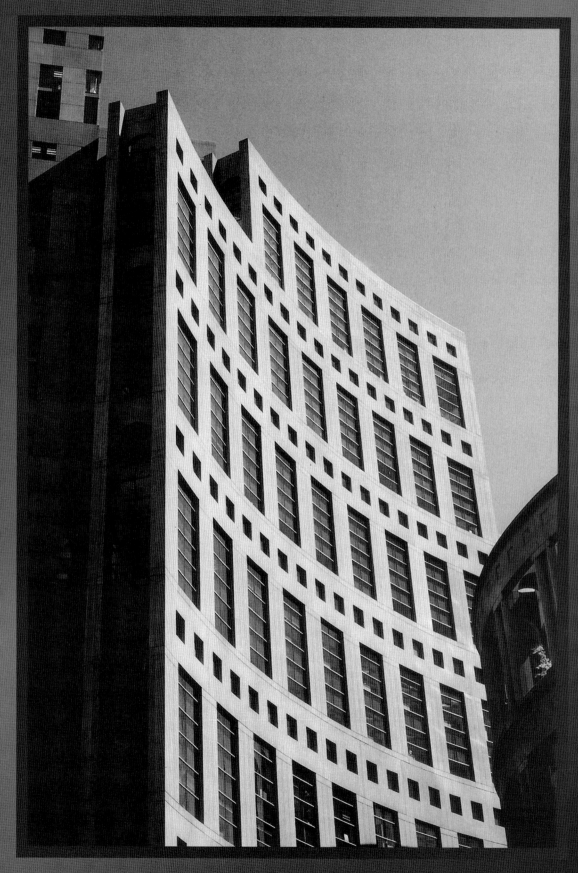

While an undeniable success, one wonders what a Roman-style coliseum has to do with a library, West Coast architecture, Vancouver or the natural environment. Perhaps the key to its success is the fact that it is so daring and unconventional.

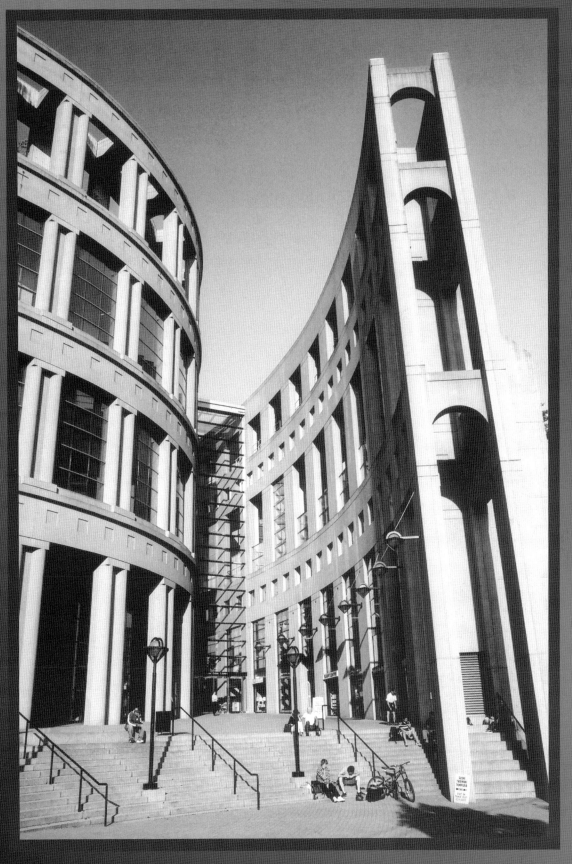

Many people take advantage of the south entrance to take a break and relax in the sun during the day. The taupe colour of the library and plaza creates a warm, welcoming environment, despite a distinct lack of landscaping.

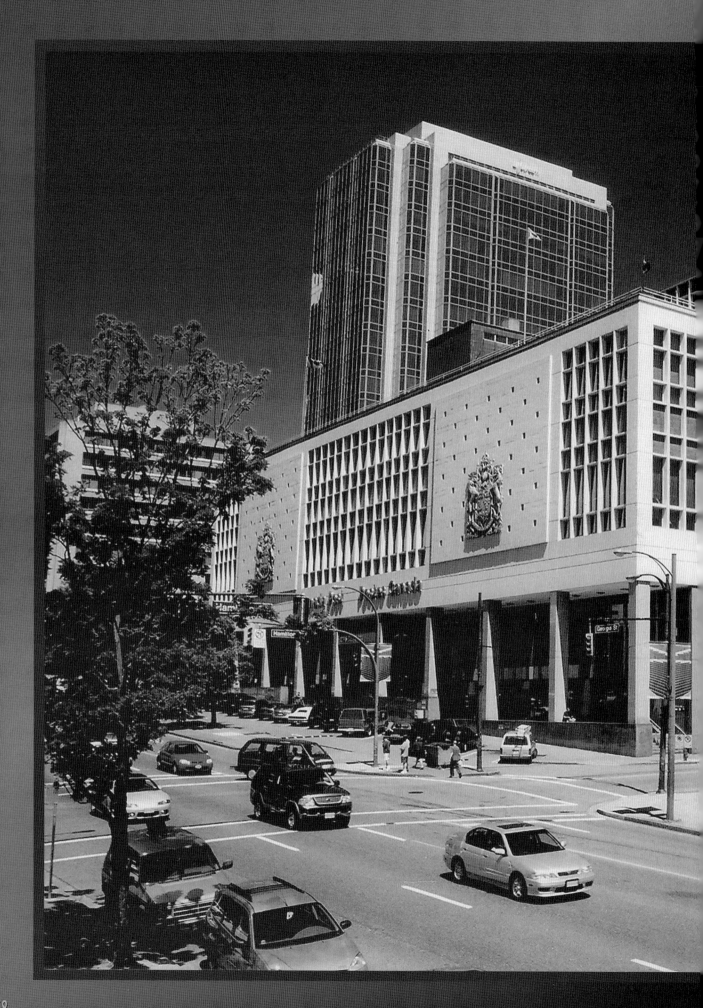

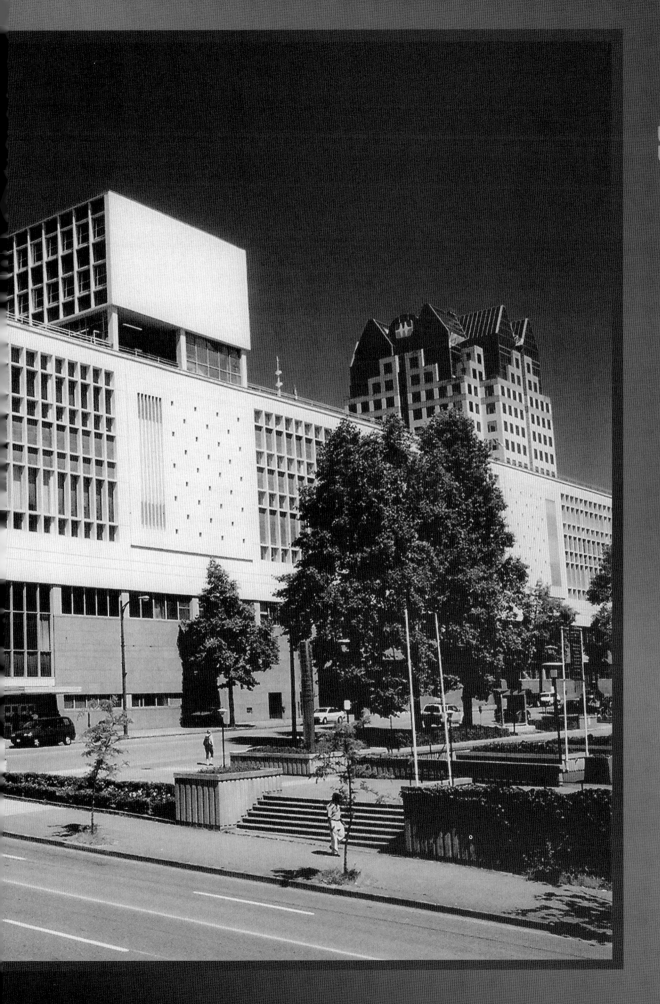

west end

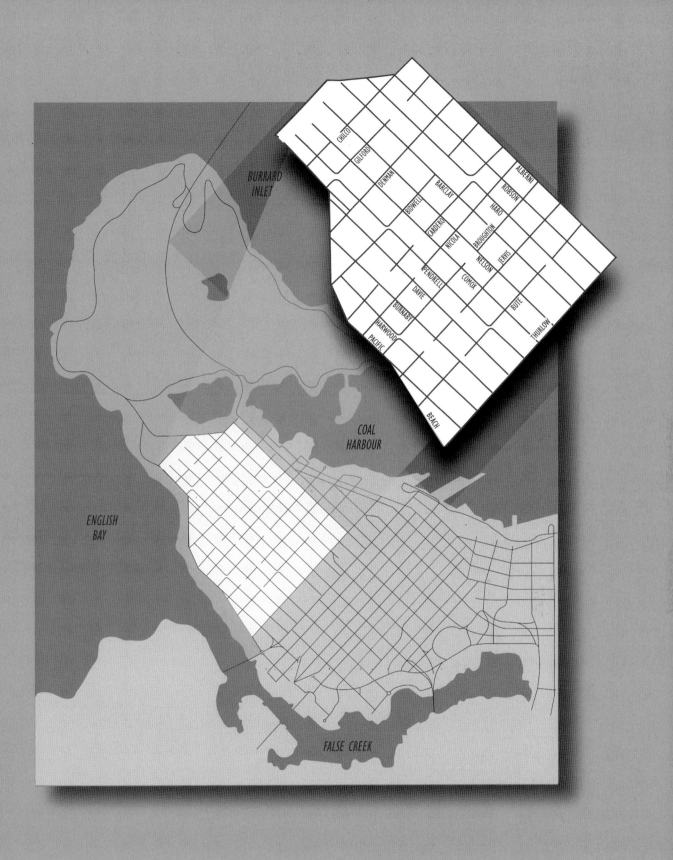

BURRARD
INLET

COAL
HARBOUR

ENGLISH
BAY

FALSE CREEK

CHILCO
GILFORD
DENMAN
BARCLAY
BIDWELL
CARDERO
NICOLA
PENDRELL
DAVIE
BURNABY
HARWOOD
PACIFIC
BEACH
ALBERNI
ROBSON
HARO
BROUGHTON
NELSON
JERVIS
COMOX
BUTE
THURLOW

WEST END

It could be said that the West End is the Miami of Vancouver. The area is surrounded by the best Vancouver has to offer: beaches, Stanley Park, Coal Harbour and the downtown core.

Residents make the West End their home and visitors come to take advantage of the many restaurants and the impressive retail experience of Robson, Denman and Davie Streets. Proximity to beaches and Stanley Park, with its many attractions, also make the West End a popular destination for tourists.

This is a high-density residential area, containing a mix of old apartment blocks and new condominiums in a wide range of styles and forms. Low-rise walk-ups mingle with residential towers, providing a diversity of choice for the aged, the young, married couples and singles. Indeed, the West End is a complete community.

If one were to select a single element that makes the West End a homey, welcoming place, it would be the trees. Old trees of all species, both native and exotic, line the streets and prevent the area from feeling sterile, grey. Walking down any residential street, one seems unaware of the towers above. The canopy of trees serves to act as a barrier between street-level views and the concrete overhead. Conifers do a particularly wonderful job, unselfishly continuing this duty over the winter. And during summer days, the shade is a nice respite from the seasonal heat.

The perspective from a 12th-floor suite above the trees can be equally rewarding. The area's towers comprise only part of the view. Looking down to the street, lush greenery of all shades and textures completes the feeling that one is living in a park, far away from the city's hectic pace. The mountains and the ocean may also be enjoyed, depending on the direction faced. In many cases, pavement and cars do not exist from this vantage point.

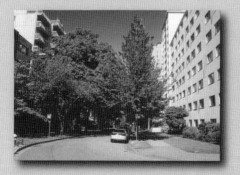 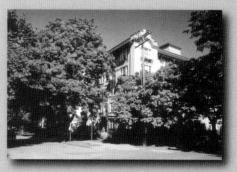

Two views showing how trees have influenced the livability of the West End. On the left is the intersection of Bute and Pendrell; the right image shows Nicola and Pendrell.

For residents of the West End, the need for a car is either diminished or completely eliminated. Everything is within a short walk, and transit options are plentiful. In many ways, this is an ideal community, and interestingly, it was not created out of the rigid urban planning processes that are in place today. Its evolution has been guided largely by trial and error, particularly in the early days. Time has also played a role, allowing buildings to age, trees to grow, and architectural styles to come and go.

After the Great Depression and World War II, the West End had become a densely populated area of transients. Until 1950 the tallest building was the eight-storey Sylvia Hotel on Beach Avenue. In the early 1950s, many Victorian-era houses were replaced by 90 three-storey walk-ups, built with little thought of design or style. After seeing the error of this approach, the city planning department rezoned the area in 1956 to allow high-rise buildings. The first regulations gave rise to a series of uninspired, carbon-copy concrete slab towers, around ten storeys tall. The planning department then began to ease restrictions, especially building height, in exchange for additional open spaces or off-street parking. In the next thirteen years 220 highrises were built. As a result, the West End became the highest-density apartment neighbourhood in Canada, currently with a population of 45,000 in just over two square kilometres.

Surprisingly, some single-family houses remain in the area, serving as a reminder of what the neighbourhood was like decades ago. One interesting and successful project is the revitalization of the Mole Hill Community.

A handful of unrestored single-family homes remain in the West End, this one dwarfed by the Empire Landmark Hotel.

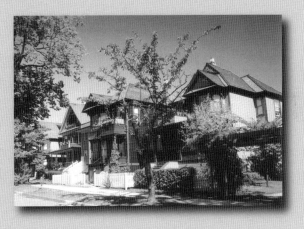

The homes of Mole Hill (Pendrell Street view) have been restored to their original condition.

Mole Hill, named after two early residents of the area, is bordered by Bute, Thurlow, Comox and Pendrell Streets. It contains the city's only intact Victorian and Edwardian neighbourhood, dating back to 1888. In the 1950s the city started buying up homes on this block with the intent of demolishing them to create a park. Even up to 1996, the plan was still current. But after a five-year campaign by residents and citywide supporters, City Council agreed to save the block and created policies to guide its future. Some of these are:

- Maintain city ownership of the land;
- Accommodate existing tenants in the redevelopment;
- Give priority to low-income rental housing;
- Preserve the heritage buildings;
- Include community uses in the redevelopment.

Twenty-six heritage houses were restored, creating 170 affordable (non-market) housing units. A community garden, lane greenways, daycare and a facility dedicated to persons living with HIV/AIDS are important components. Innovative technologies were incorp-

orated, such as geothermal heating and sustainable building practices. This approach considers the environment and human health and well-being, in addition to the usual criteria of function, cost and aesthetics.

Many partners made the Mole Hill project possible, including the City of Vancouver, the provincial government, various charitable organizations, community groups and businesses. The project is a great success story, balancing heritage building preservation, development and community needs. It is a shining example of various agencies and groups coming together to achieve a goal that benefits society.

The roundabout, a common traffic-calming device, eliminates the need for stop signs while slowing traffic. The abundance of old trees greatly enhances the livability of the area.

In the West End, people and not traffic are the prime consideration. To that end, measures have been taken to manage the traffic in the area — a prudent consideration given the population density. Strategies include the installation of traffic roundabouts, corner bulges, diagonal diverters, street narrowing, and the closure of street sections to create miniparks. The intent of these traffic control measures is to reduce speed, volume, noise and accidents, and also to increase crosswalk safety, all of which make the area more livable. People can be seen in the streets late into the evening — walking along enjoying the sights, dining out, shopping and taking in the nightlife. This ambience helps make the West End a vibrant community.

In addition to the beaches, stunning mountain vistas, recreation and nightlife, the West End is home to some major events. The Celebration of Light fireworks competition, Gay Pride Week and Parade, and the Polar Bear Swim on New Year's Day are all successful, with the fireworks drawing hundreds of thousands of people.

As well, Canada's many cultures are represented, living harmoniously in an extremely dense but geographically small area. One may say that the West End has laid the foundations for what Vancouver has become — a densely populated area but also a very livable community. It is a desirable place to live with the right balance of nature, proximity to the city's core, nightlife and ample recreational opportunities.

The beaches of English Bay, with Stanley Park to the left and the North Shore mountains in the background.

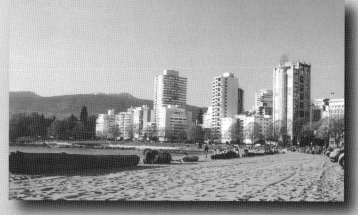

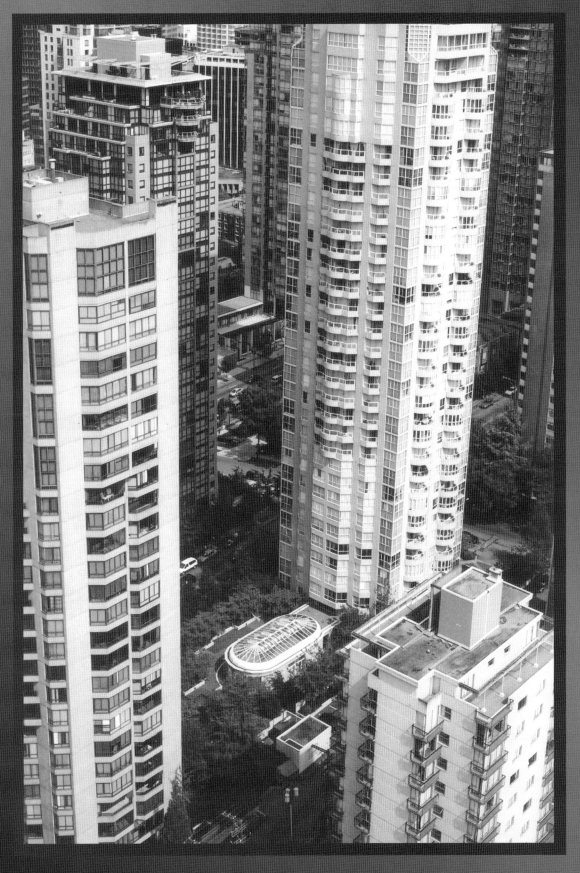

Despite the density of the residential towers, the area is open and inviting. To achieve this livability, two-level townhomes are built at street level, with the towers set back. Public plazas, tree-lined streets and a variety of building textures help to make the area an enjoyable place.

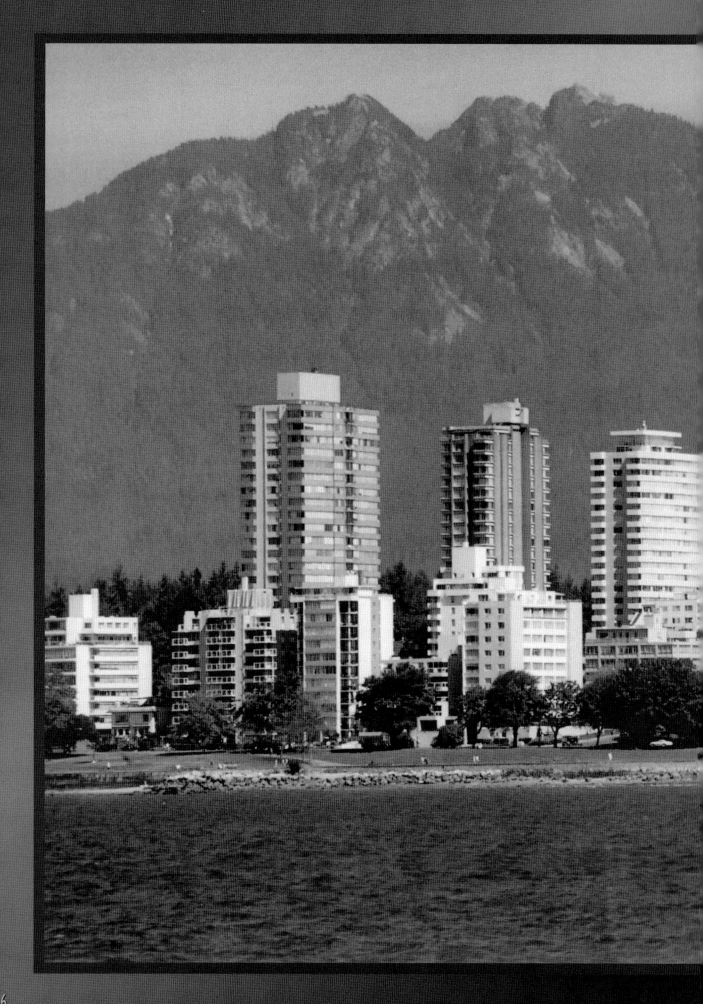

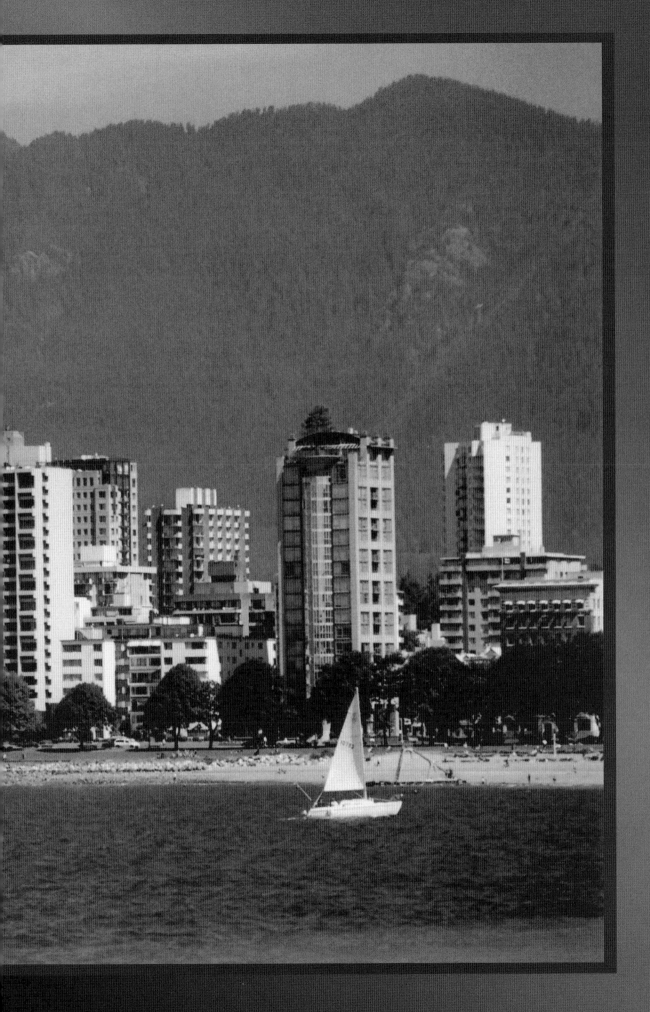

english bay

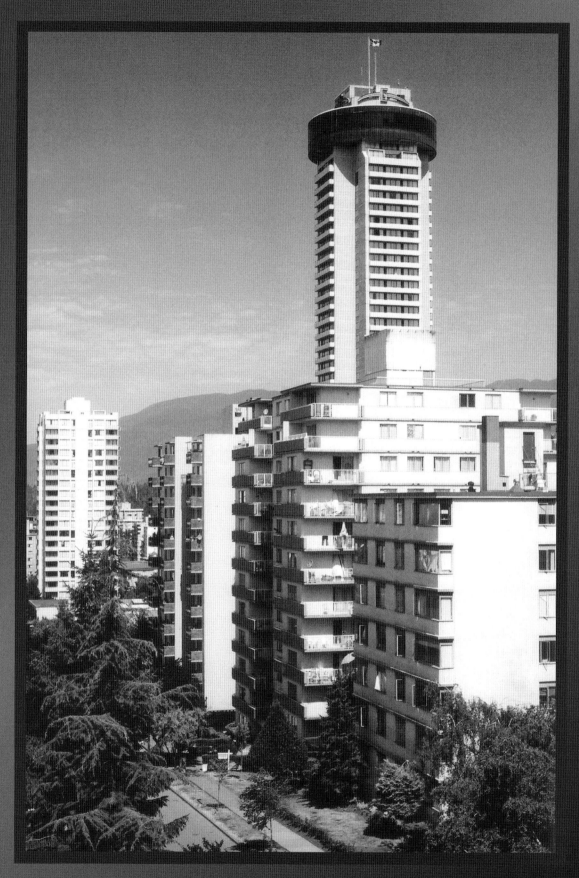

haro street

Haro Street exhibits the typical concrete slab apartment blocks of the 1960s, built with little thought of style or design. Still, the area is attractive due to the lush vegetation and natural surroundings. The Empire Landmark Hotel, towering above its neighbours, seems out of place from this perspective.

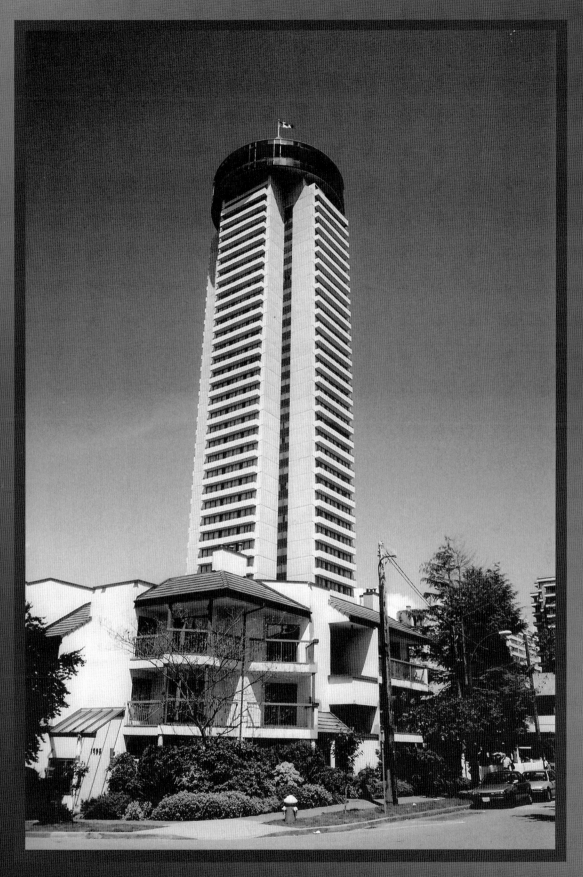

Address: 1400 Robson Use: Hotel Floors: 42
Completed: 1973 Architect: Lort & Lort Height: 120 metres (394 feet)

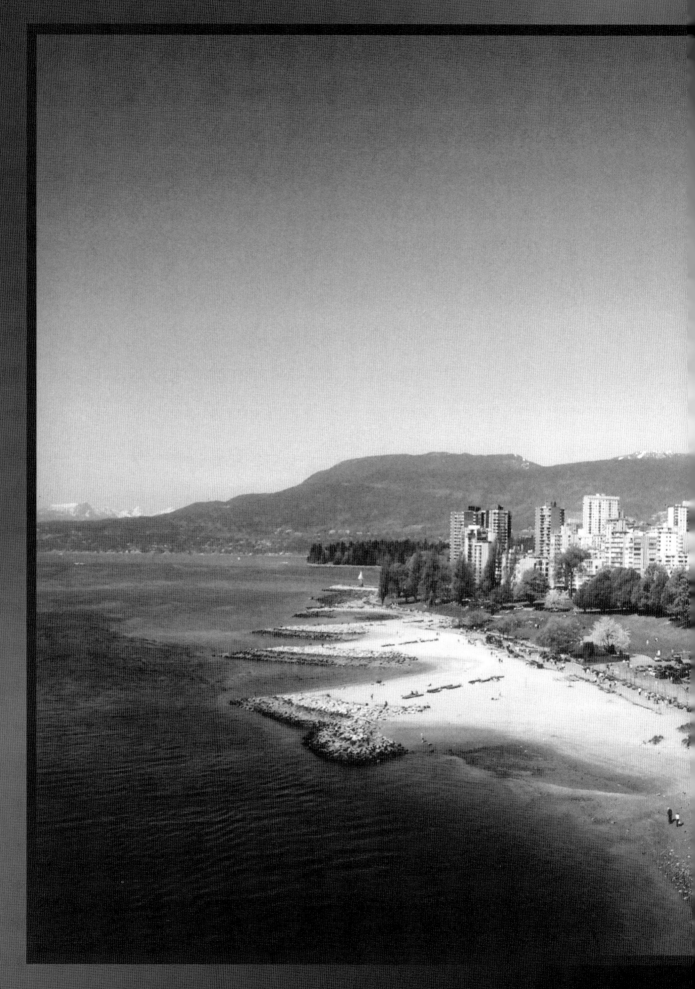

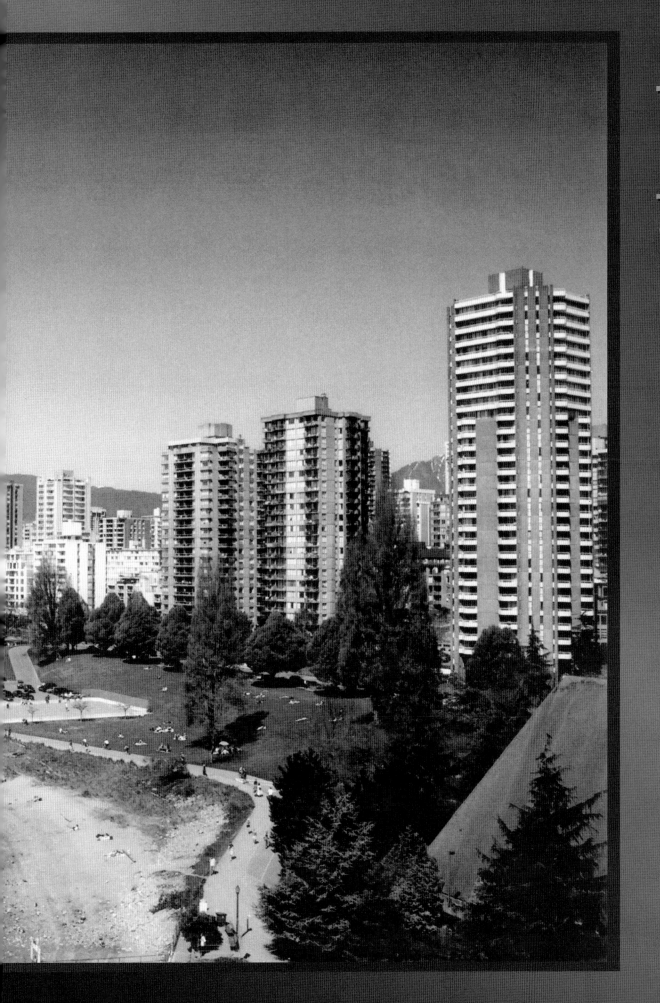

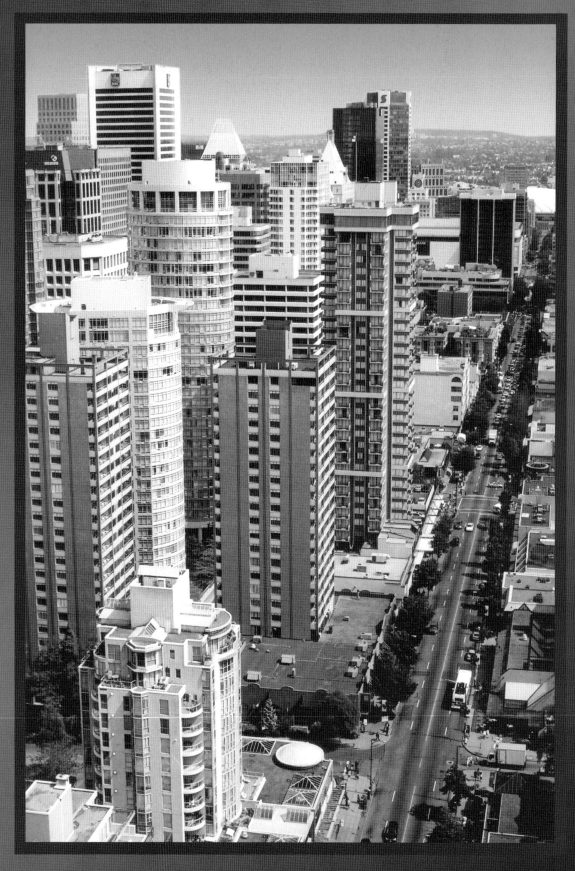

Decades ago, Robson Street was known as Robsonstrasse – a collection of European shops, delicatessens and boutiques. In modern times, it has evolved into Vancouver's prime retail destination and is a major tourist draw, featuring hotels, high-end shops, restaurants, coffee houses and boutique stores.

Address: 1995 Beach

Completed: 1976

Use: Residential

Architect: Reno C. Negrin
Architects

Floors: 20

Height: 58 metres (191 feet)

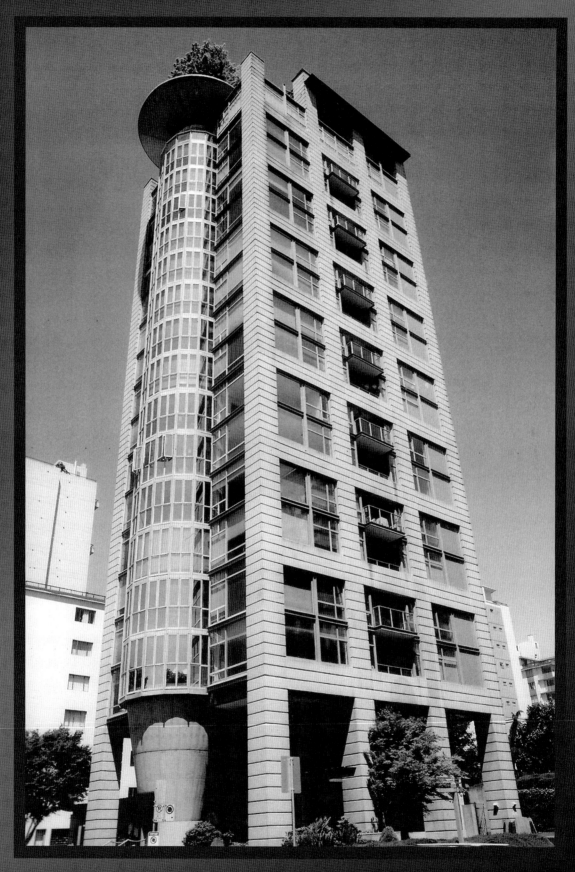

Address: 1919 Beach Use: Residential Floors: 19
Completed: 1991 Architect: Henriquez Partners Height: 58 metres (189 feet)

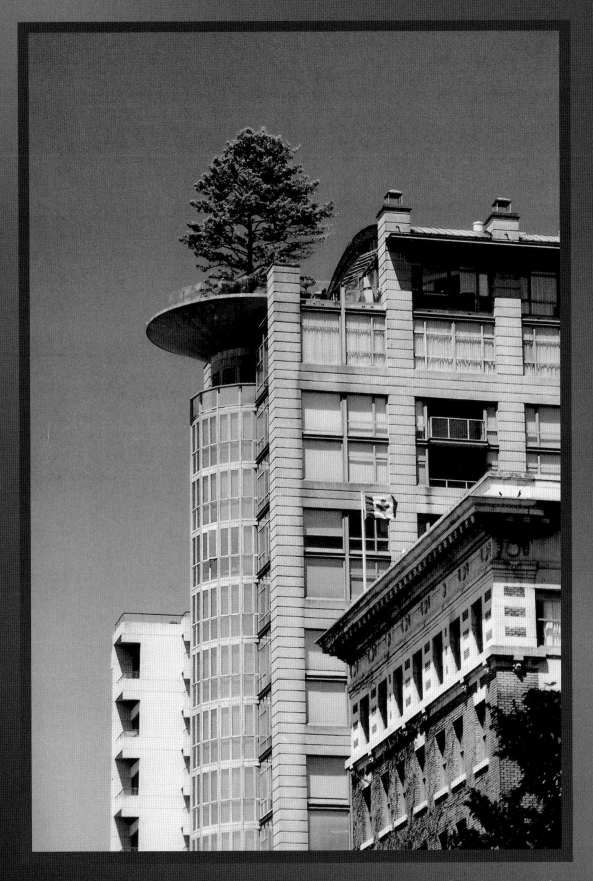

This details of this building pay tribute to the area's natural history: its height is the same as the original Douglas firs that occupied the site, the 35-foot oak tree on the top is a reference to natural continuity, and concrete stumps were added at ground level.

coal harbour

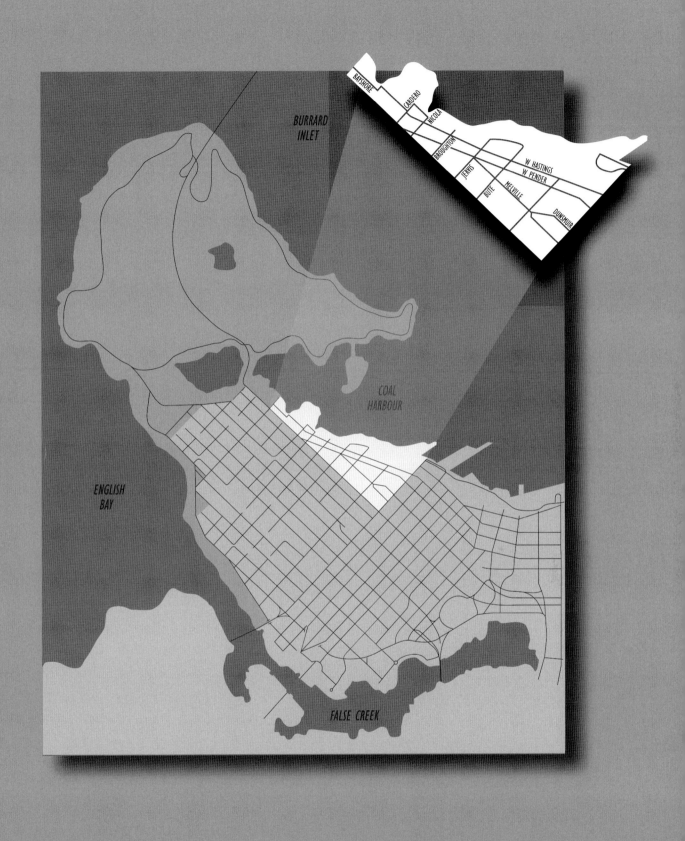

BURRARD
INLET

COAL
HARBOUR

ENGLISH
BAY

FALSE CREEK

BAYSHORE
CARDERO
NICOLA
BROUGHTON
JERVIS
W HASTINGS
W PENDER
BUTE
MELVILLE
DUNSMUIR

COAL HARBOUR

One might assume that Coal Harbour and the West End would be similar because they are neighbouring communities, but nothing could be further from the truth. The West End has evolved over decades and therefore offers a mix of architectural styles and building types, accented by old trees lining the streets. In comparison, Coal Harbour is a new community, well integrated with the rest of the surrounding downtown core and with consistent architectural designs. This area was subject to rigorous modern urban planning processes from the very beginning. The result is a stunning achievement: attractive residential towers, generous public areas and a seaside walk that is a natural extension of Stanley Park's famed 8.1-kilometre seawall.

Three neighbourhoods totalling 20.2 hectares blend seamlessly into each other, the most westerly being Bayshore Gardens, anchored by the Bayshore Hotel. At the centre is Harbour Green, followed by Burrard Landing, a project that includes the new convention centre. Coal Harbour's eastern boundary is defined by Canada Place, housing the current convention facilities and the cruise ship terminal.

Residents of this area are privy to every morning sunrise — a perfect start to the day. Sunsets, however, are the pleasure of English Bay residents of the West End. Coal Harbour seems less crowded than other areas in downtown Vancouver, due to lower densities, more generous spacing between towers and less exposure to traffic. Stanley Park, directly across the harbour and, further beyond, the North Shore mountains and the city that resides on their slopes, provide a pleasing view. To the east, the unique sails of Canada Place and the massive cruise ships arriving and departing add to the scenery. Floatplanes take off regularly and many pleasure craft make Coal Harbour their berth of choice. For those living in this area, there is never a shortage of views to enjoy.

This young, vibrant community was formerly an industrial area and working harbour. Named for hoped-for coal deposits that never materialized, Coal Harbour was primarily a CPR railway yard until the mid-1980s. The transformation took place in the 1990s, although redevelopment planning began in 1973 and continues to this day with the construction of the new trade and convention centre.

The towers here are tall, slim, elegant. The lean profiles were required under the urban design process so as to not disrupt the city's view corridors, especially down north-south streets. Concrete of previous areas has given way to glass, creating a glamorous look. Mixed in with the towers, townhomes of shorter stature bring a balance of scale and help to define the street edge.

Part of what makes Coal Harbour attractive is simply its newness. There has been no time for facades to deteriorate, for mould to take hold on concrete, for wear and tear to take place on street-level surfaces. The landscaping is manicured to perfection, and everything looks exceptionally clean. Some may equate this with a lack of character, preferring heritage neighbourhoods and the associated impressions that time has left on them. Some may argue that there is a sense of artificiality in the whole design scheme: perhaps the planners envisioned some sort of urban utopia? However, there is no denying the attraction of something brand new, and it will be interesting to see how time shapes this area.

In planning the public spaces at Coal Harbour, it was determined that the majority should be along the waterfront and be easily accessible, attractive and interesting. It was also decided that the buildings should not loom over and shadow the seawall, thereby dominating the site rather than integrating with it. To achieve this, large grassed areas accented by attractive landscaping serve as buffers between the towers and the walkway. The seawall design clearly separates pedestrians from cyclists. The ample benches make a nice place to stop, rest, chat with a friend, or to just enjoy the view. The seawall links Coal Harbour to Stanley Park and the downtown core.

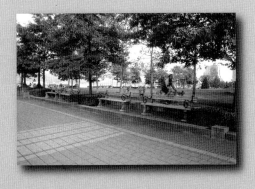

Benches along the seawall are plentiful, and well-placed trees provide shade for those who wish to sit and rest. Note the attractive surfacing treatment of the pedestrian pathway in the foreground.

The generous grassed area between the seawall and the towers prevents shadowing of the walkway from buildings. The area is visually attractive, a great place for kids, and a place for owners to exercise their dogs.

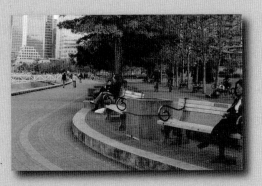

Another view of the seawall, clearly showing the separation of pedestrians and cyclists. This important design element prevents user conflict.

As attractive as the seawall is, rainy days bring people indoors. An important component of a healthy community is a place for people to gather, and Coal Harbour has its community centre. Constructed almost entirely underground and covered by a huge lawn, it features large windows facing the water and mountains that give a grand view. The centre consists of seven large rooms including a dance studio, arts and crafts room and a gymnasium.

Other amenities in Coal Harbour include social housing, an elementary school, daycares, art galleries and restaurants, all of which serve to bring people together as a community; the area is more than an aggregate of anonymous towers.

Coal Harbour was planned with extensive public input. The developer and the city worked together to solve problems and create the plan — a process adapted to other major projects in Vancouver. Coal Harbour has been completely transformed from working port to master-planned, highly desirable waterfront community.

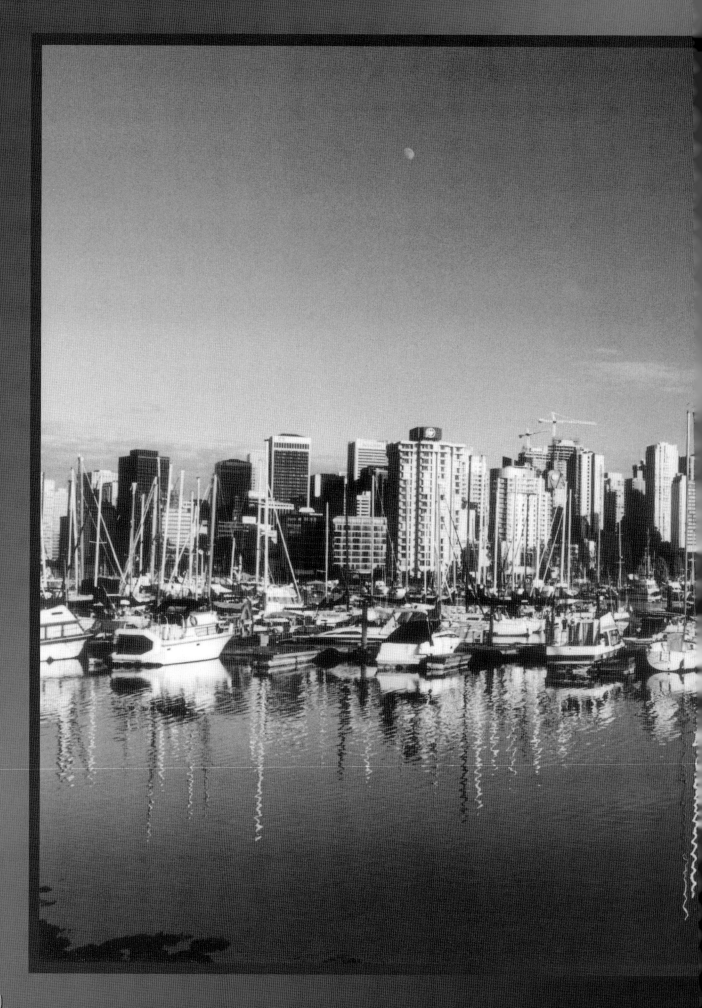

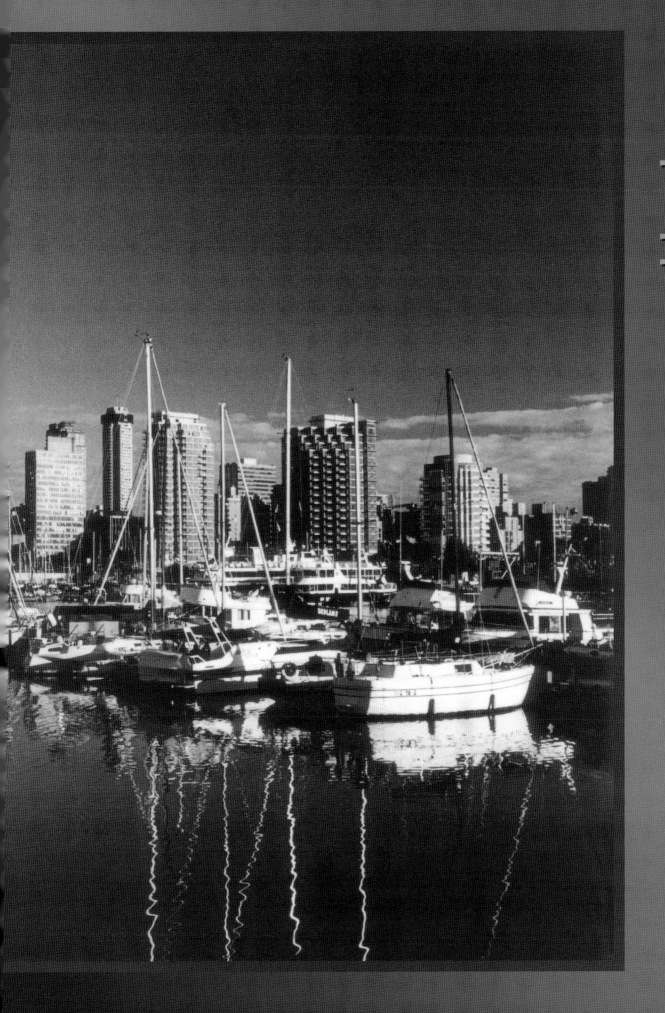

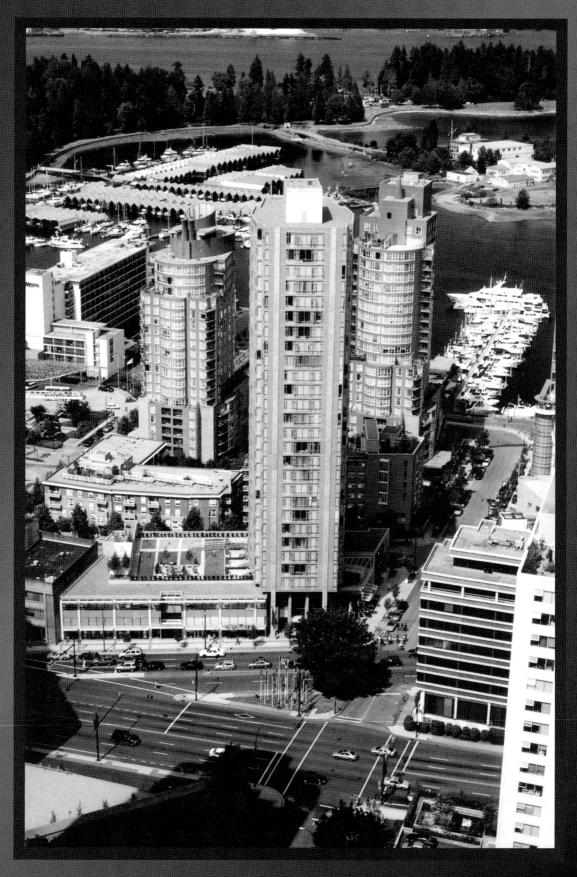

Coal Harbour is an area where the point tower concept has been used – slender towers that have minimal impacts on the views from streets or other buildings. This photo shows the northerly view, with West Georgia Street in the foreground.

Address: 1140 West Pender Use: Offices Floors: 18
Completed: 1984 Height: 71 metres (234 feet)

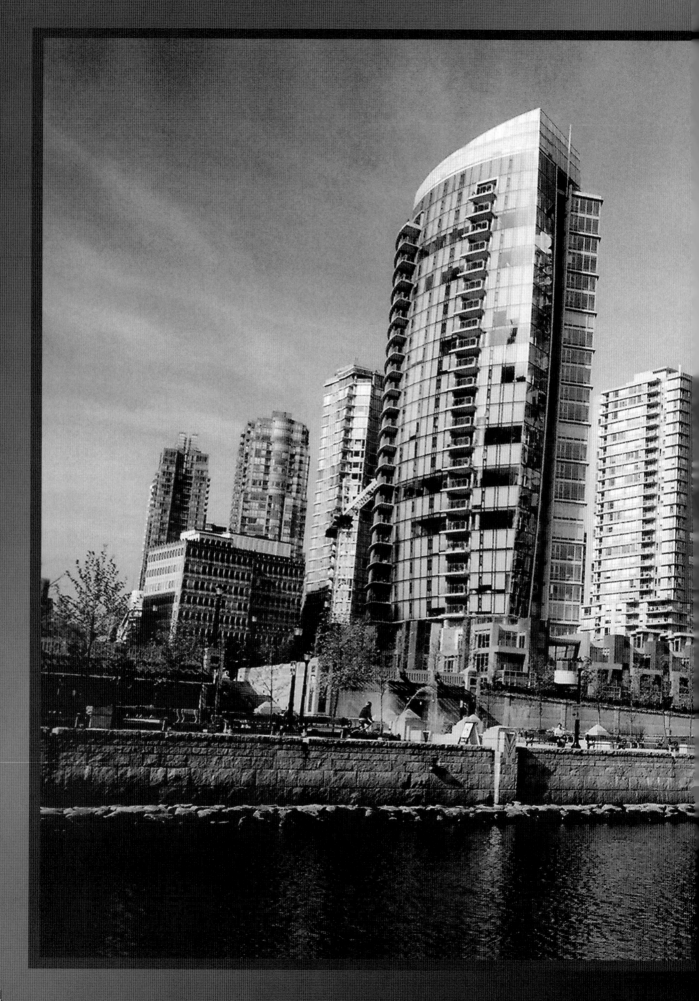

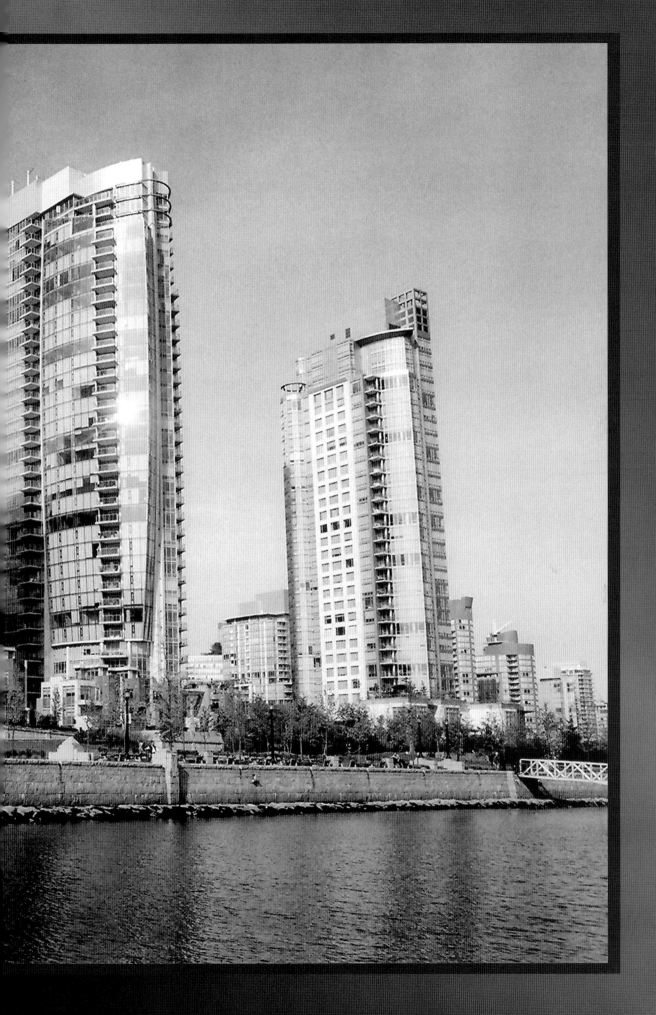

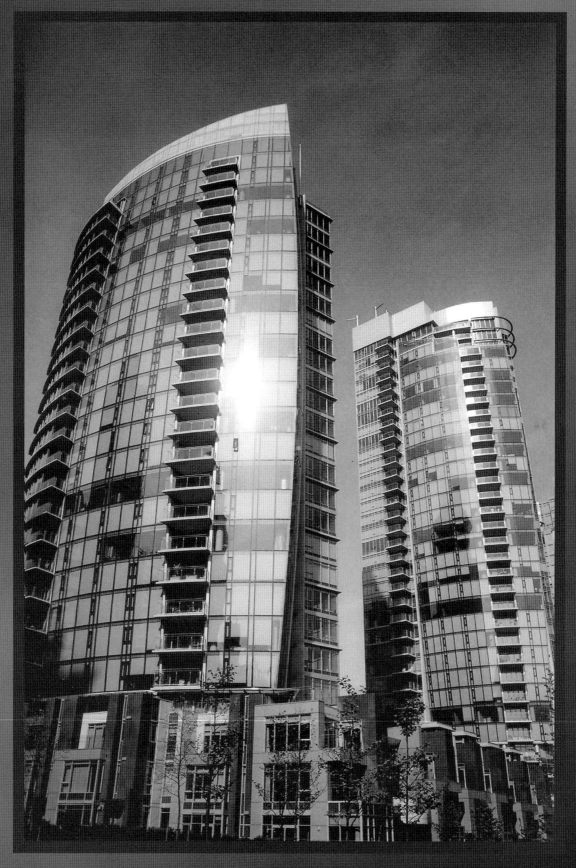

harbour green place

Harbour Green Place consists of five towers. Featured here are the Carina (foreground) and Callisto (background). The unique sweeping curves on these buildings are absolutely magnificent. Resembling giant sails, they continue the theme of Canada Place and fit well into the environment.

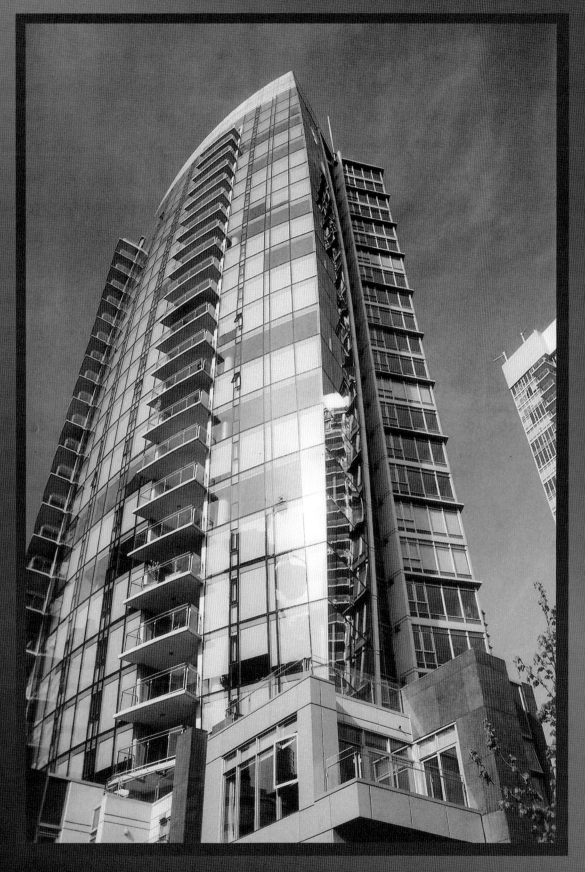

Address: 1233 West Cordova Use: Residential Floors: 27
Completed: 2003 Architect: Hancock Bruckner Height: 79 metres (259 feet)
Eng + Wright

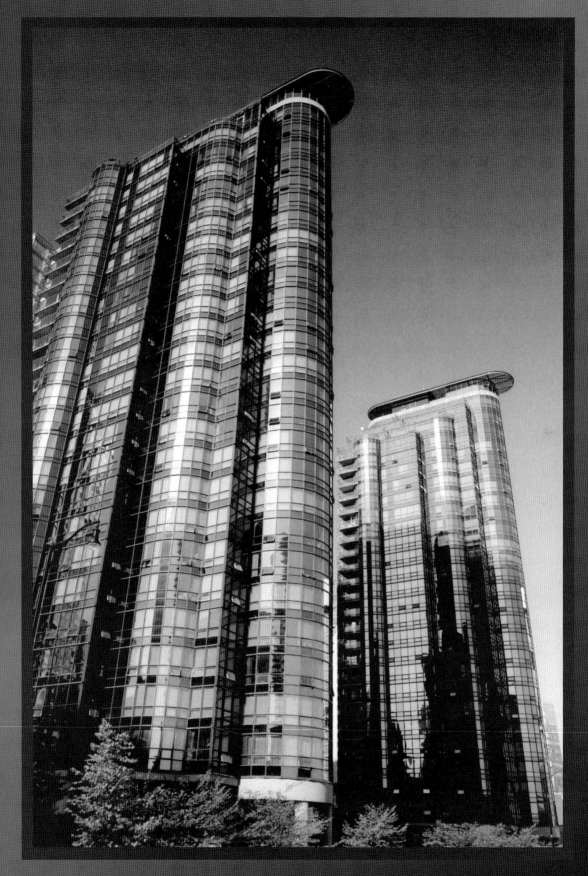

harbourside park

Address: 555 Jervis
 588 Broughton

Use: Residential
Architect: VIA Architecture

Floors: 28
Height: 82 metres (269 feet)

Completed: 1997

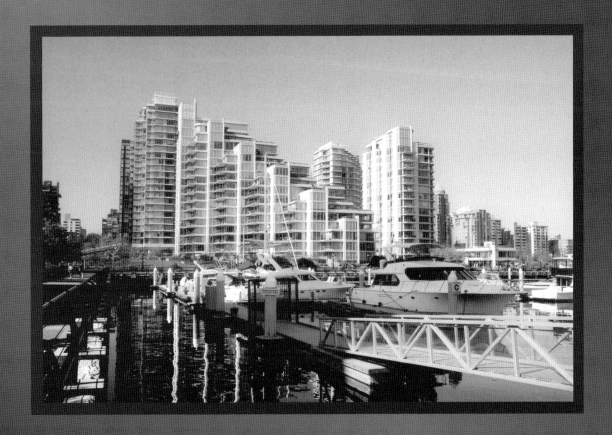

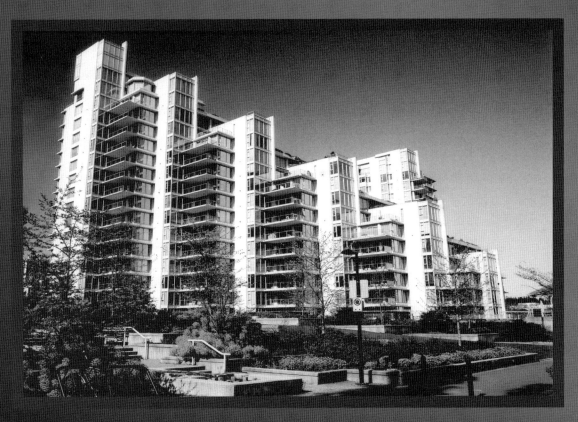

Address: 1717 Bayshore Use: Residential Floors: 18
Completed: 1999 Architect: Henriquez Partners Height: 52 metres (172 feet)

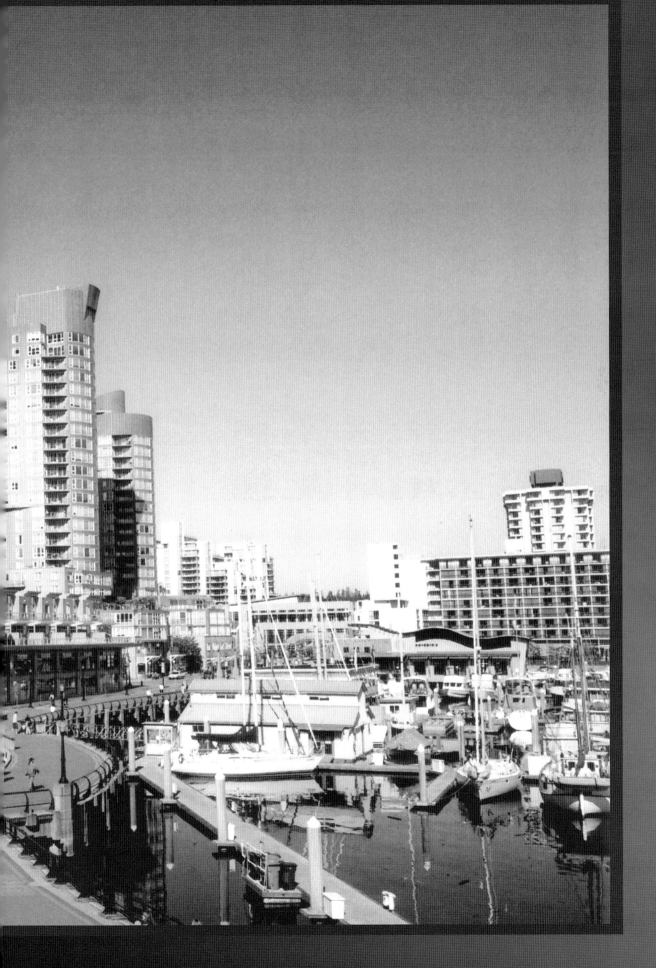

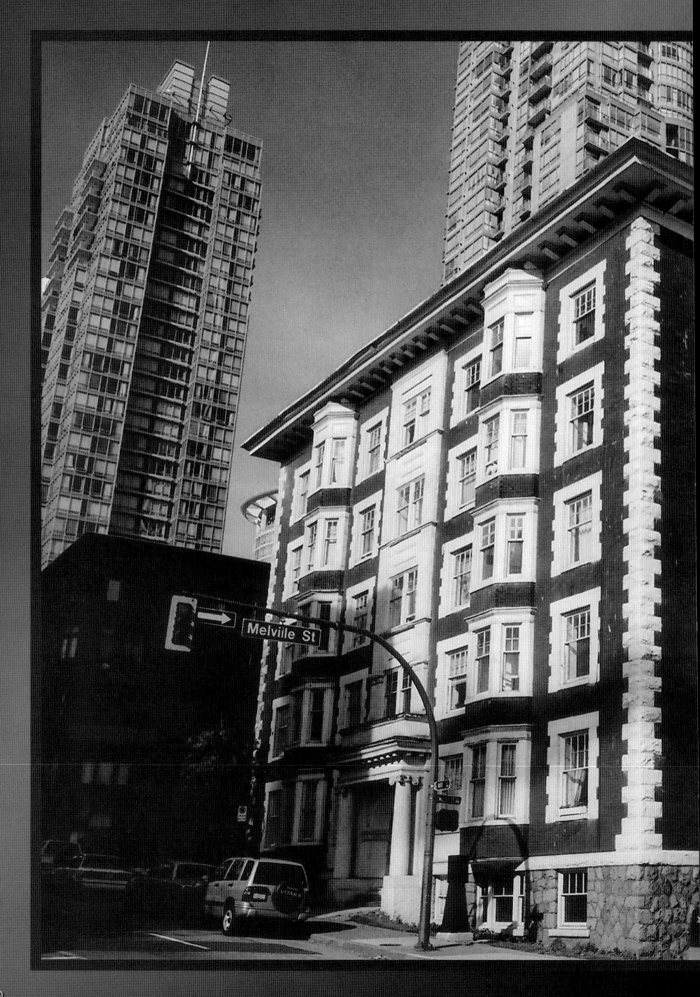

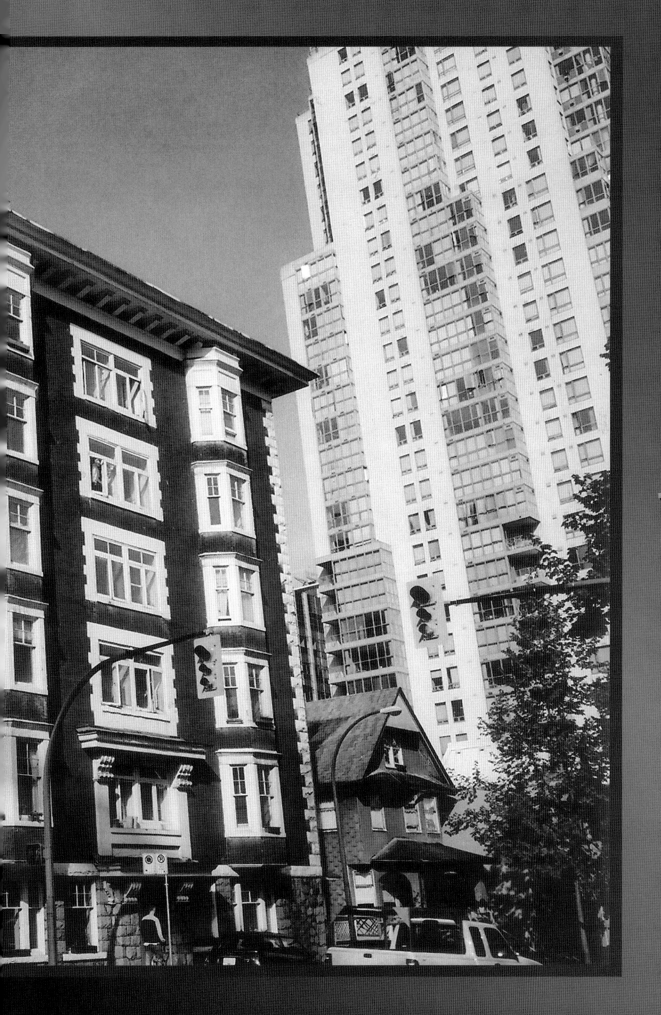

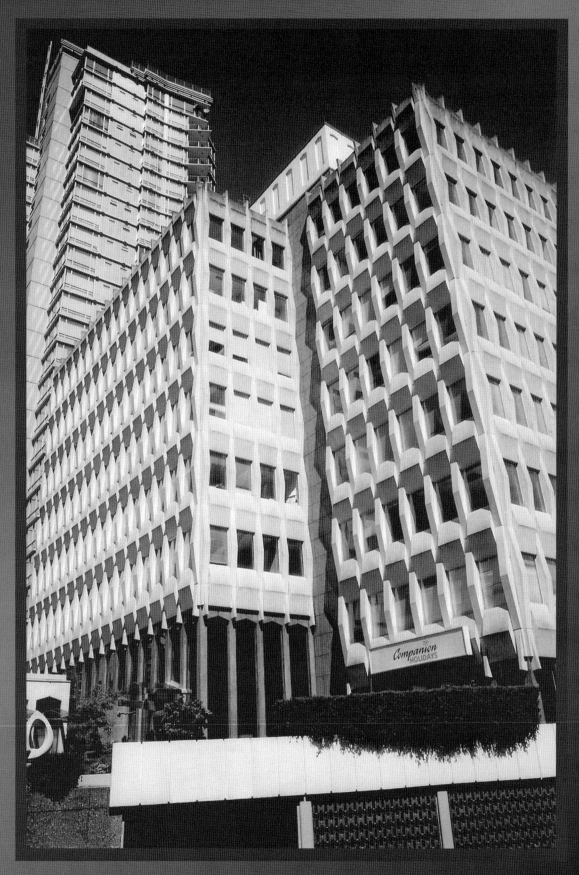

Address: 1201 West Pender Use: Office Floors: 9
Completed: 1966

East Asiatic House, an office building, has aged very well. The design pushed the boundaries of the typically drab 1960s slab towers. The texture and depth of details make this low-rise tower particularly interesting.

waterfront

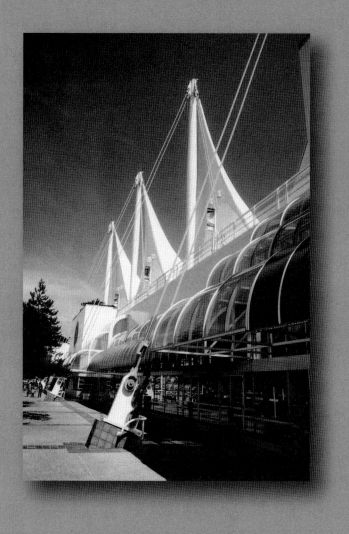

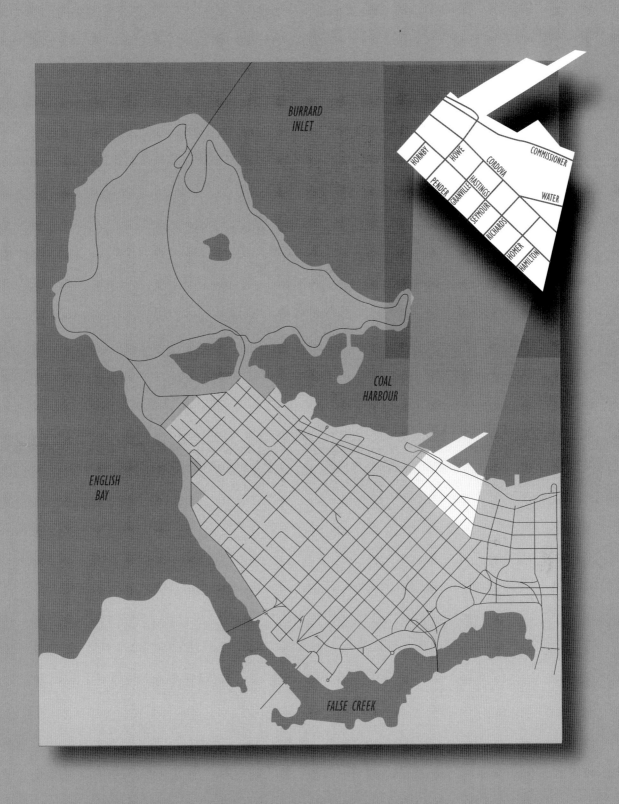

BURRARD
INLET

COAL
HARBOUR

ENGLISH
BAY

FALSE CREEK

HORNBY
HOWE
CORDOVA
COMMISSIONER
PENDER
HASTINGS
WATER
GRANVILLE
SEYMOUR
RICHARDS
HOMER
HAMILTON

WATERFRONT

Imagine being on a cruise ship entering Burrard Inlet. Having just passed underneath Lions Gate Bridge and slowly easing by Stanley Park, you see the glass towers of Coal Harbour come into view, reflecting sunlight as the ship moves along. It is apparent that the city fits into its environment.

Passengers might also notice two other cruise ships docked at the edge of downtown Vancouver, and that another is sailing a few lengths behind their vessel under Lions Gate Bridge. Soon the ship's docking place is evident. The graceful sails of Canada Place capture the attention, as does the flying saucer—shaped top of Harbour Centre. These are the two most recognizable landmarks of Vancouver's waterfront, and in this small area a flurry of activity takes place.

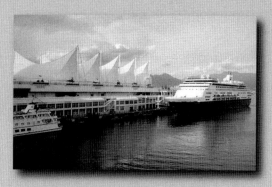
One of the many cruise ships that will dock at Canada Place during the busy season (May to October).

At Canada Place, as many as four cruise ships can be docked at once, each with hundreds of passengers who will explore Vancouver. Just east at Ballantyne Pier, two more ships can be accommodated. Most people will venture on foot, strolling Coal Harbour or enjoying the tourist-oriented shops and attractions of Gastown. The more ambitious will walk to Stanley Park or take a city tour.

Canada Place is many things: cruise ship terminal, hotel, convention centre, IMAX theatre, restaurants. Built by the federal government as the Canada Pavilion for Expo 86, it has become a very visible landmark, often compared to the Sydney Opera House. When cruise ship traffic showed a marked increase, the pier/public plaza was extended to allow more ships to dock.

Beside Canada Place is Granville Square, which has a history that helped shape the future of the city. During the 1960s, the idea of building a freeway to downtown Vancouver was considered. It was intended to service a major development complex, "Project 200," consisting of 14 towers built on a deck over the railway tracks. Public outcry over the negative impacts of a downtown freeway and the effect on Gastown stopped it from proceeding, except for one office tower — 32-storey Granville Square.

Connected to Granville Square via a large viewing deck is Waterfront Station, housed in the Canadian Pacific Railway station of 1912. Here, the major modes of city transit converge: buses, SeaBus, SkyTrain and the West Coast Express commuter train. Nearby is a heliport and a seaplane base.

Adjacent to Waterfront Station is Sinclair Centre. This unique retail/restaurant and government office complex consists of four restored heritage buildings (1910 Post Office, 1911 Winch Building, 1913 Customs Examining House and the 1937 Federal Building), with glass-enclosed lanes that connect the structures. The copper-crowned clock tower, one of the oldest heritage landmarks in the city, stands 18 metres tall at the

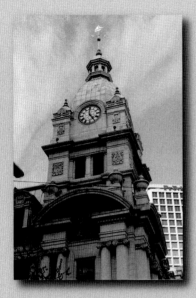
Sinclair Centre's clock tower, beautifully restored along with the rest of the buildings.

southeast corner. The restoration of Sinclair Centre was a project of the federal government, completed by local architecture firm Henriquez Partners.

With the construction of the new trade and convention centre at the foot of Burrard Street, the look of this area is changing. This $565-million partnership between the federal and provincial governments and Tourism Vancouver will add 102,000 square metres to the city's existing convention space and is slated for completion by 2008. The centre, which will connect to Canada Place, is designed as a low-profile building that extends into Burrard Inlet. Features include a 2.4-hectare green roof, planted with native species that will reduce heating costs and capture rainfall for water use within the facility. It is being built to the highest environmental standards and will serve as the media centre for the 2010 Winter Olympics.

As would be expected, the Waterfront area also contains a number of major hotels. Formerly part of the city's industrial landscape, this area is now a place primarily for visitors and office workers.

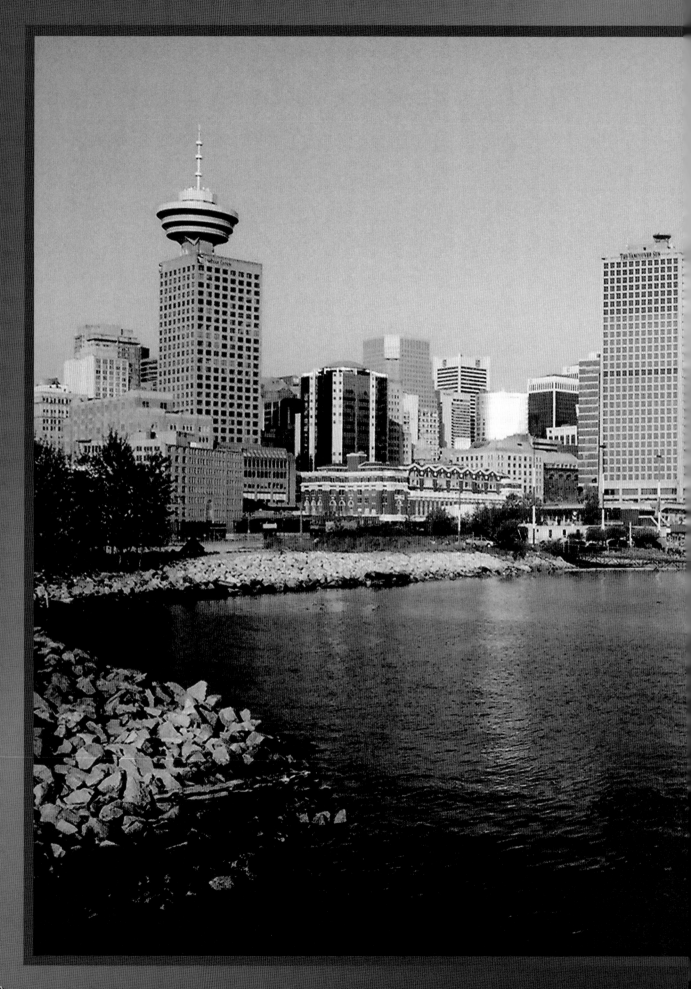

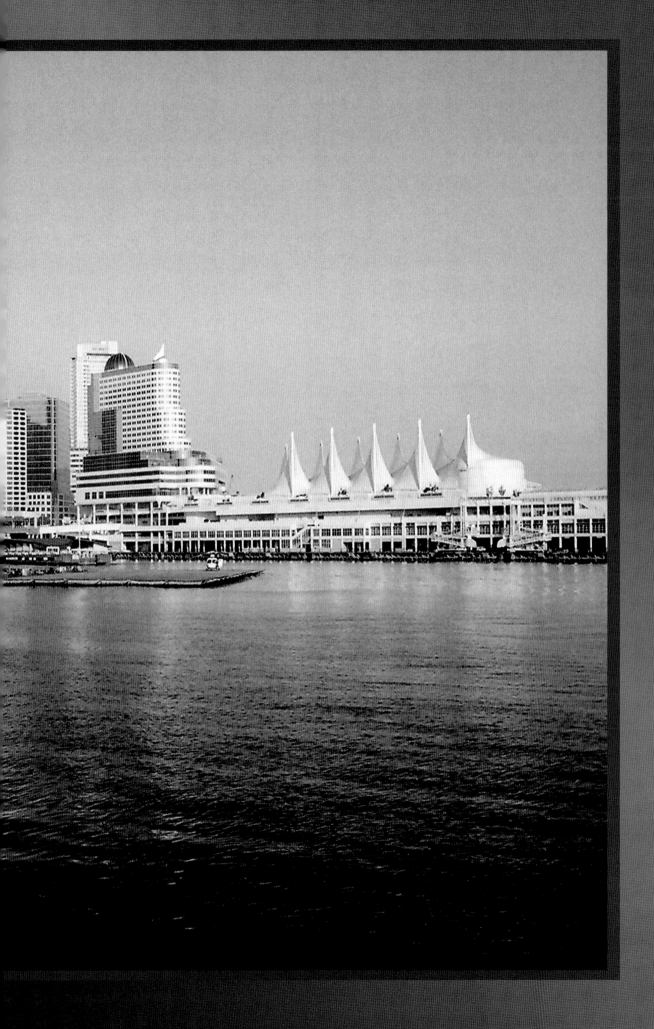

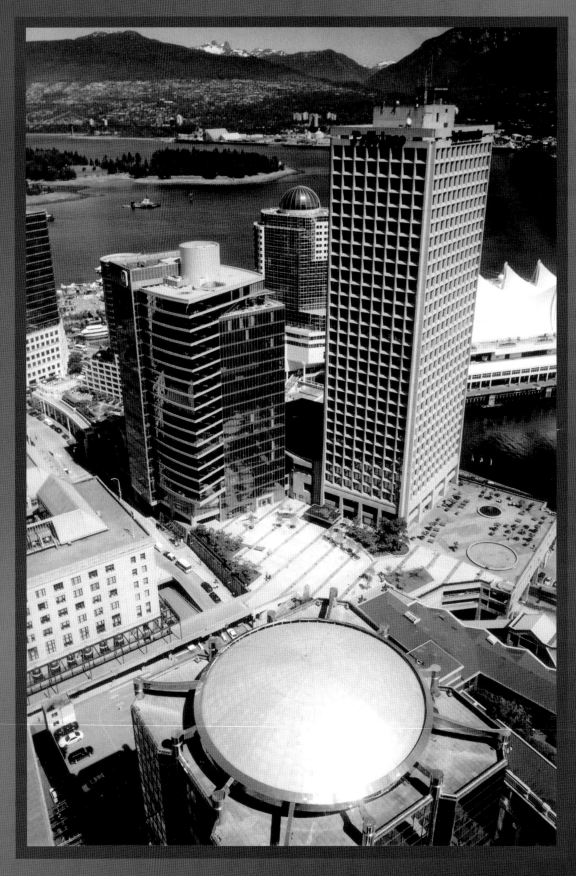

Granville Square, the tallest building in this photo, is home to the city's two major newspapers and the only building to be constructed as part of the "Project 200" of the late 1960s. It was to include 14 towers and a downtown freeway system.

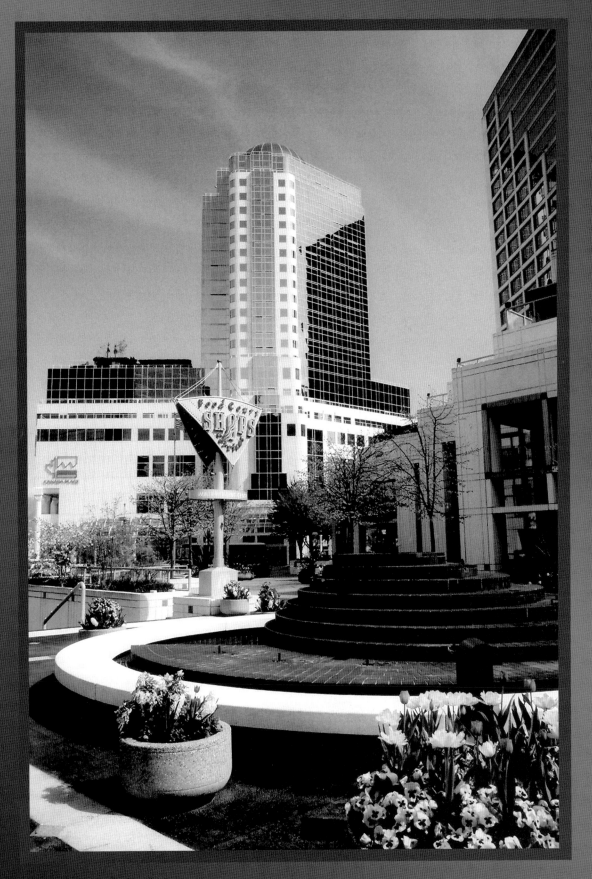

This is an excellent example of the kinds of public spaces incorporated into new building developments in Vancouver. This open area is a great place for office people to enjoy their lunches outside while enjoying the view of Canada Place and the North Shore mountains.

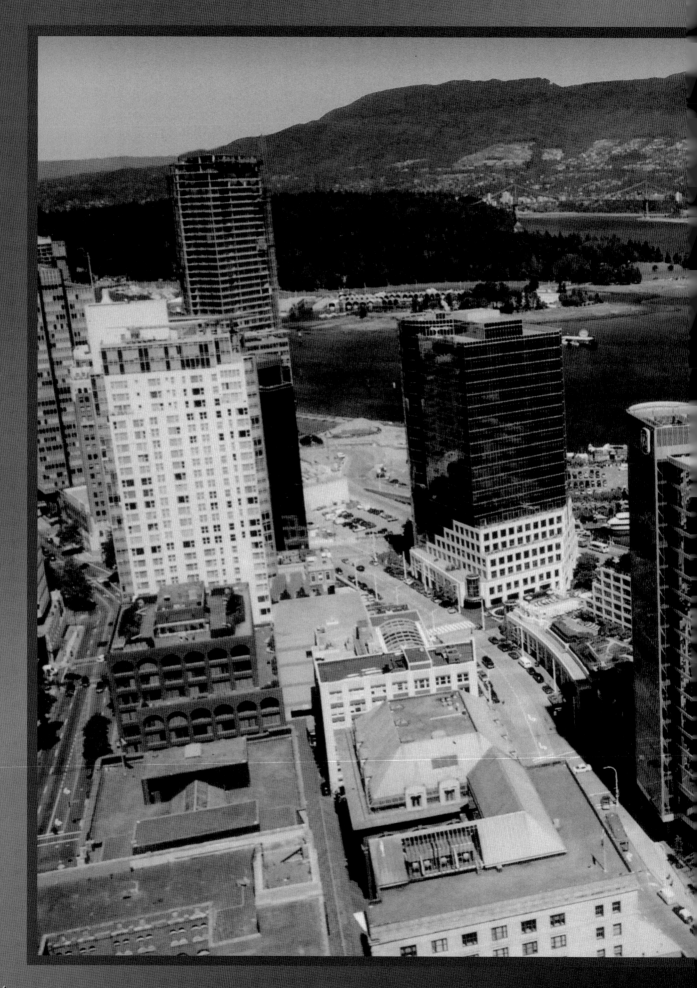

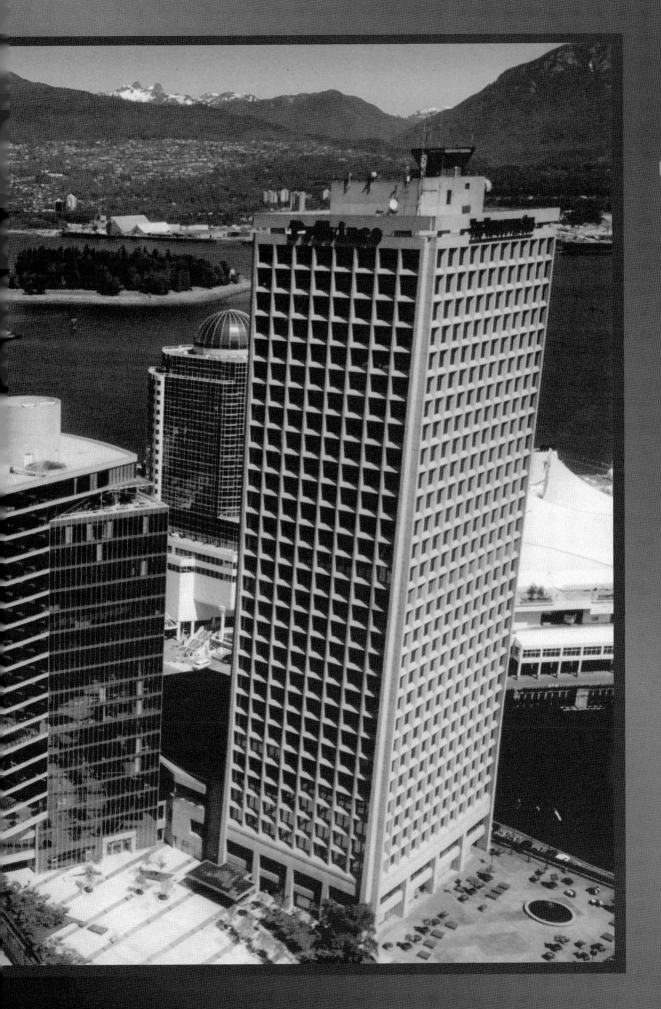

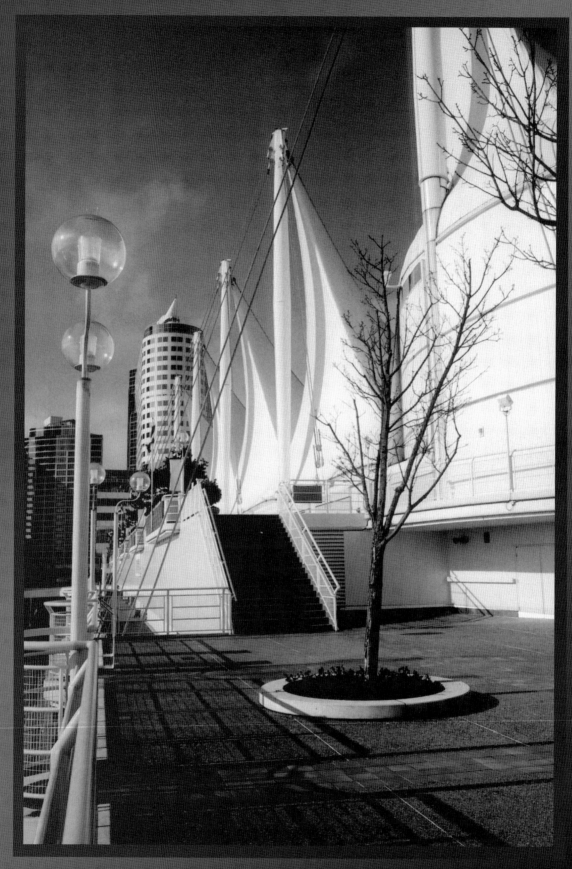

Address: 999 Canada Place Use: Convention Centre Pier Length: 487 metres (1597 feet)
Completed: 1986 Architect: Zeidler Roberts, Height: 111 metres (363 feet)
 Musson Cattell Mackey

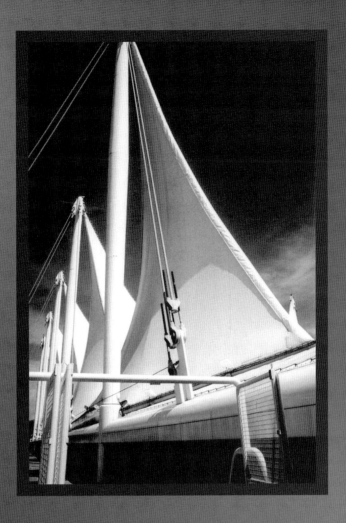

Canada Place is the city's leading trade and convention centre as well as the cruise ship terminal, where four ships can be docked at once. Built by the federal government for $144.8 million, it served as the Canada Pavilion for Expo 86.

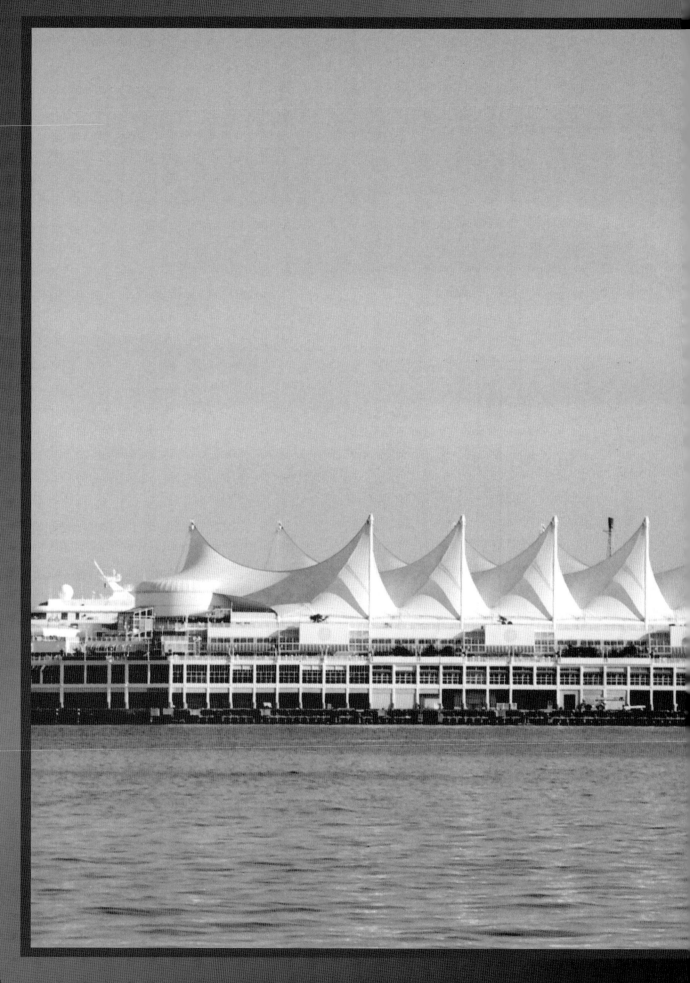

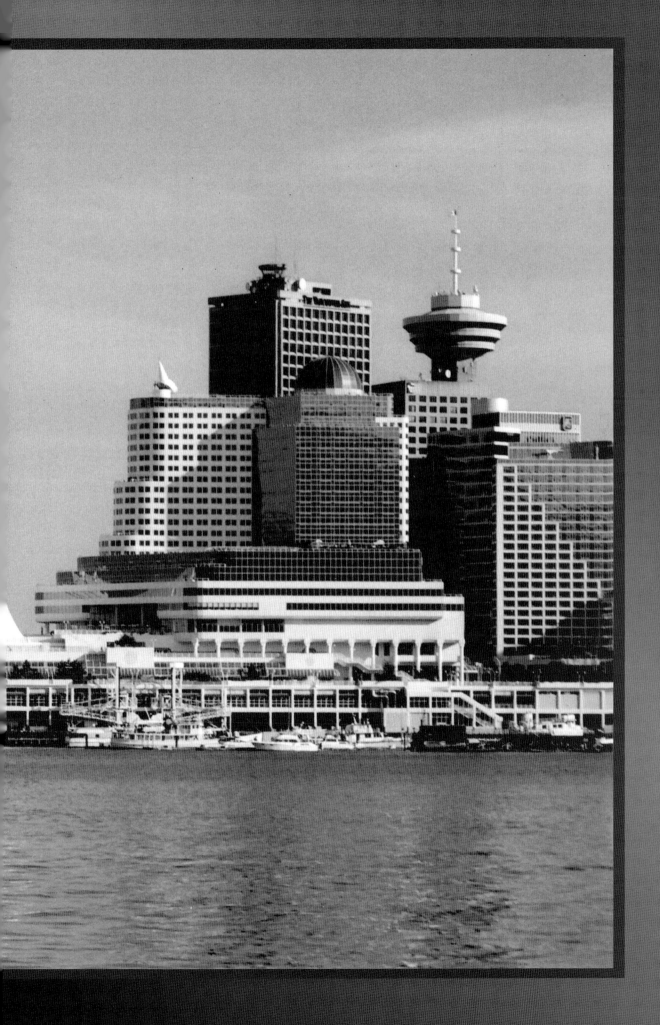

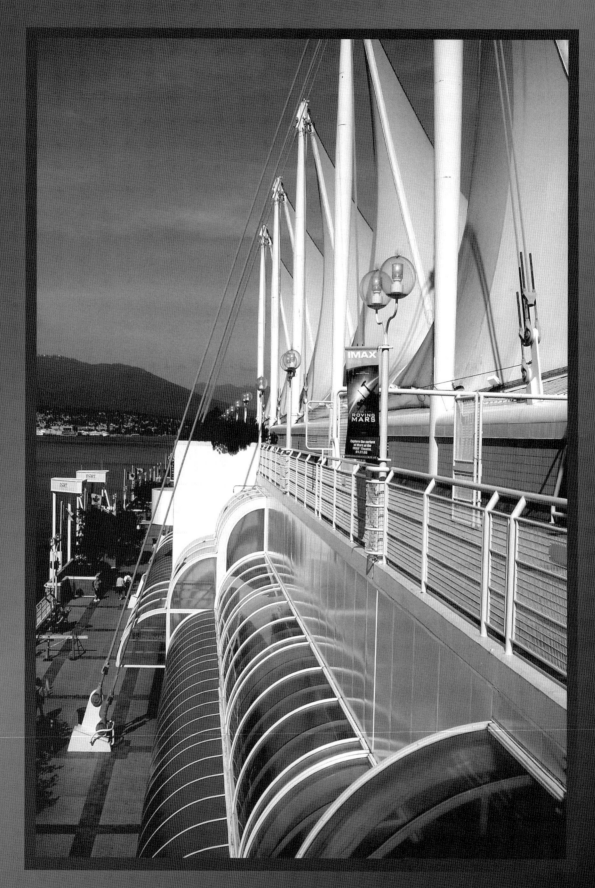

Canada Place, with its large sails resembling ships from the past, instantly became a Vancouver landmark. In 2002, the pier was extended to accommodate increasing cruise ship traffic. The Pan Pacific, one of the city's 5-star hotels, is part of Canada Place and was remodelled in 2003.

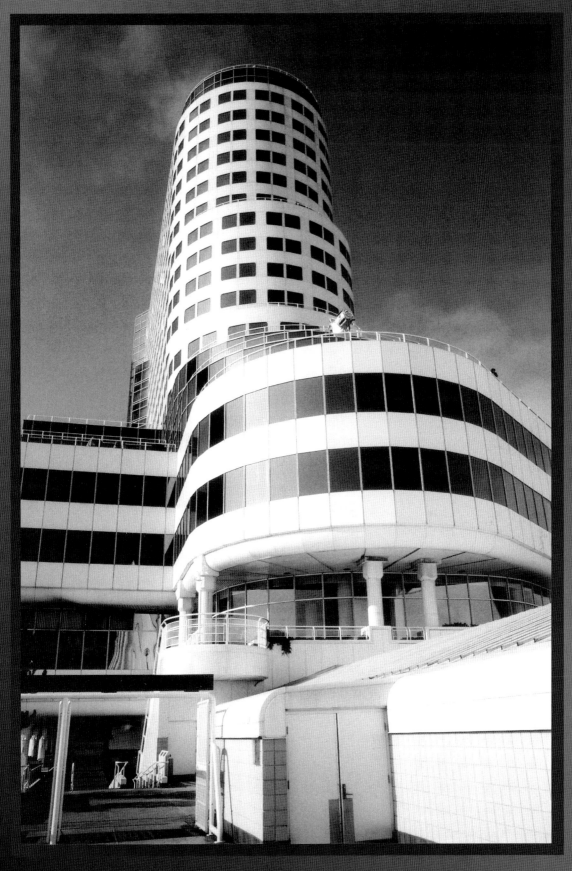

Address: 999 Canada Place Use: Hotel Floors: 23
Completed: 1986 Architect: Zeidler Roberts, Height: 82 metres (267 feet)
 Musson Cattell Mackey

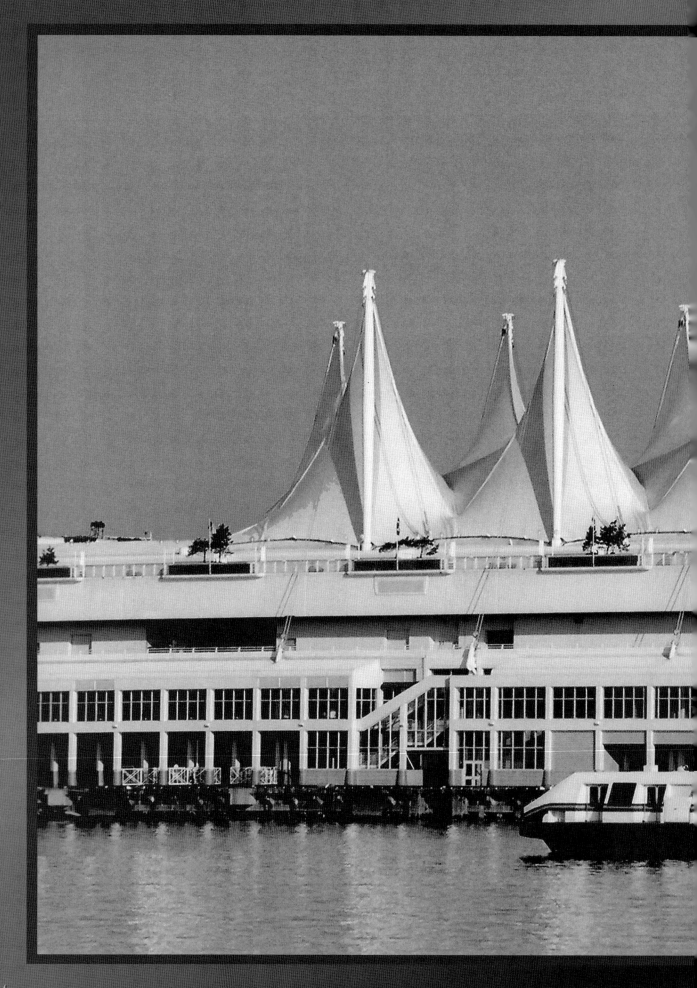

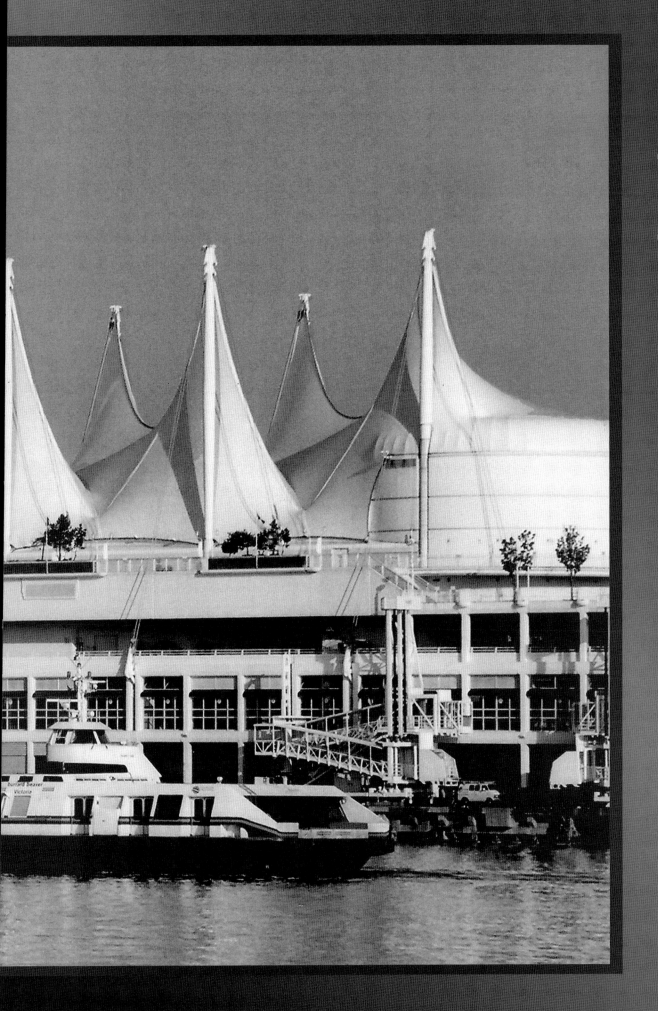

harbour centre

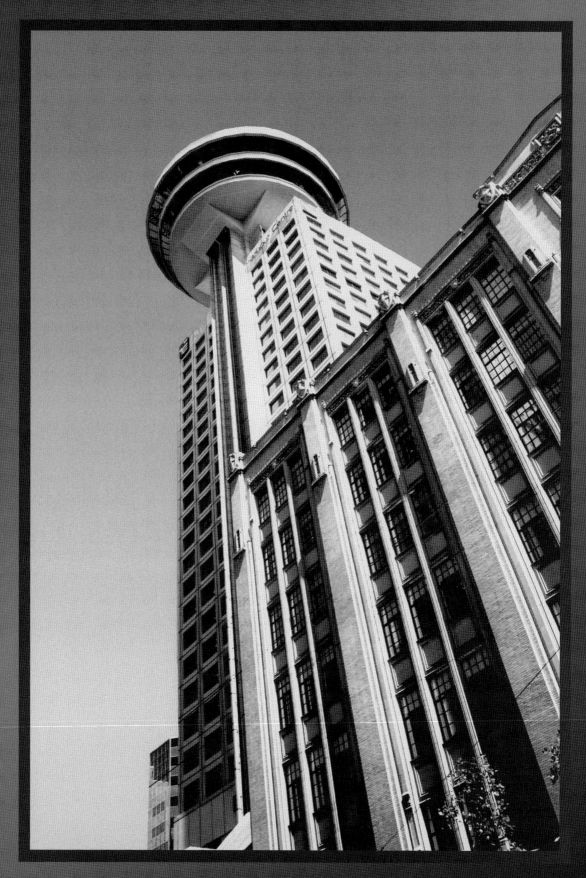

Address: 555 West Hastings Use: Offices/Restaurant/Retail Floors: 28
Completed: 1977 Architect: WZMH Architects Height: 146 metres (481 feet)

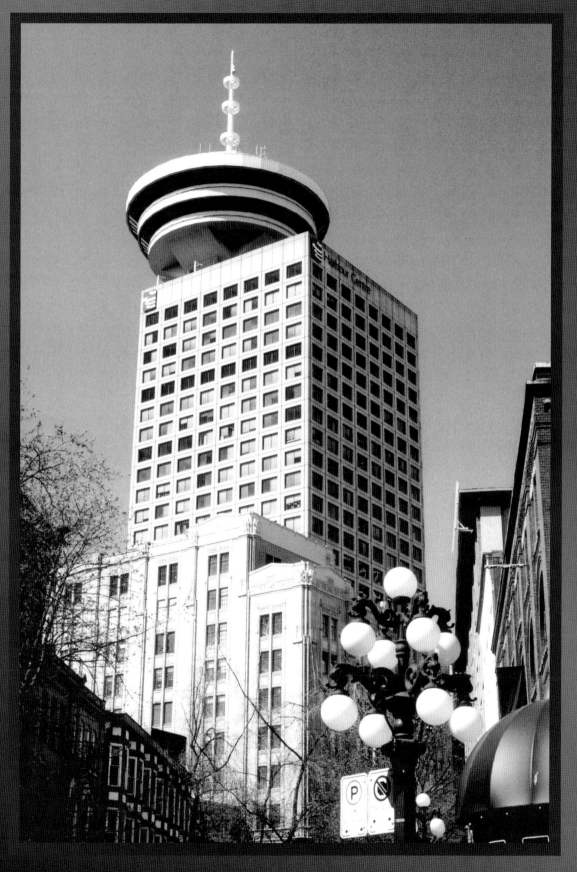

This Vancouver landmark, opened by astronaut Neil Armstrong, is topped with a structure similar to Seattle's Space Needle, housing a revolving restaurant and an enclosed observation deck. If one takes into consideration the ornamental spire, this is the city's tallest building at 177 metres (581 feet).

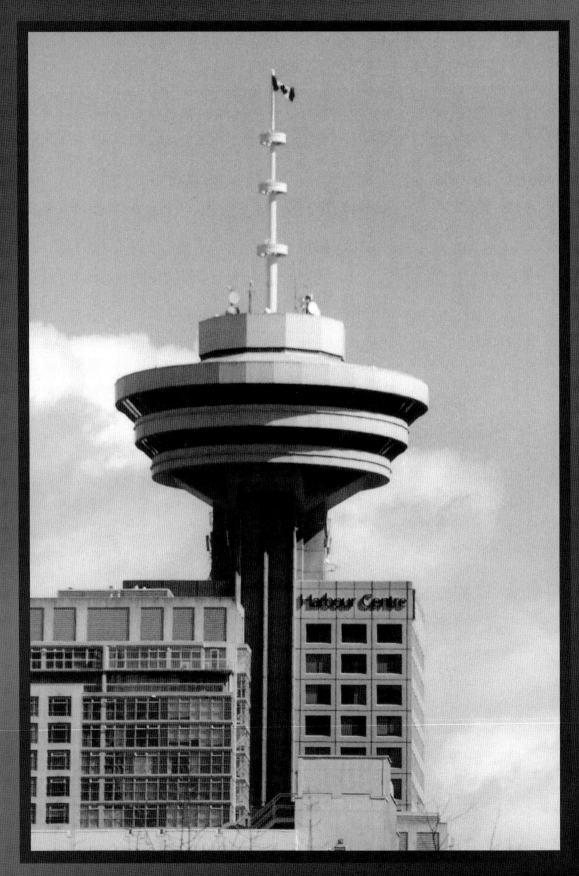

Simon Fraser University has a campus at Harbour Centre – a trend among schools of higher learning to offer programs in the downtown core. The stunning view from the observation deck, accessed by a glass elevator on the building's exterior, is a popular tourist attraction.

Address: 200 Granville Use: Offices Floors: 30
Completed: 1973 Architect: Francis Donaldson Height: 142 metres (466 feet)

burrard

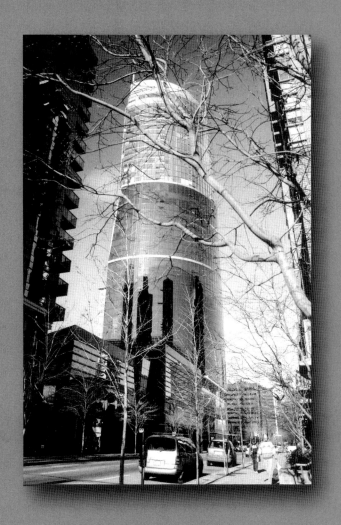

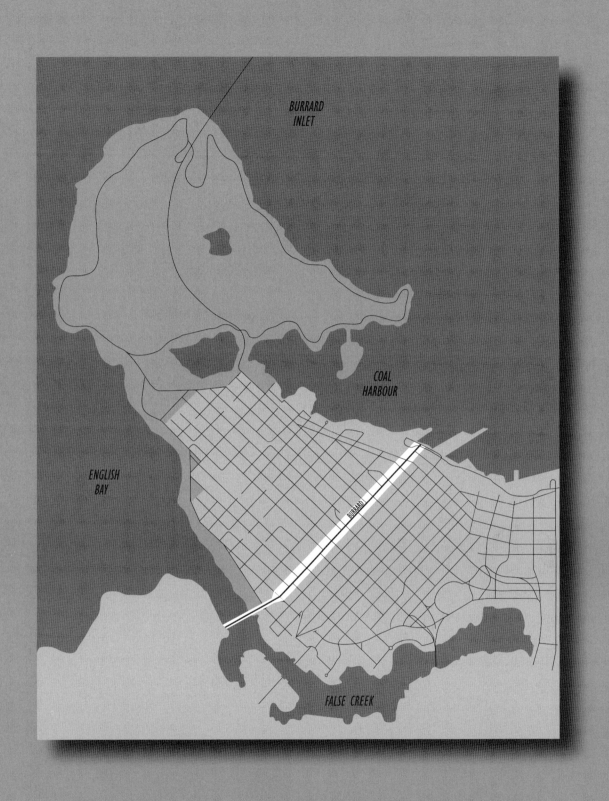

BURRARD
INLET

COAL
HARBOUR

ENGLISH
BAY

BURRARD

FALSE CREEK

BURRARD

Burrard Street is downtown Vancouver's major north-south thoroughfare. More than any other street in the downtown area, Burrard mixes architectural styles from each era of Vancouver's history in grand fashion, from carved stone to reflective glass. Art deco, neo-gothic, modern, post-modern — all of these and more can be seen on this street. Some of Vancouver's most prominent and iconic buildings are on Burrard, creating a visual feast of colours, shapes and textures.

Downtown Vancouver's grand gateway from the south is the Burrard Bridge. As one crosses it, three things stand out: the art deco style of the bridge galleries, the towers of False Creek and the West End, and the waters of English Bay.

With Burrard, one is not brought into the downtown area in a gradual manner, as is the case with West Georgia Street. From the moment Burrard Bridge becomes Burrard Street, towers preside. Most impressive is the iconic Wall Centre, Vancouver's tallest building, flanked by the elegant Electra; the two buildings representing entirely different eras. Across the street, with gothic towers, stained glass and granite walls, sit contrasting links to the past — St. Andrew's Wesley Church (1933) and the First Baptist Church (1909).

North of the Wall Centre, Burrard crosses Robson Street, the prime retail area of downtown Vancouver. A major tourist destination, Robson features hotels, restaurants, clothing boutiques and coffee houses. Further north, at the intersection of Burrard and West Georgia, stands the landmark neo-gothic Hotel Vancouver.

Beyond, the financial district's four-tower main Bentall complex (built between 1967 and 1981), offers significant office space in the downtown core. The original four towers, a massive development at the time, exhibit a uniform style, while the more modern fifth tower, built in 2002, incorporates cutting-edge design technology. An additional 12 floors are currently being built atop the original 22 storeys without impacting the operations of the building. This vertical phasing allows expansion as market conditions dictate. Completion is slated for 2007, at which point Bentall 5 will be Vancouver's tallest building, surpassing the Wall Centre by just three metres.

The Marine Building, also in the financial district, is a special treat. This art deco structure, a magnificent tribute to a bygone era when construction techniques and craftsmanship were far different than they are today, was completed in 1930. Its design reflects Vancouver's marine heritage, as is evident in the building's many motifs: portrayals of sea life are carved into exterior tiles and historic ships are etched into the relief above the intricate entry arch. The theme continues into the opulent two-storey wood lobby, where even the clock has sea creatures instead of numerals. The Marine Building held the honour of being the city's tallest until 1967, when the Guinness Tower next door surpassed it by just two metres. Since then, many towers have eclipsed the Marine Building. While still marvellous, it has lost its position of prominence on the waterfront.

At the northern terminus of Burrard Street, the sails of Canada Place rise to the east and the new Shaw Tower soars to the immediate west. Looking over the water, one sees Stanley Park and the North Shore mountains — two magnificent constants in Vancouver's scenic setting.

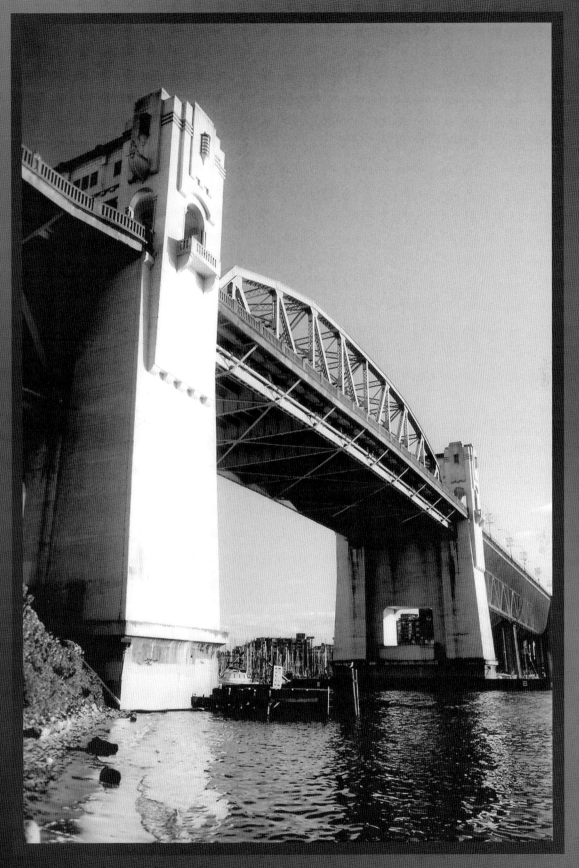

Completed: 1932 Design: Sharp and Thompson Total Length: 836 metres (2743 feet)
Structure: Truss Bridge Engineer: John Grant Spans: False Creek
Cost: $3 million

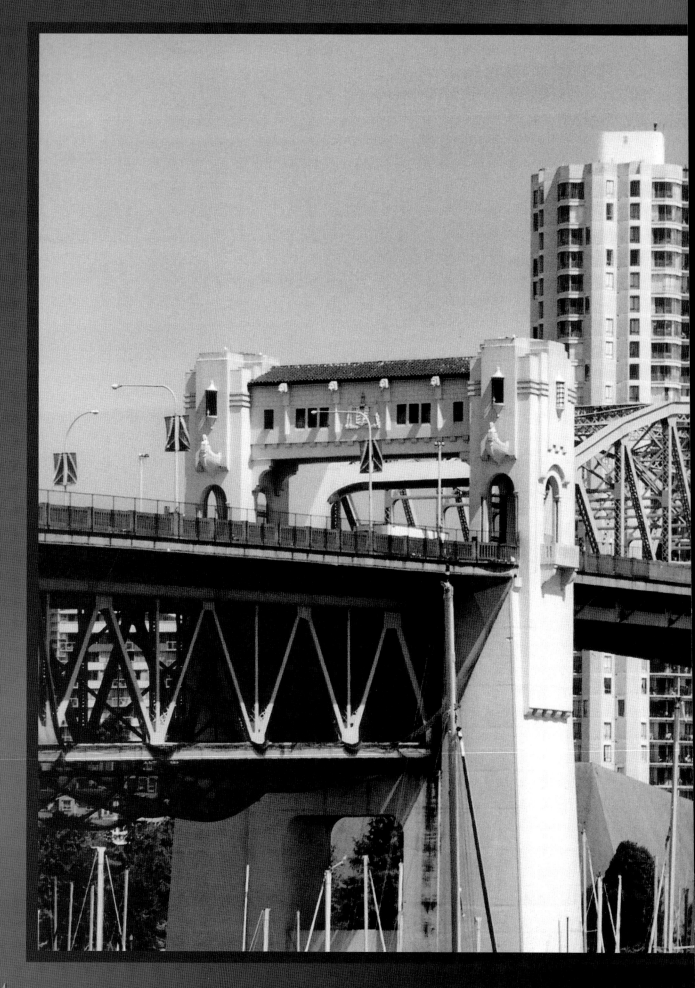

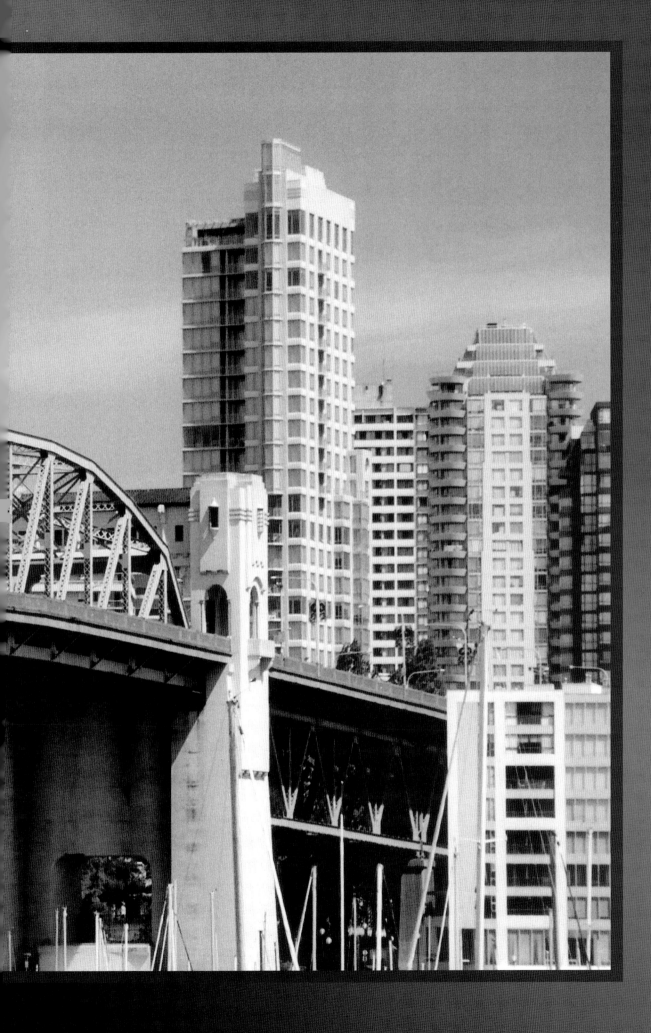

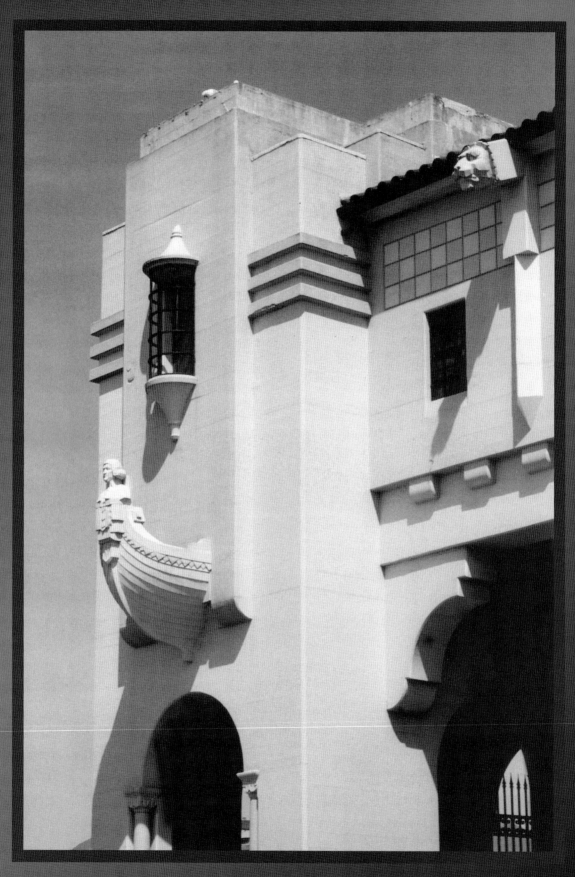

Some examples of the bridge's art deco details include ship's bows, arches and ornate lamps. Other features include busts of George Vancouver and Harry Burrard, as well as the city's coat of arms. These were created by Charles Marega, one of British Columbia's most talented sculptors.

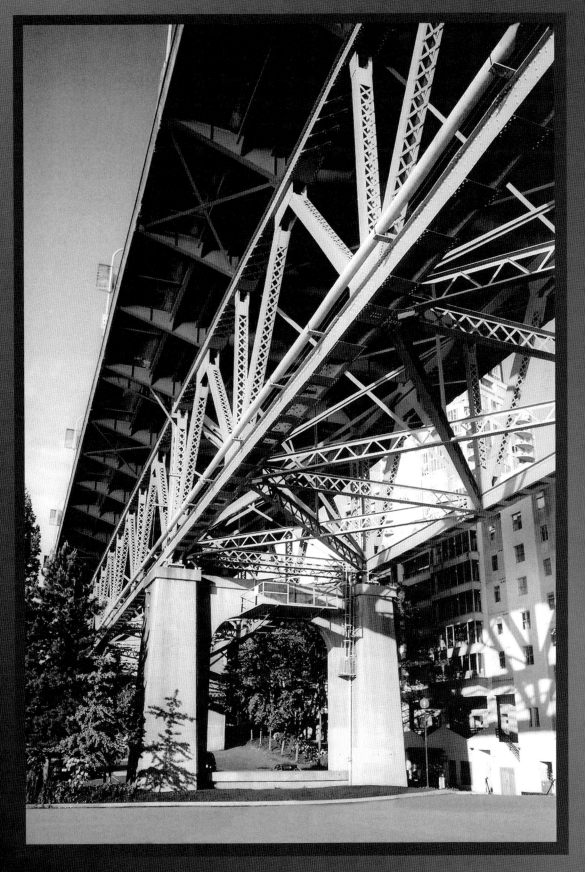

This public area under the north end of the Burrard Bridge is part of the seawall that runs along the shores of English Bay and continues to False Creek. The steel girders and trusses complement the surroundings, seeming more like modern art than structural engineering.

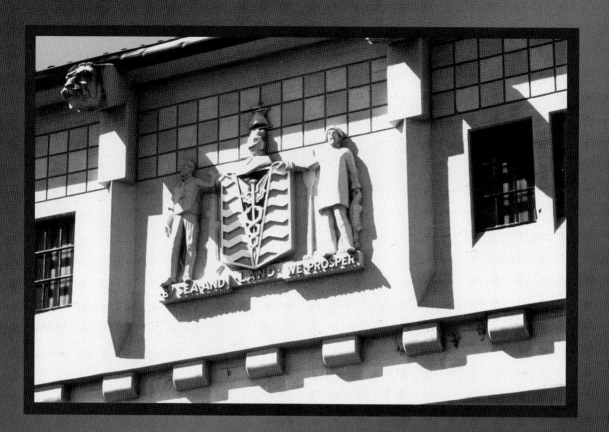

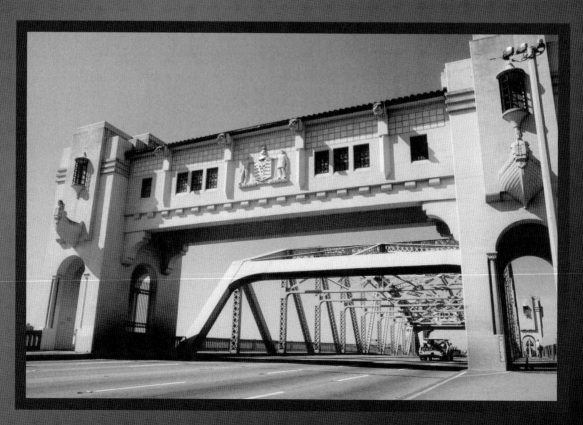

The purpose of the art deco concrete structures is to hide the steel trusswork from the approaches. An urban myth states that people once lived in apartments in the galleries, perhaps because the windows are lit.

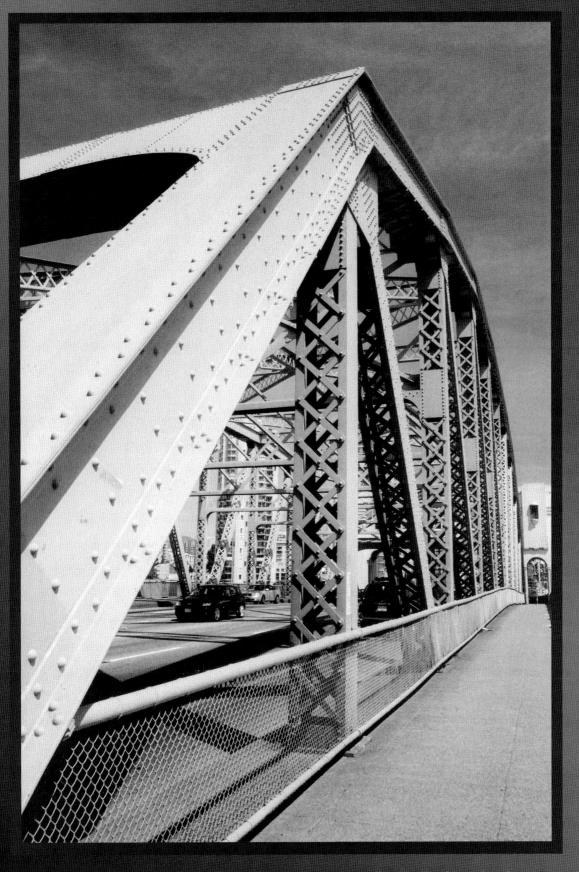

This photo shows the steel trusswork between the concrete galleries. Bicycles and pedestrians share the narrow sidewalks on this bridge. Many people choose to walk or ride to their places of work in the downtown area, rather than use a car.

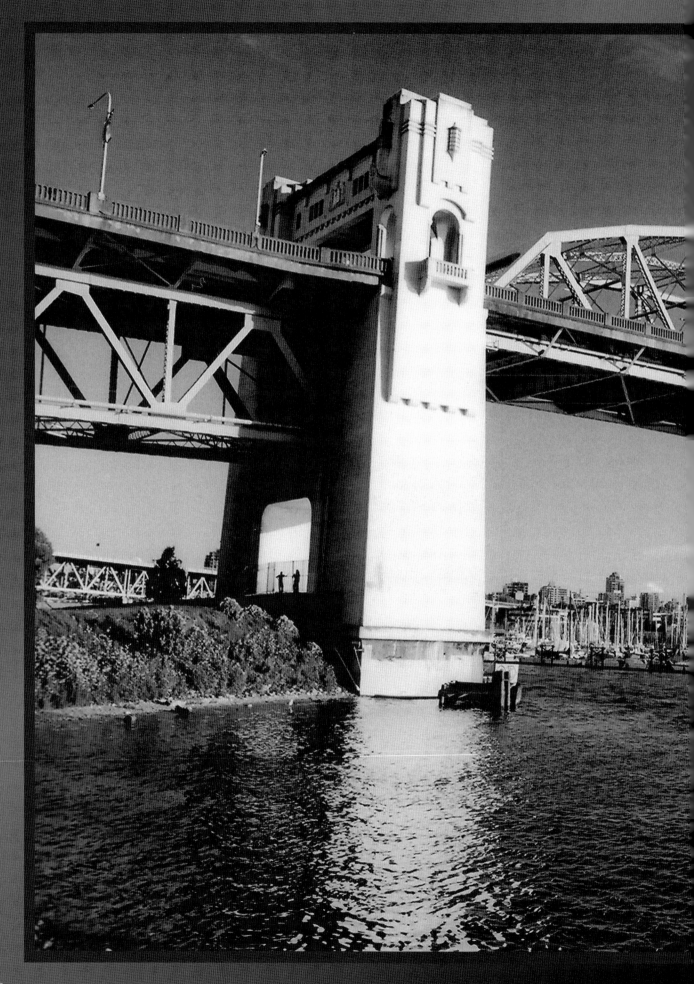

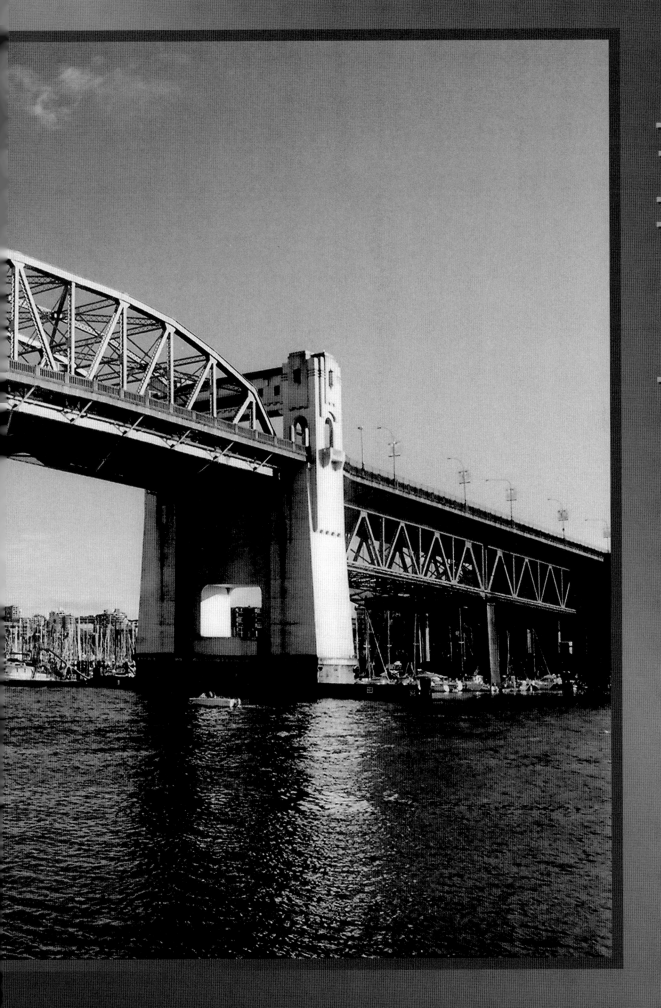

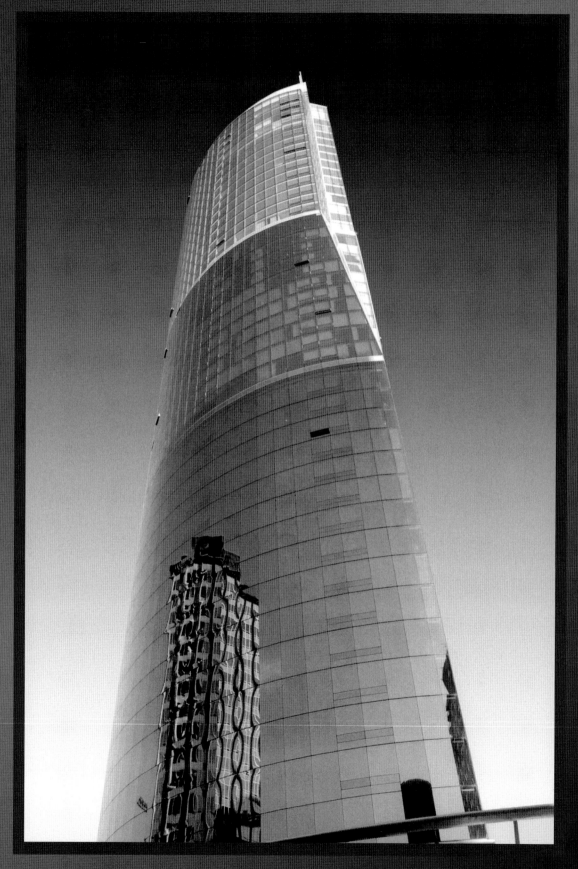

wall centre

| Address: 1000 Burrard | Use: Hotel / Residential | Floors: 48 |
| Completed: 2001 | Architect: Busby + Associates | Height: 150 metres (491 feet) |

132

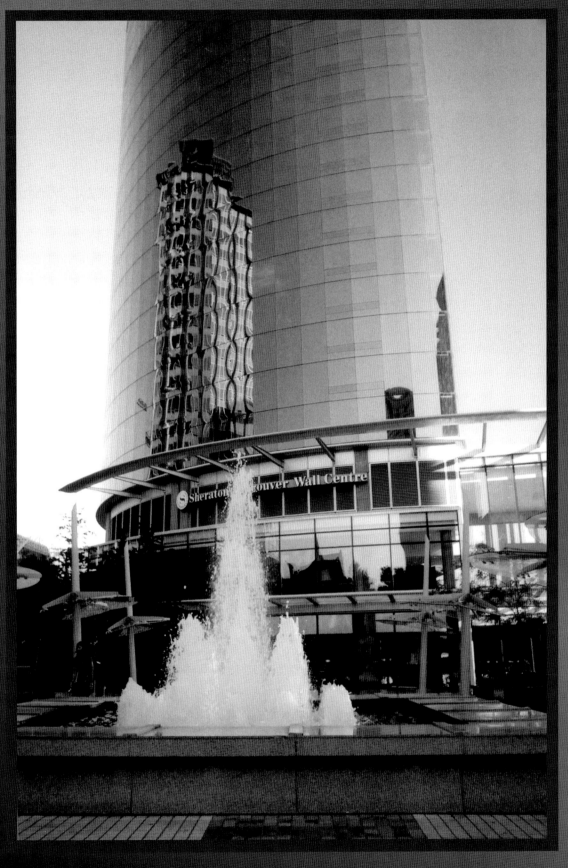

The Wall Centre's first 25 floors are hotel space, while the remainder are residential units. The two glass colours are the result of a conflict between the developer and City Hall, the latter forcing the change to lighter glass after dark panels were installed on the lower floors.

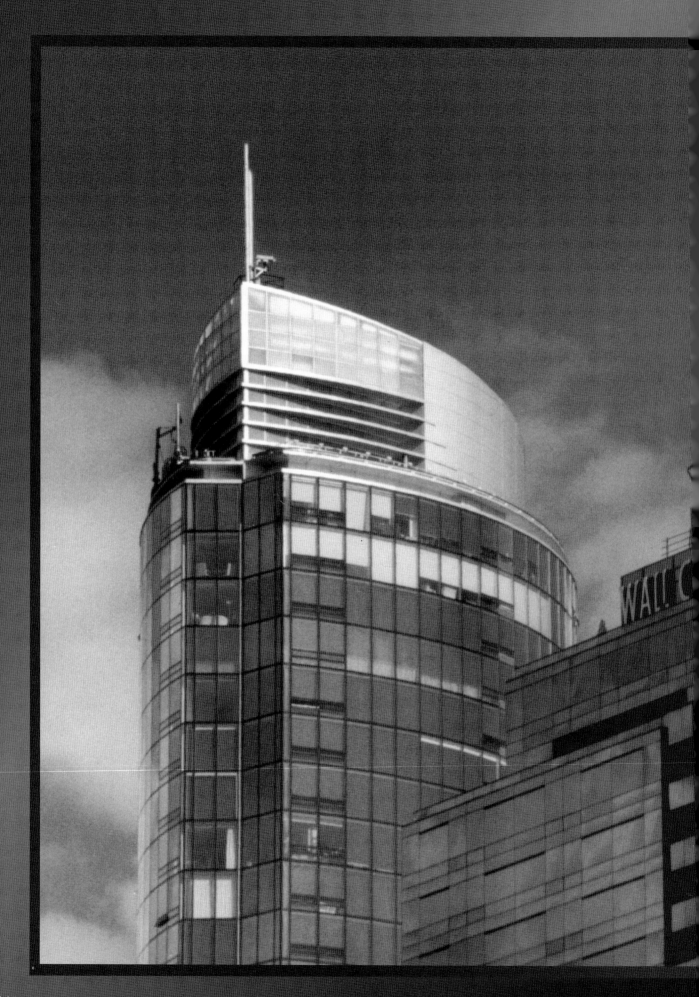

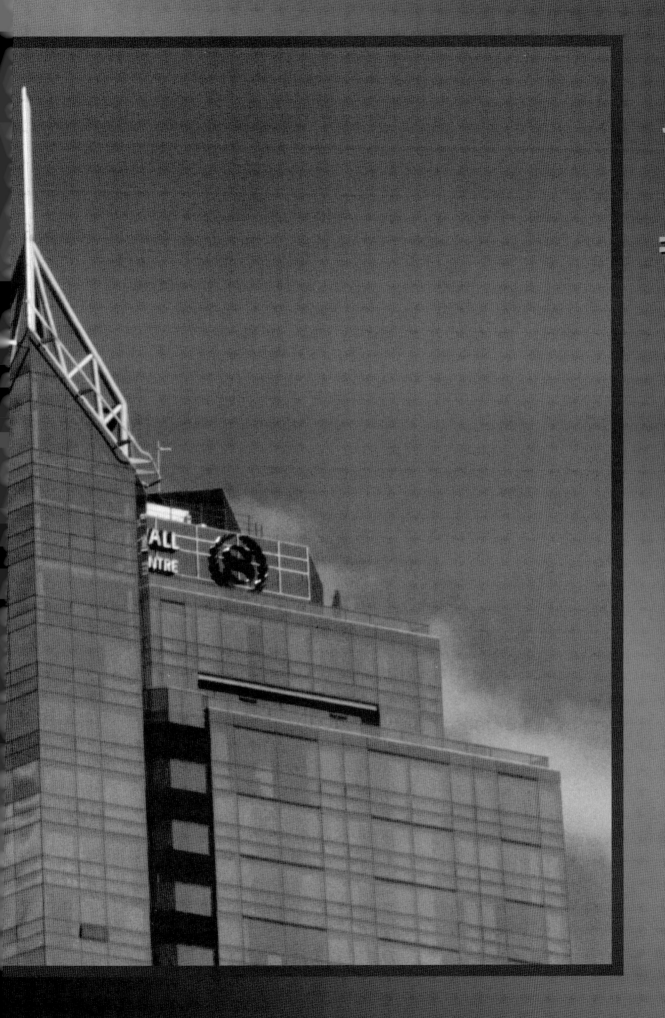

The entrance to the Wall Centre, with the Electra in the background. Along with being Vancouver's tallest building, it also boasts the deepest excavation at 23 metres (75 feet).

These stylized rain shelters complement the fountains and reflecting pools in the public area of the Wall Centre. An annual event is the "Climb the Wall," where runners climb the stairs to the top of the building for charity.

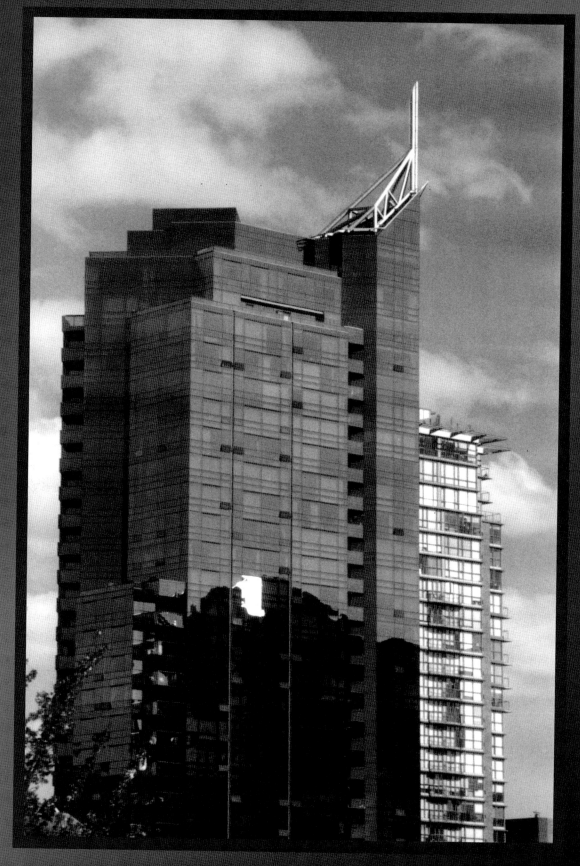

Address: 1088 Burrard
Completed: 1994

Use: Hotel
Architect: Bruno Freschi
Chris Doray

Floors: 35
Height: 102 metres (335 feet)

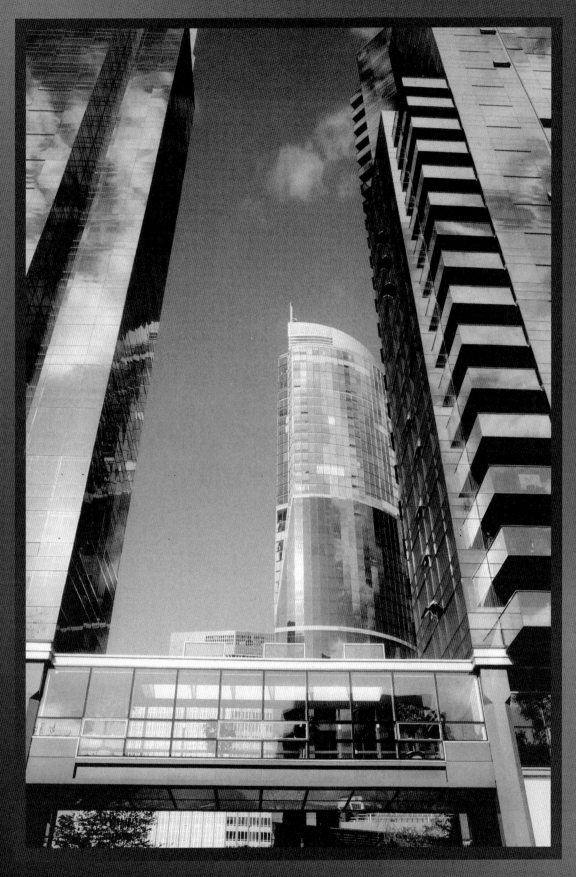

With 733 rooms, this is the city's largest hotel. The complex is built on the highest elevation of the downtown peninsula, making the towers appear even taller when viewed from a distance.

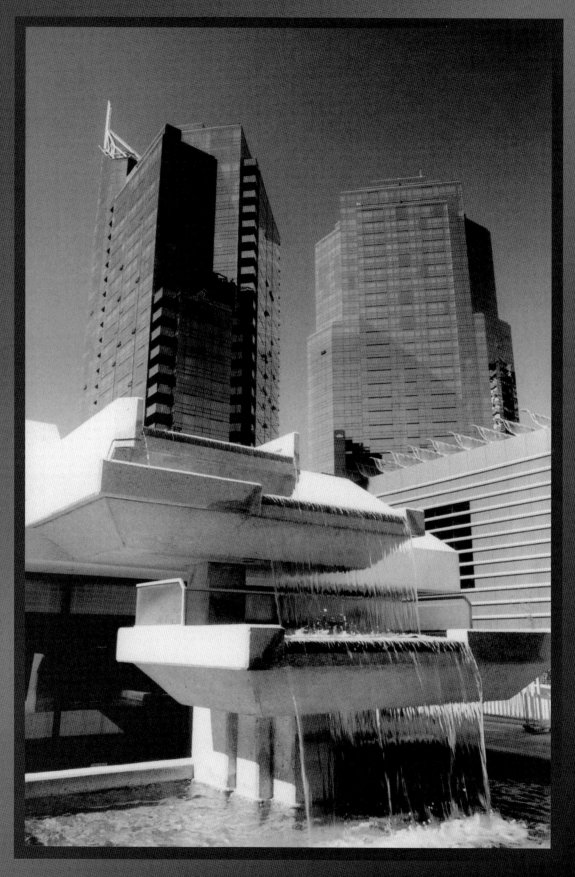

A detail on the top of each tower is the "light pipe" – a 36-foot high, 6-inch-wide tube lit by a single 250-watt metal halide bulb. This technology makes the pipes visible for kilometres.

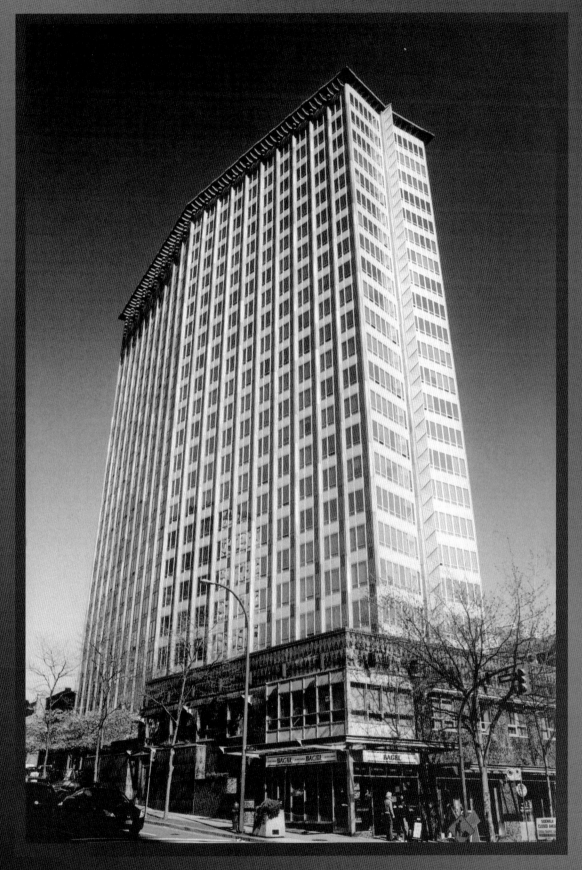

Address: 989 Nelson Use: Offices / Residential Conversion Floors: 22
Completed: 1957 Architect: Thompson Berwick Pratt Height: 89 metres (293 feet)

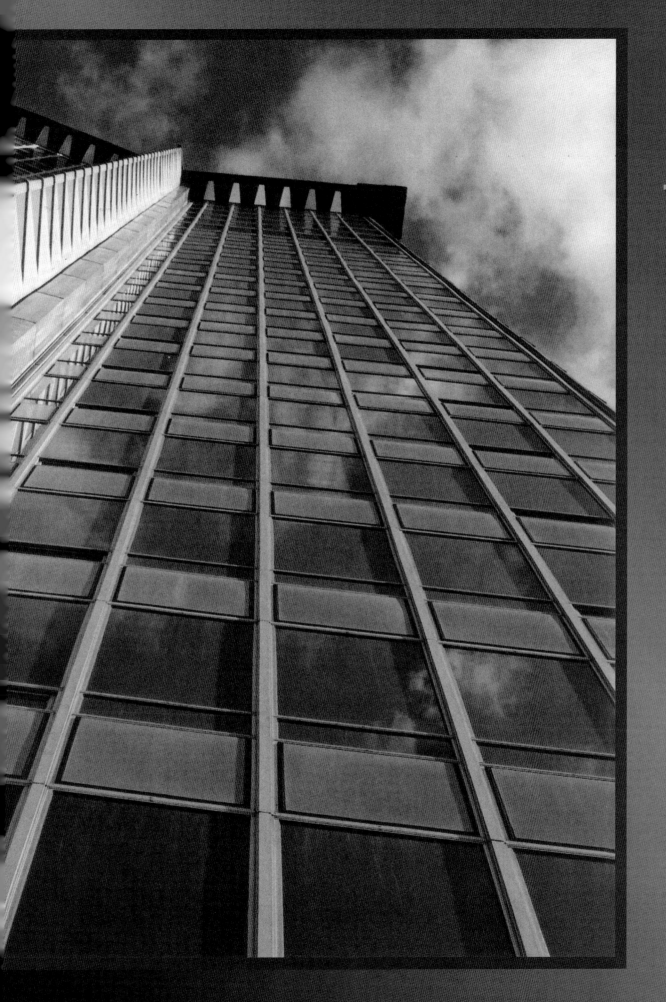

electra

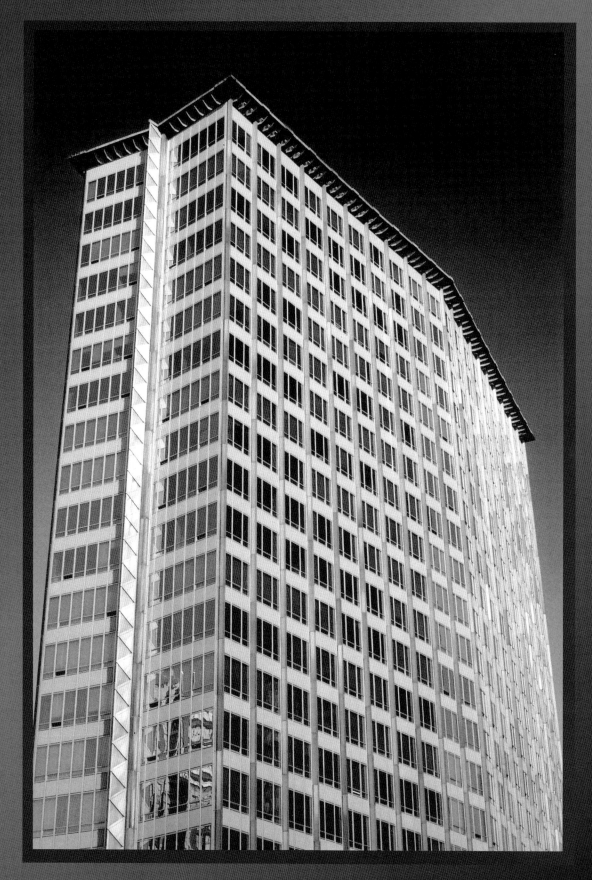

This was one of the first modernist buildings in Canada. In all areas, there is attention to detail – doors, lobby tiles and elevator motifs reflect the six-sided shape of the structure. The building has aged extremely well, with the design elements and colours exuding a subtle retro ambience.

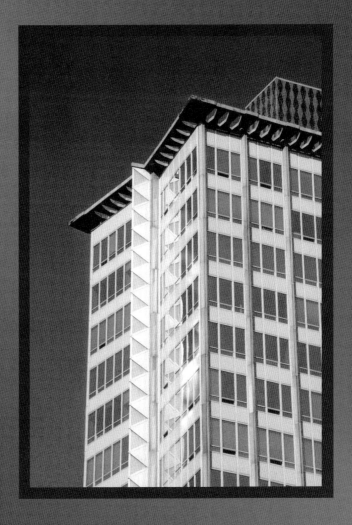

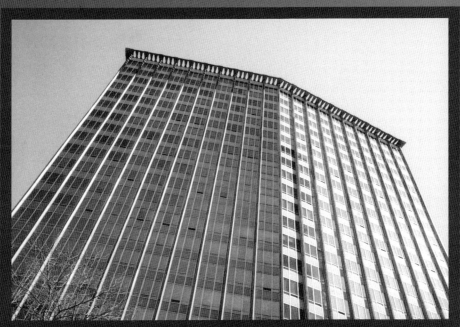

This Vancouver icon is the former headquarters of BC Hydro. The triangular panels on the vertical fins (top) illuminate at night, creating a striking profile. Truly the city's most elegant tower, it was Vancouver's first postwar building to achieve heritage designation.

electra

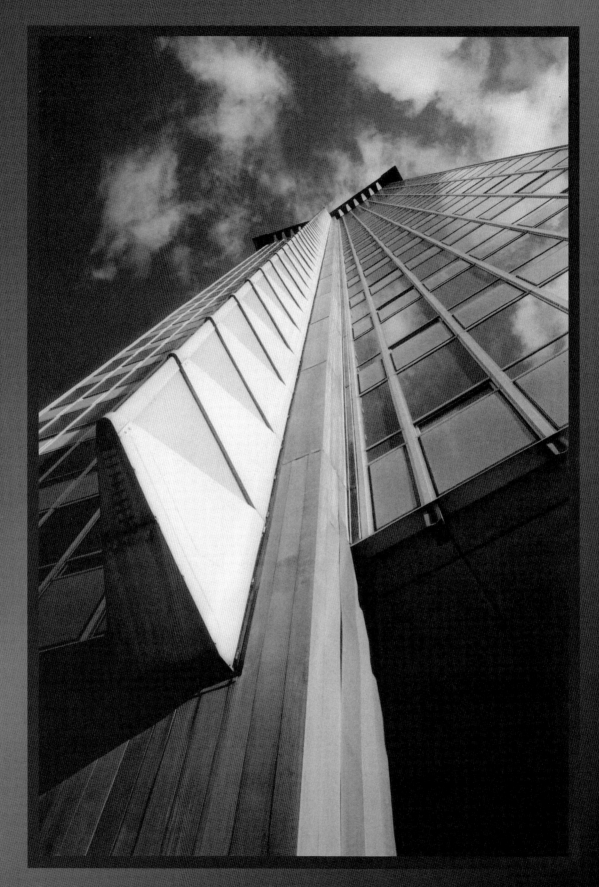

From Canada's centennial in 1967 until 1994, ten loud horns on the roof proudly played the first four notes of "O Canada" each day at noon, carrying the anthem as far as North Vancouver. When the building was converted to residential use in 1995, the horns were relocated to Canada Place.

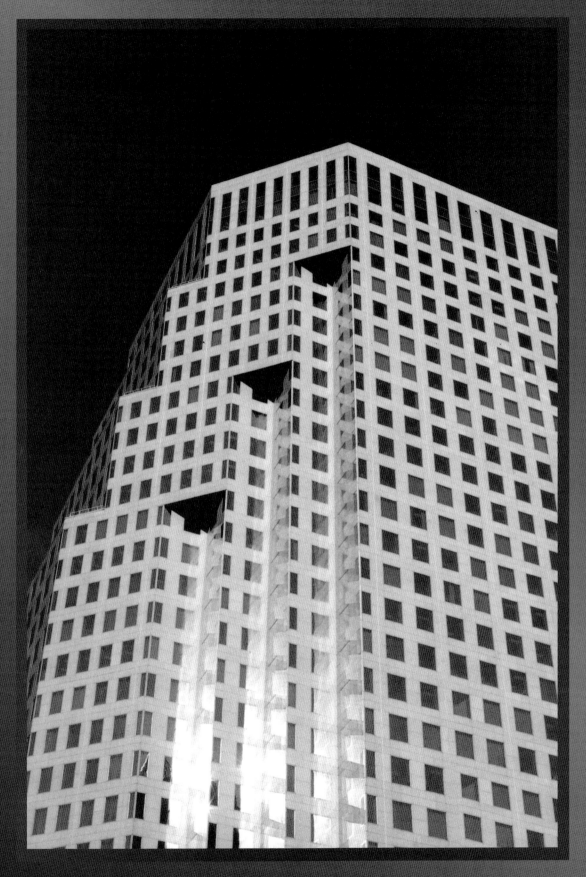

Address: 666 Burrard Use: Office Floors: 35
Completed: 1984 Architect: Musson Cattell Mackey Height: 140 metres (459 feet)

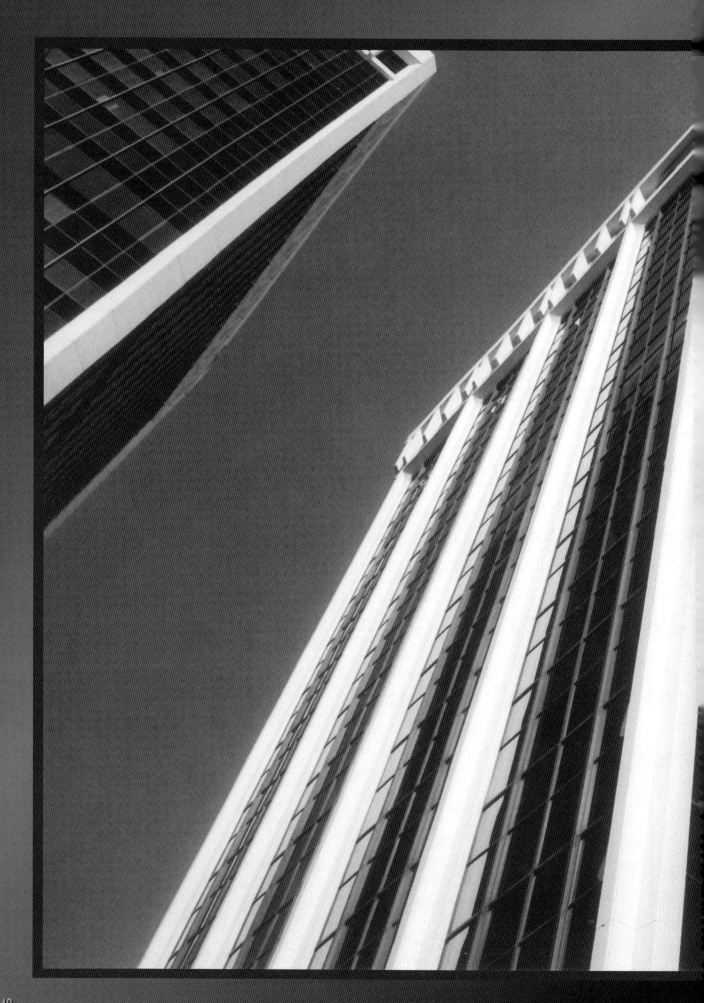

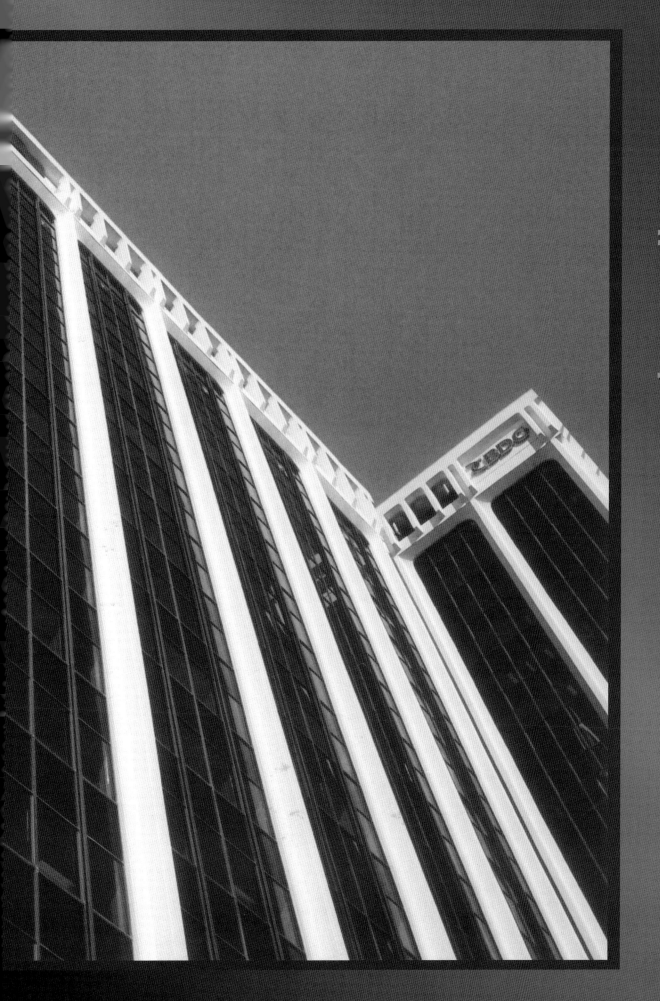

bentall centre

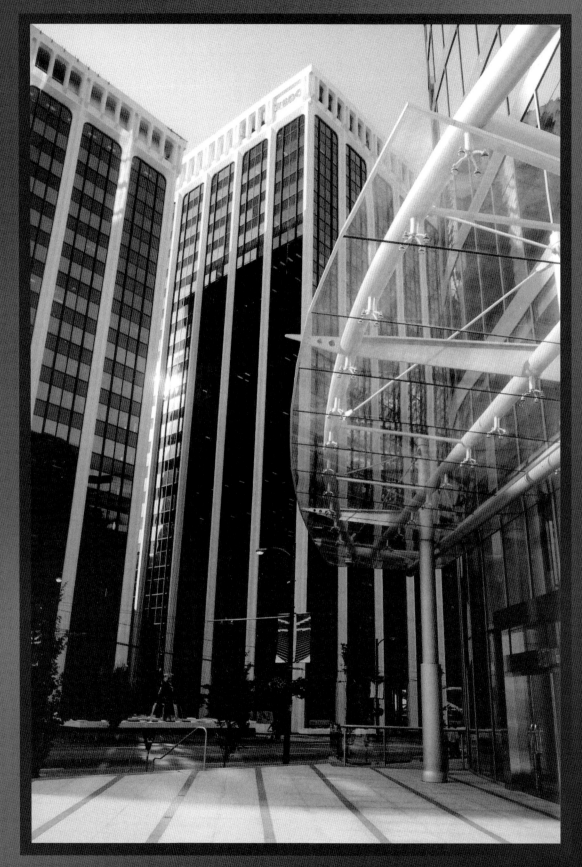

Left: Three Bentall Centre Centre: One Bentall Centre Foreground: Bentall 5
The Bentall Centre comprises four towers in the financial district of Vancouver. Bentall 5 is not
always considered part of the complex because it is across the street and of a different style.

The five-tower complex of the Bentall Centre has a staggering 2.1 million square feet of office space; it was the largest superblock development in Western Canada. Five thousand people work in the original four towers, built between 1967 and 1981.

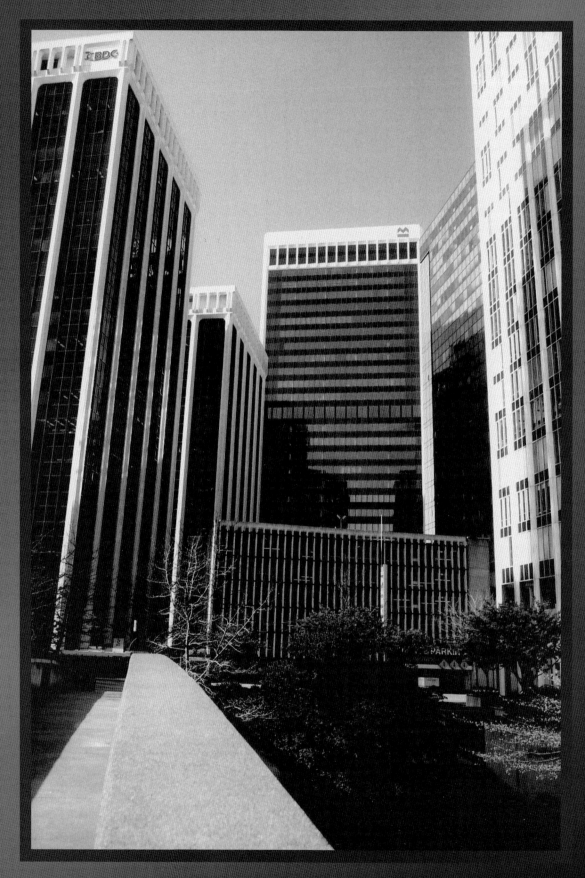

Charles Bentall Architects designed the first two towers in 1967 and 1969, while the Musson Cattell Mackey Partnership designed the latter two. Bentall's Dominion Construction Company built the whole complex.

commerce place

Address: 400 Burrard Use: Office Floors: 21
Completed: 1986 Architect: Waisman Dewar Height: 88 metres (289 feet)
 Grout Carter Inc.

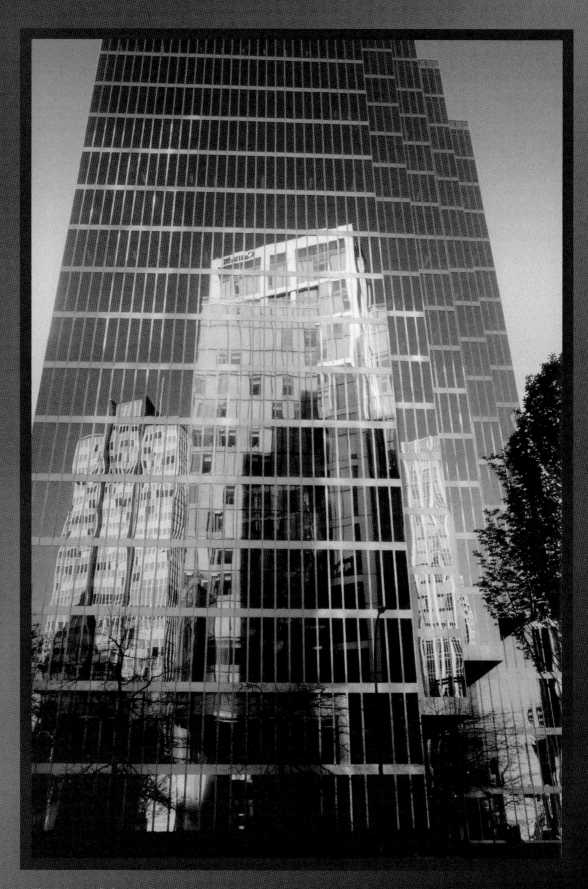

The mirrored glass and multitude of angles of Commerce Place create stunning reflections, espe-cially during the morning. This building is the headquarters for CIBC.

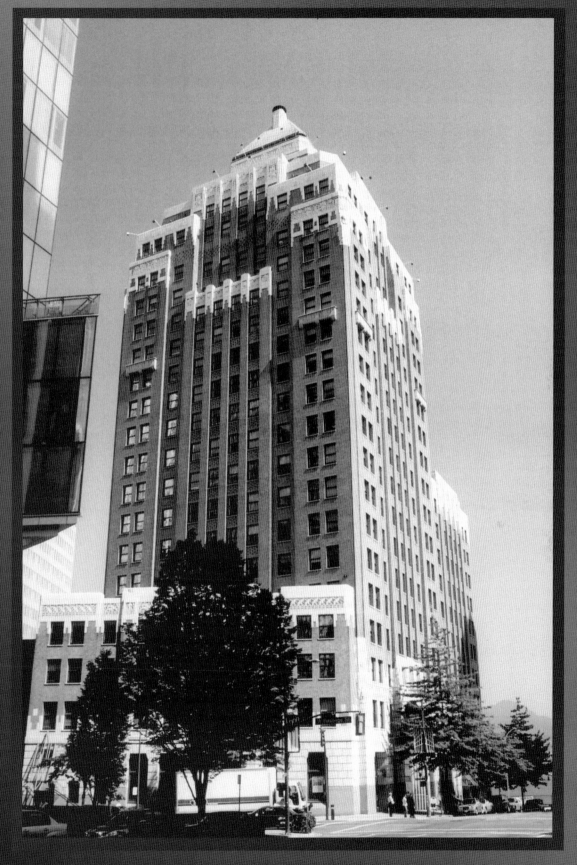

Address: 355 Burrard Use: Offices Floors: 21
Completed: 1930 Architect: McCarter Nairne & Partners Height: 98 metres (321 feet)

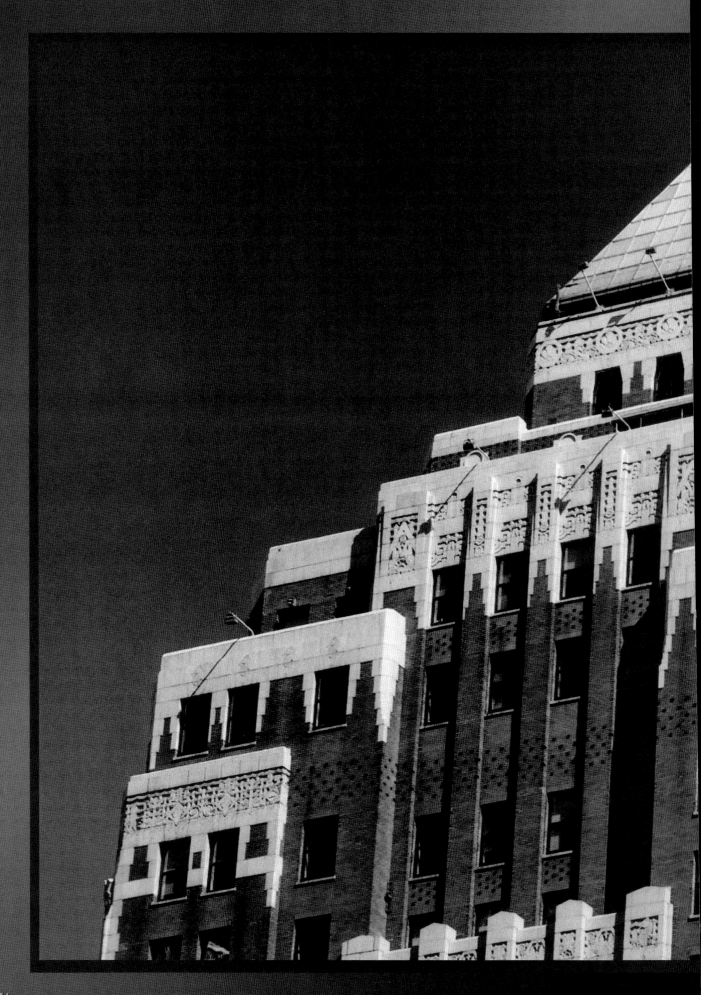

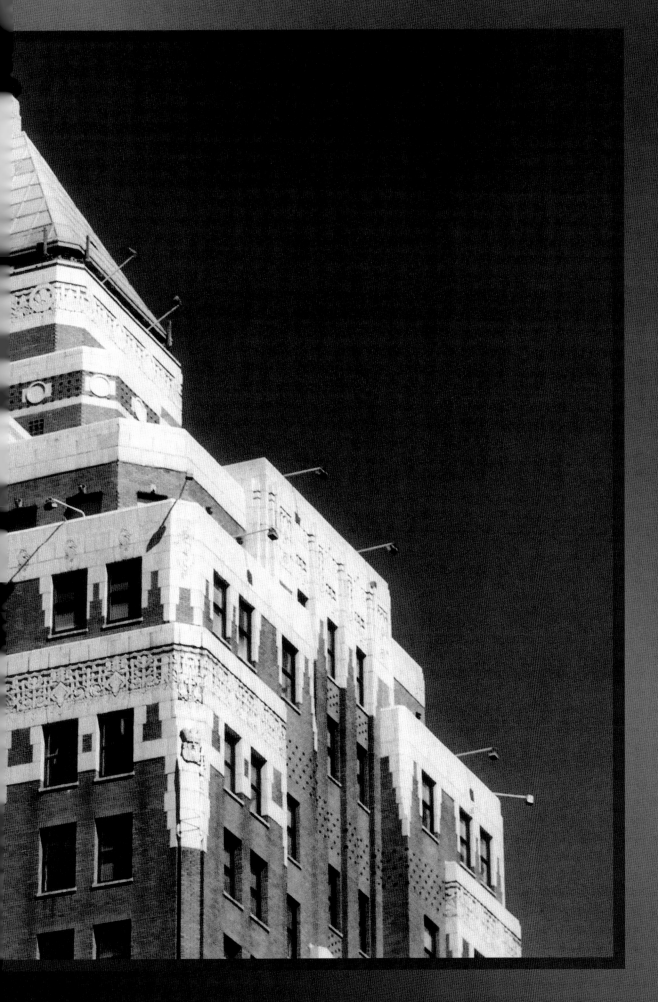

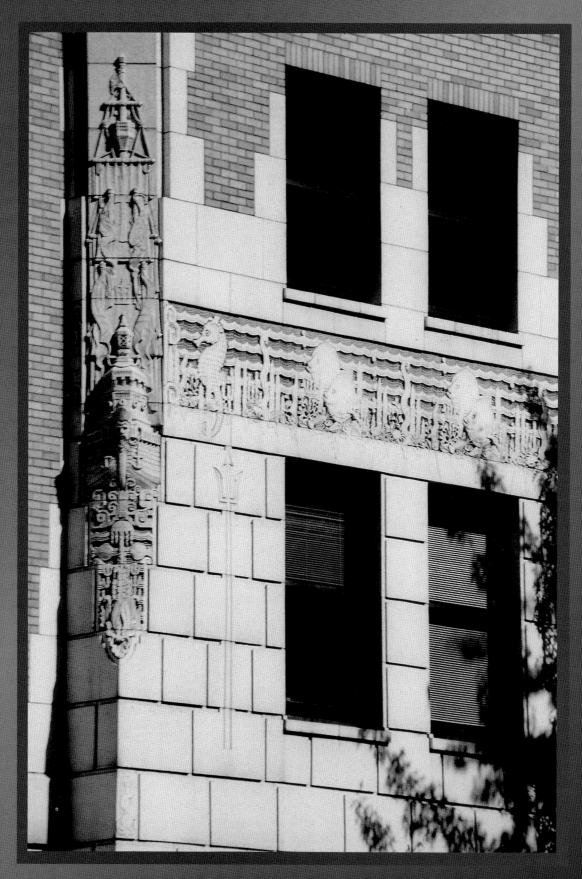

This photo shows some of the detail found on this building. At the time of construction, this was to be Vancouver's most opulent skyscraper and one of the best examples of the art deco style. From 1982 to 1989, the building's environmental systems were updated at a cost of $15 million.

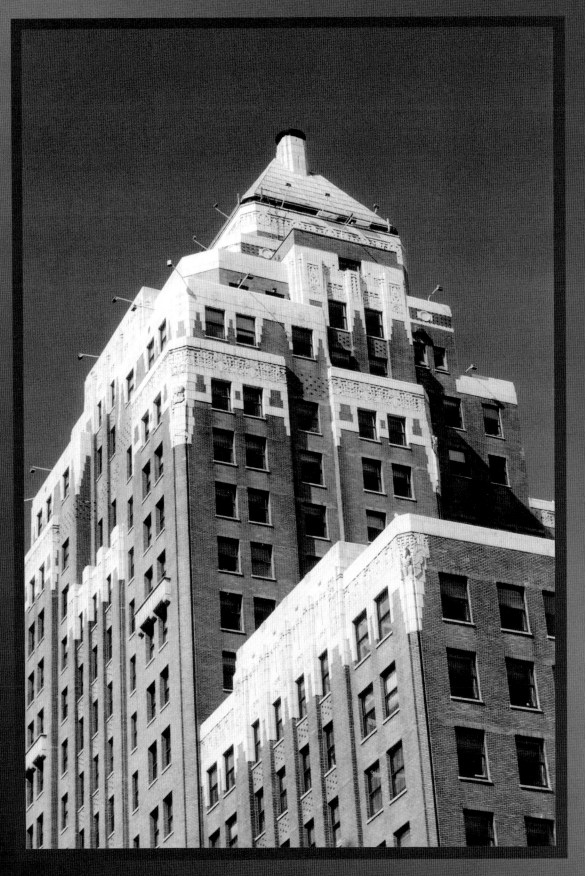

The Marine Building is simply amazing and must be seen. The craftsmanship is superb, from the marine-motif carvings on the exterior to the bronze elevator doors inside. Because of this attention to detail, the original construction budget of $1.5 million was insufficient – it escalated to $2.3 million.

downtown core

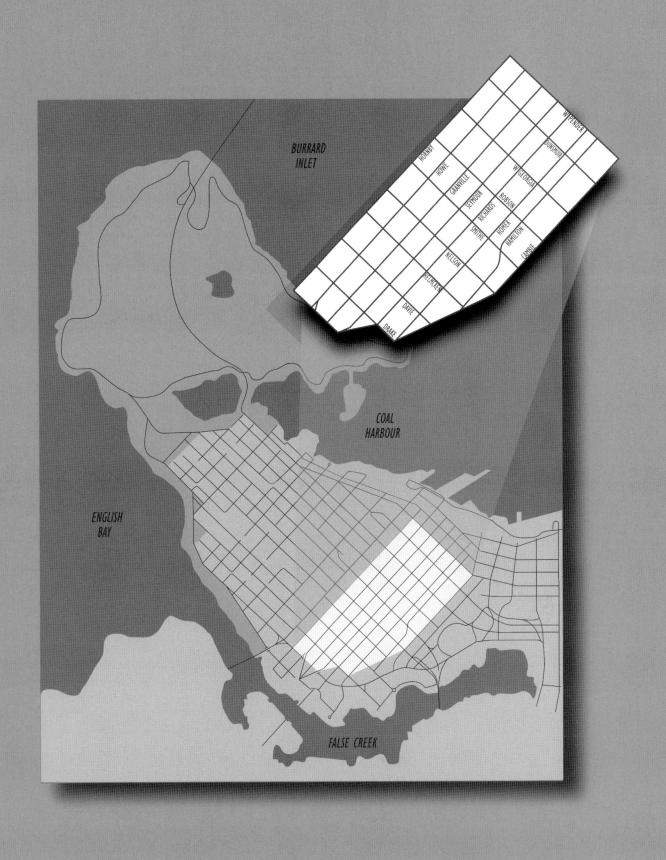

BURRARD
INLET

COAL
HARBOUR

ENGLISH
BAY

FALSE CREEK

W PENDER

HORNBY

HOWE

DUNSMUIR

GRANVILLE

W GEORGIA

SEYMOUR

ROBSON

RICHARDS

SMITHE

HOMER

HAMILTON

NELSON

CAMBIE

HELMCKEN

DAVIE

DRAKE

DOWNTOWN CORE

The downtown core is the very heart of Vancouver. Here, architectural styles represent every decade. Old structures such as the Seymour Building become neighbours to brand new towers. The core is ever changing — buildings that have outlived their usefulness are torn down and replaced. Some heritage buildings are preserved while others, such as the Scotia Bank Dance Centre at the corner of Granville and Davie Streets, have new ones built behind their facades.

There have been some successes in terms of protecting heritage buildings. Notable examples include:

- Vancouver Art Gallery
- Orpheum Theatre
- Sinclair Centre
- Hotel Vancouver
- Marine Building
- Christ Church Cathedral

In preserving such buildings, the exteriors are the focus. However, interiors of heritage buildings have almost always undergone alterations from their original design, allowing upgrades to heating, plumbing, electrical and structural systems, necessary for a safe and functional environment.

Many buildings that would have achieved heritage status today have been torn down. A fairly recent example, and one which was the focus of some controversy, was the demolition of the Georgia Medical Dental Building, at Burrard and West Georgia Streets, now the site of Cathedral Place (1991). Built in 1929, the Medical Dental Building was a 15-storey brick tower richly decorated in the art deco style. The campaign to save it was not successful, but perhaps the movement inspired architect Paul Merrick to incorporate stylistic details from the original building, such as the copies of the tenth-storey nurse statues, into Cathedral Place.

In the past, many wonderful old buildings, both commercial and residential, have been demolished to make room for new developments. While progress is inevitable, there must also be a provision to preserve the past, especially fine examples of past architecture. The Vancouver Heritage Register was created in 1986 to protect various buildings and structures from being demolished. To be recognized, sites must be identified as having heritage value and/or heritage character and be at least 20 years old. The inventory currently consists of 2,150 buildings, divided into three classes based on historic, architectural, cultural, spiritual, scientific and social values. It must be noted that being on the register does not guarantee a building's survival. However, each demolition application is closely examined by City Hall.

What goes on in the downtown core has also evolved. Vancouver's financial district is still there, as are the nightclubs, shopping areas and tourist attractions. But something unique has happened, something special. The major universities along with British Columbia's premier technical school have opened campuses. Simon Fraser University and the University of British Columbia occupy existing buildings, while the British Columbia Institute of Technology had a building constructed.

Entertainment and cultural events take place here as well, in venues such as the Orpheum Theatre, the Commodore Ballroom, the Queen Elizabeth Theatre and the Centre for the Performing Arts.

As one wanders the downtown core, it is obvious that the traditional businesses and offices one would expect are not the sole tenants. Condominium towers are being built at a furious pace. People not only work downtown, they live there in increasing numbers, creating a revitalized and rejuvenated city core. Vancouver's downtown doesn't become a ghost town at 5:00 pm, as is the case in many other cities. The mass exodus of office workers to the suburbs is dwindling. Another benefit of this trend is manageable traffic, even during rush hour. Public transit works well, with options including the elevated SkyTrain and electric trolley buses. If one lives and works in this area, there is almost no necessity for a car.

Decades ago, newly built suburban shopping malls and movie theatres threatened a vital part of the downtown experience. As well, few major buildings were constructed in the 1950s, and downtown saw many vacant stores. Revitalization was needed to prevent inner-city deterioration. In the 1960s, office towers were built and firms such as MacMillan Bloedel and Westcoast Transmission established their head offices downtown. Then came the phenomenon of Pacific Centre. The project was controversial from the outset. The intent was to make room for the construction of office towers but retain existing retail establishments. The largest downtown redevelopment when construction began in 1969, Pacific Centre consists of an underground shopping mall, the Eaton's department store, the TD Building, the IBM Tower and the Four Seasons Hotel.

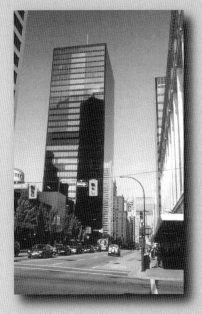 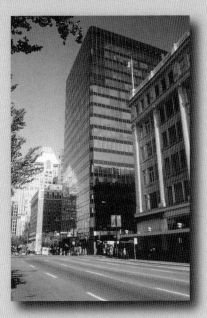

Upon their completion, city residents referred to these two structures as the "black towers" or "the towers of darkness." On the left is the 30-storey TD Tower and directly across the street is the 19-storey IBM Building. There is a noticeable lack of stylistic detail that is commonly found on today's towers. However, there is a certain sleekness that was in vogue in 1969 when these buildings were designed.

The underground mall itself was successful, but with unexpected negative side effects — street-level activity had been moved underground. In an effort to restore it, Granville Street was turned into a pedestrian mall with widened sidewalks and vehicular traffic restricted to buses.

This failed to restore commercial vibrancy to the street, however, and it appeared that the mall conversion was an urban planning mistake. Inadvertently, a business slum had been created; Granville Street was home to sex shops, pawnshops, street people and drugs. Subsequent revitalization attempts over three decades were mostly unsuccessful. Recently, the area has started to change, largely because of the residential towers being built nearby. The latest focus is to retain the street's edgy character and heritage buildings but without the associated problems. The "entertainment" portion of the strip, abundant with clubs, live venues and movie houses, has proven successful and is very animated at night, with the large neon signs evoking feelings of the glory days of the past. It appears that Granville Mall, as a focus for the city's nightlife and its revitalization, is an idea heading in the right direction.

There is an energy in the downtown core. So much is happening: business, leisure, shopping, nightlife. It is a mix that makes for a lively area and the residential component will no doubt add a positive new twist as downtown continues to evolve into more than the sum of its parts. Looking at what was, and what is, one could say the sky is the limit.

Left: Clubs and hotels on Granville Mall.

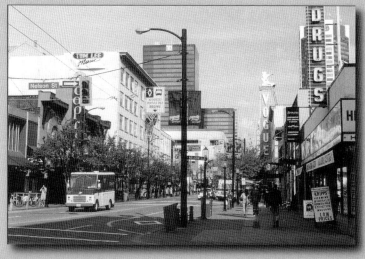

Large neon signs (Drugs, Vogue, Orpheum, Caprice) help make the street come alive at night; various clubs and venues draw the crowds.

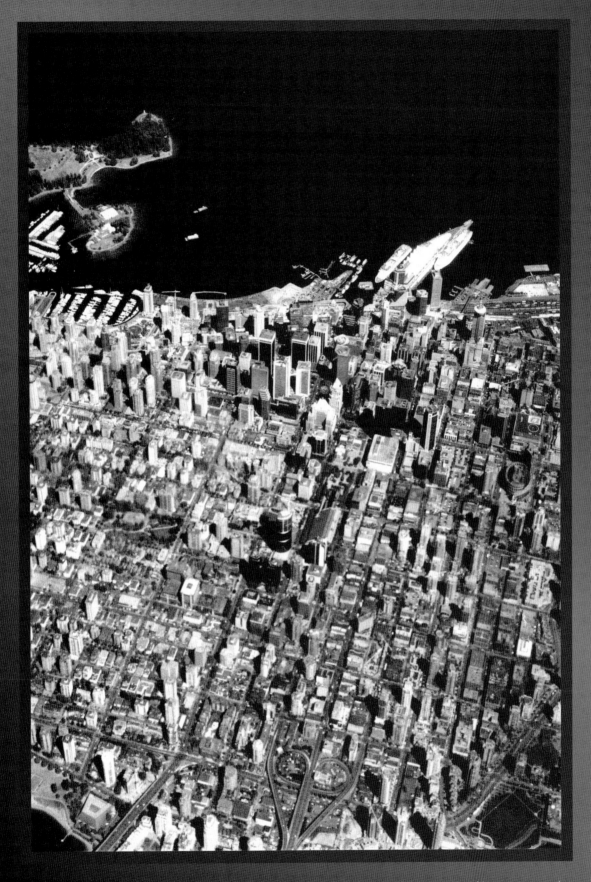

With this aerial view, it is easy to pick out such landmarks as the Wall Centre, Hotel Vancouver and Canada Place.

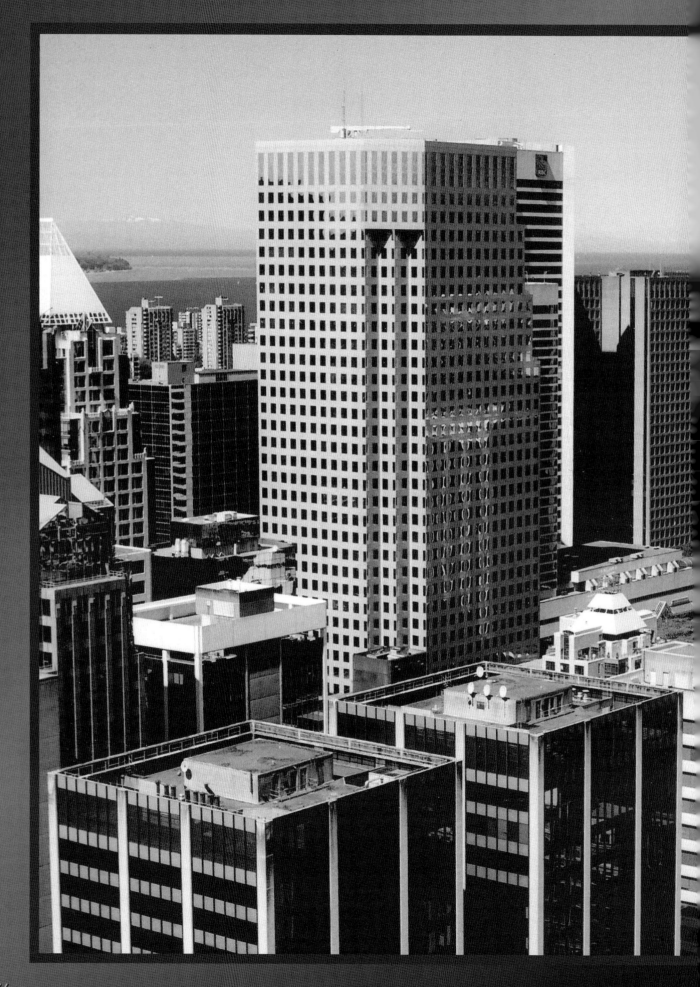

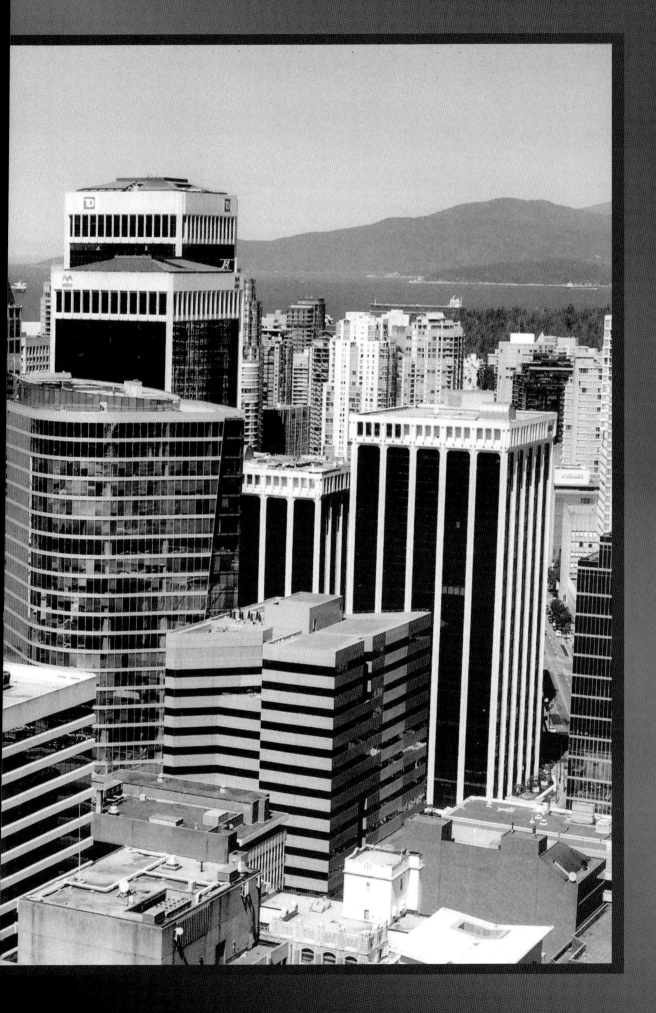

seymour building

Address: 525 Seymour Use: Offices Floors: 10
Completed: 1920 Architect: Somervell & Putnam Height: 36 metres (119 feet)

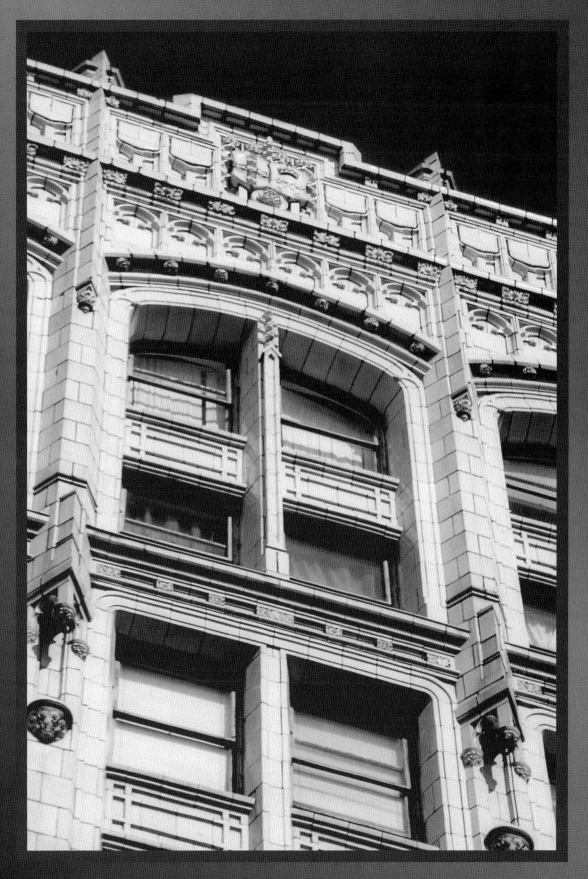

The Seymour Building is typical of the towers of 1920s Vancouver. Ornate details make it distinctive and elegant compared to some later architectural styles. Similar buildings downtown have either been well-maintained or restored, adding a sense of history and variety to the area.

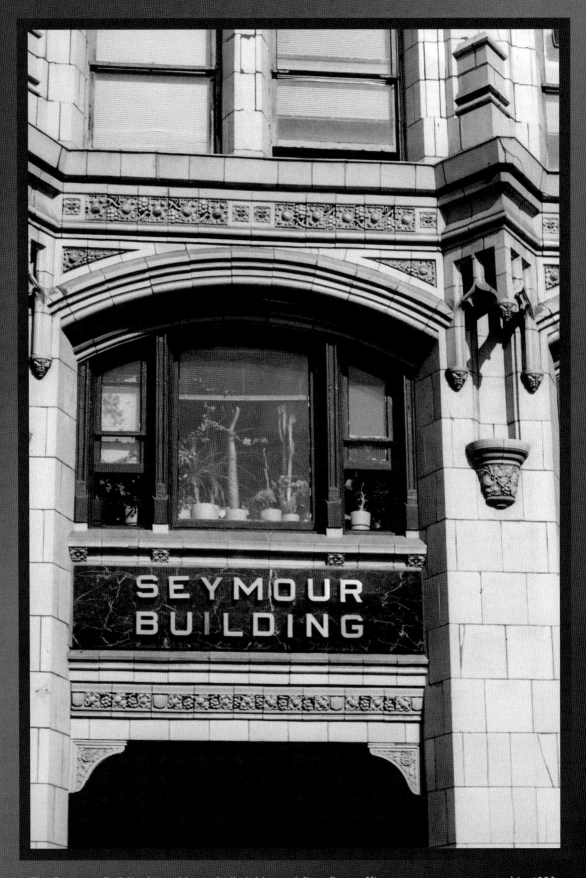

SEYMOUR
BUILDING

The Seymour Building's marble-and-gilt lobby and first-floor office space were renovated in 1990.
Any walking tour of the downtown area should include this building as well as others like it.

The intersection of West Georgia and Seymour is home to two significant buildings from different eras: the Scotia Tower, one of Vancouver's tallest at 138 metres (452 feet), built in 1977, and the 1914 Hudson's Bay department store, which is on Vancouver's Heritage Register.

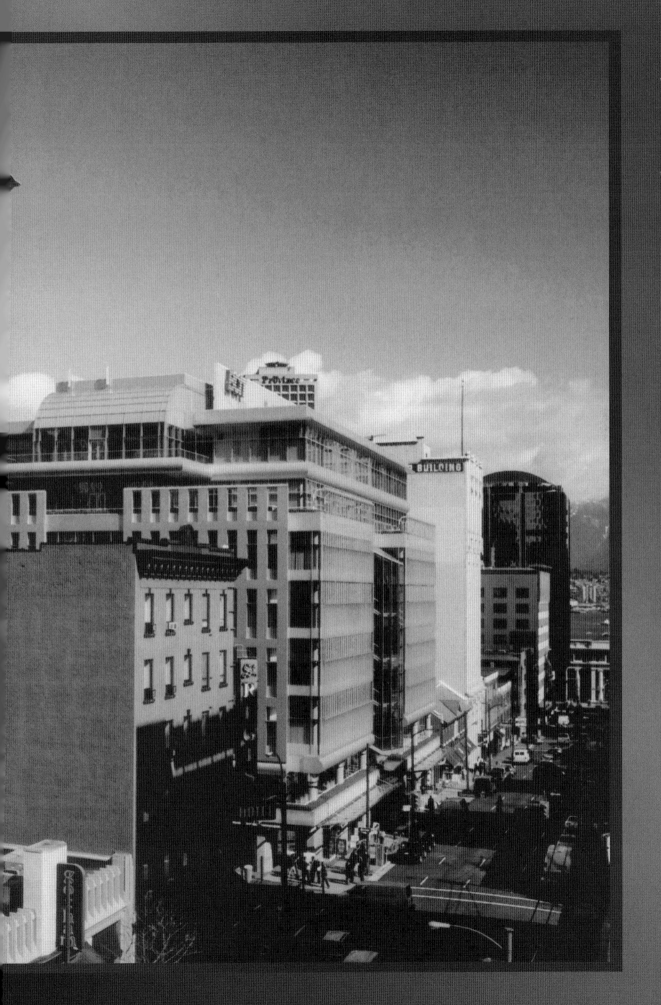

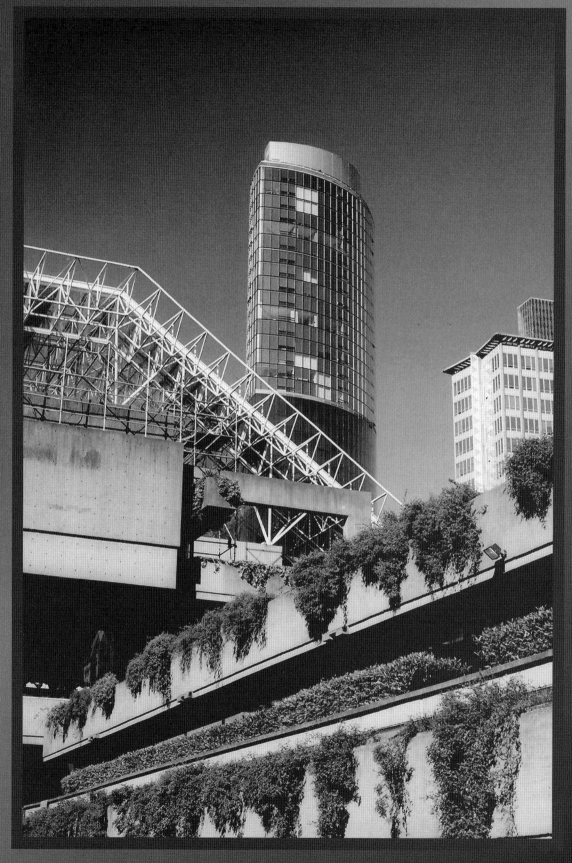

Address: 800 Smithe Use: Government Floors: 7
Completed: 1979 Architect: Arthur Erickson Cost: $139 million

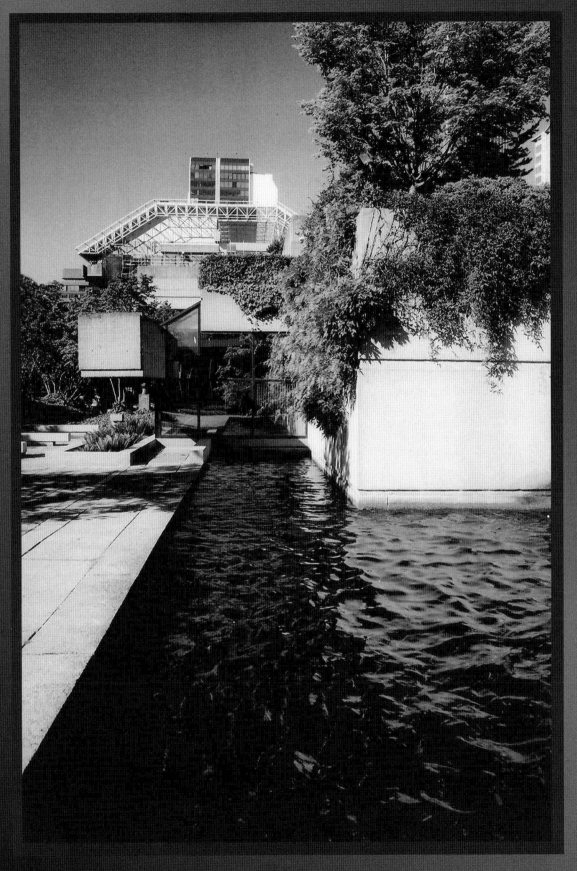

The Provincial Law Courts comprise 35 courtrooms and accommodate 60 judges. The design was based on three principles: circulation of people while ensuring security, separation of public and business areas, and the ability to change according to the judicial system.

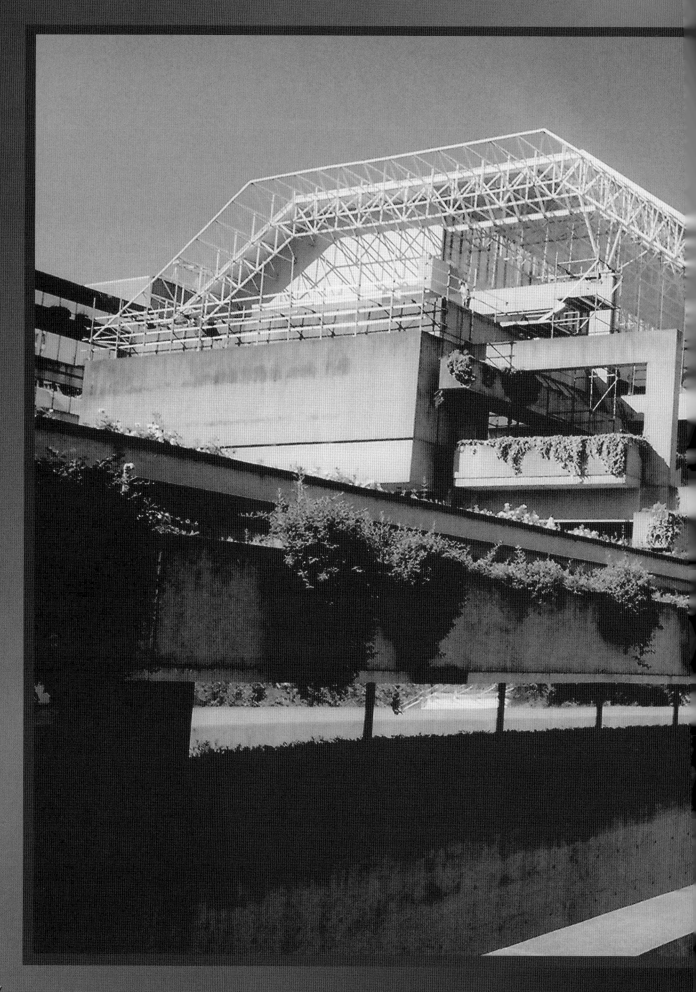

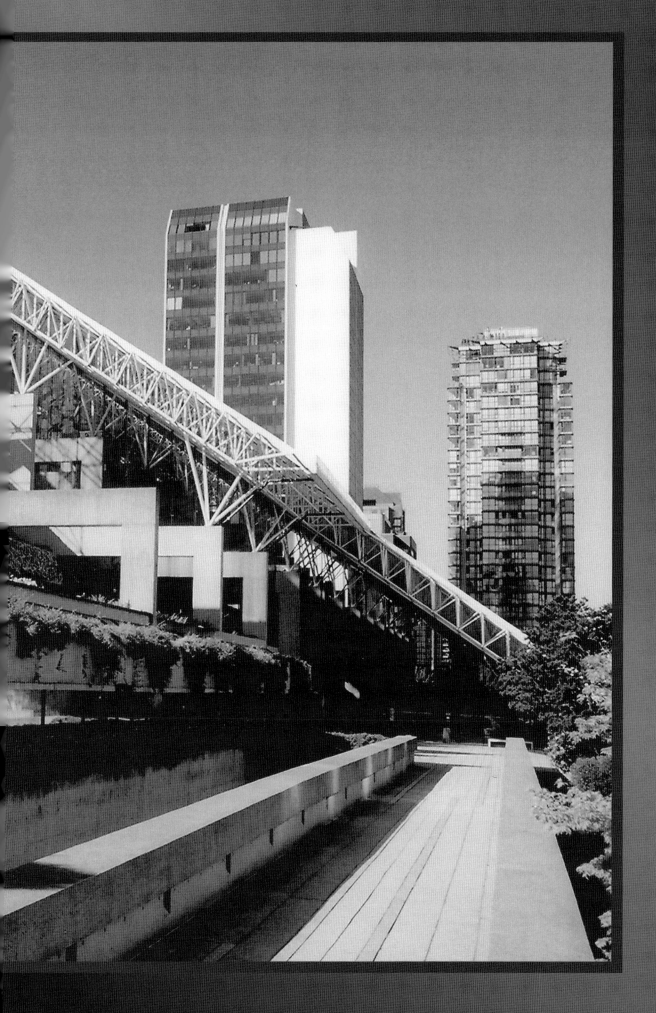

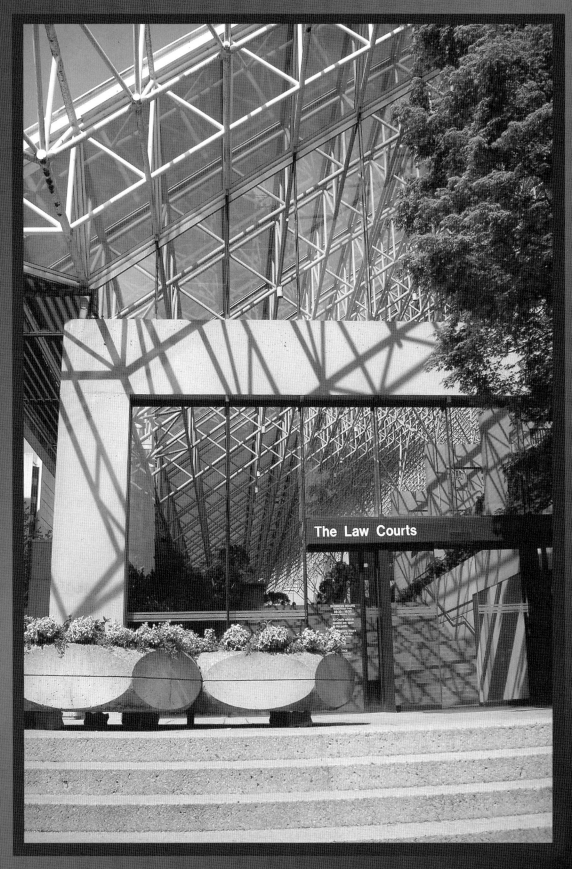

As one approaches the main entrance on Nelson Street, the massive glass roof and tubular super-structure comes into view. Measuring over one acre, the sloping roof provides abundant natural lighting, particularly in the Great Hall – the main public area on the first level.

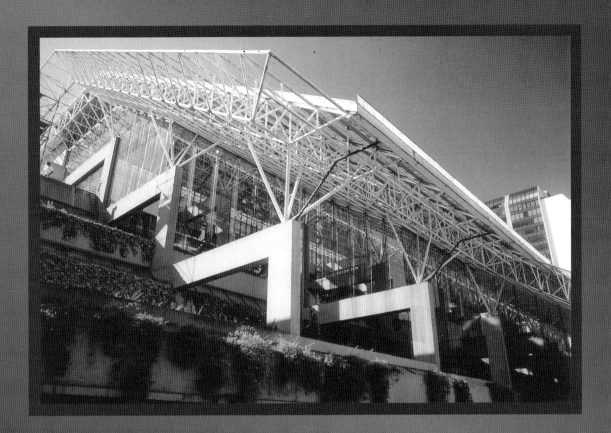

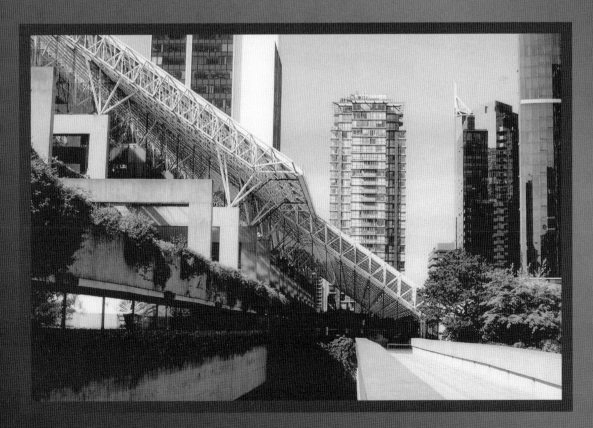

The glass roof symbolizes the transparency of the legal system; the intent is to make people feel welcome to enjoy the public spaces or participate in the judicial process. The bottom photo shows the walkway that carries over Smithe Street, as does the whole complex.

downtown east

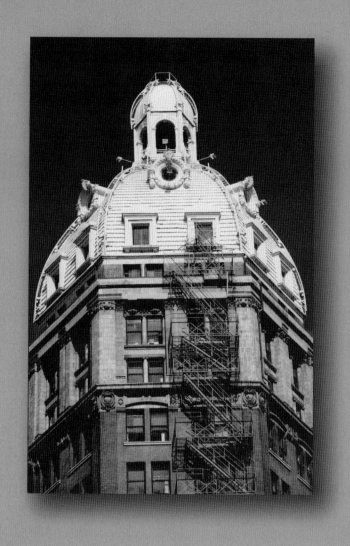

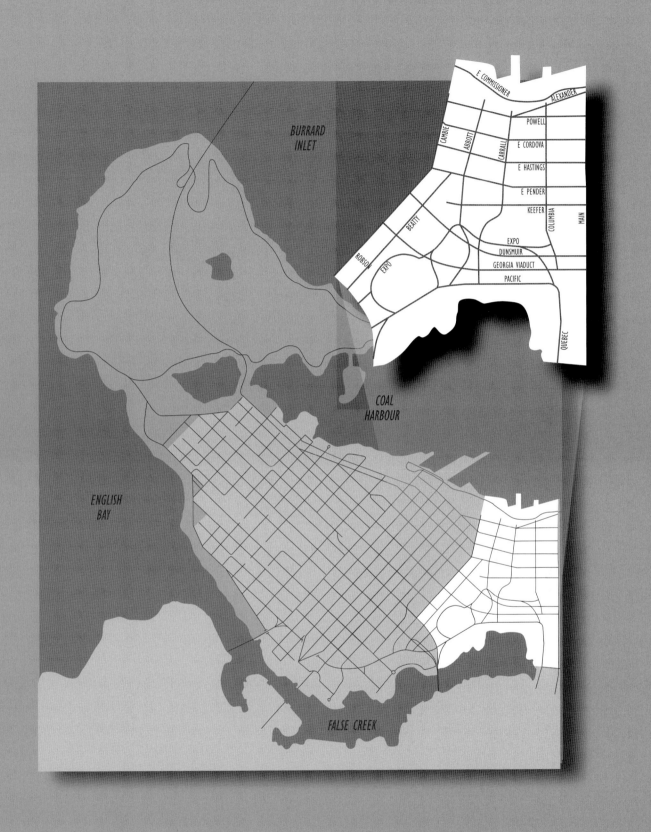

BURRARD
INLET

E COMMISSIONER

ALEXANDER

POWELL

CAMBIE

ABBOTT

CARRALL

E CORDOVA

E HASTINGS

E PENDER

KEEFER

COLUMBIA

MAIN

BEATTY

EXPO

DUNSMUIR

ROBSON

EXPO

GEORGIA VIADUCT

PACIFIC

QUEBEC

COAL
HARBOUR

ENGLISH
BAY

FALSE CREEK

DOWNTOWN EAST

Downtown East, as delineated in this book, encompasses Gastown, Chinatown, International Village, the two stadiums and Citygate. An eclectic mix of neighbourhoods — from Asian heritage steeped in Chinatown to the new International Village residential development — downtown East is an area in transition, and is also a transitional area. Citygate, being built as a new community in the new Vancouver style, will, through future development, connect with International Village to the west.

Chinatown will be preserved and old buildings restored. City officials and residents recognize this as a unique area that should be excluded from massive redevelopment. Indeed, when the idea of a freeway to the downtown core was proposed, it would have gone right through Chinatown. The public protested, which set the tone for the Vancouver of the future.

As one of the city's oldest communities, Chinatown contains some of Vancouver's most historically significant structures. The province, recognizing Chinatown's special history and architecture, designated it a historic district in 1971. While preservation bylaws have prevented redevelopment, many of these old buildings have fallen into disrepair.

A typical example of recessed balconies — a feature with its origins in southern China. The architecture is a blend of Edwardian and Asian styles.

The architecture, unique to North America, reflects a hybrid of Asian and Edwardian styles. Recessed balconies are a typical example of the Asian influence. The design came with the city's first Chinese immigrants, who were accustomed to recessed balconies in the subtropical regions of southern China. By capturing the breeze, they cool the building interiors; they also provide additional outdoor space. The Edwardian component is typically represented by columns, cornices and pediments.

The Sam Kee Building, 2 metres wide.

Chinatown contains some remarkable and unique structures. A significant heritage building is the Sam Kee Building (1913), recognized in the Guinness Book of World Records as the world's thinnest building. Its story began when the city expropriated all but two metres of a normal sized lot in order to build Pender Street, and did not compensate the owner for the remaining two metres. The owner proceeded to construct the building on the tiny lot, creating not only a curiosity, but a place that would acquire an interesting history. At one time 13 tiny businesses were housed under the narrow roof, including the only place in Chinatown to get a hot bath. Beneath the floor is a tunnel that was used to escape police raids on opium dens in adjacent Shanghai Alley.

Another of Chinatown's fascinating structures, the Wing Sang Building (1889) was built over a period of 12 years and is possibly Vancouver's oldest. It is actually two buildings spread over three lots. A planned heritage restoration of the brick structure will see the front building rebuilt as offices and an art gallery. The six-storey building in the rear will be converted to condominiums.

Bordering Chinatown is International Village, a development perhaps slightly ahead of its time. A large retail complex, residential towers, a specialized shopping mall and a high-end movie theatre have been built. With significant vacant retail space and no transition zone (as with False Creek's Yaletown area) the Village leaves the impression that the rest of the surrounding area has to catch up.

Adjacent are BC Place and GM Place stadiums, massive structures that seem out of context in the new Vancouver. BC Place was built for Expo 86 and holds 60,000 people. GM Place was built approximately ten years later to house the Vancouver Canucks hockey club and holds 18,000 fans. Perhaps future development projects in this area will help to better integrate the stadiums into their surroundings.

Citygate, located at the east side of False Creek near Science World, is anchored by the 14-storey VanCity office tower and the SkyTrain station contained within the building. Consisting of highrise residential towers, the remainder of this development will connect with International Village as more construction takes place. Perhaps Citygate is the ideal vision of large developments built around transit stations. Indeed, if one lives there, downtown is mere minutes away by SkyTrain.

It will be interesting to see how the massive development of False Creek South (36 hectares) will impact Citygate. Currently False Creek South is vacant land, but it will play a major role in housing athletes in the 2010 Olympics. Following that event, the area will be the site of a new, planned high-density community with a focus on sustainability, ecosystem stewardship, and social health and well-being. It would seem that history is repeating itself — for just as Expo 86 spawned False Creek North, the Olympics will generate a significant new development on the southern shore.

Gastown is another historic area, located between Waterfront and Chinatown. Though founded in 1867, no buildings remain from that period due to the fire in 1886 which destroyed the town. Many old buildings feature colourful retail and commercial tenants. A new phenomenon is the conversion of the upper levels of buildings into residential heritage lofts. The same change that has occurred in the downtown core is moving east into Gastown, but in a way that is sensitive to the area's current use and its history. It should be noted that Gastown, with its proximity to Canada Place and the cruise ship facility, is a major tourist draw and public officials do not want to impact this in a negative way.

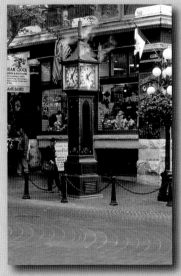

The Steam Clock is a tourist favourite.

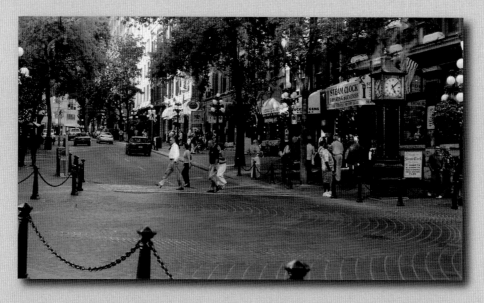

Gastown, unique in Vancouver, is a great place to browse, buy Canadiana and enjoy good food, partly because of the street treatments and heritage buildings. While being tourist oriented, it does not have a theme-park atmosphere.

Examples of "facade architecture" are occurring in Gastown: an old building, demolished except for the facade, is gingerly propped up and reinforced while a new building rises immediately behind. The debate continues as to whether this satisfactorily preserves some semblance of the old building, or if it is merely a tokenistic approach to appease conservationists and City Hall. Since many old buildings simply cannot be economically renovated to today's standards, this solution provides a compromise.

In 1971, Gastown was declared a historic district by the provincial government and in 1972, all three levels of government contributed funds to reverse the trend towards dilapidation. The streets were paved with brick, utility lines buried, period lamps installed and trees planted. This led to the building renovations and a revitalized area. The world's only steam-powered clock, a favourite tourist attraction, was designed in 1875, but wasn't built until 1977. It has been a fixture in Gastown ever since. The charm of Gastown can be attributed to brick streets, Victorian architecture, tourist boutiques, restaurants and brewpubs. All of these components come together to create a lively, colourful place that draws both tourists and residents.

More than any other area, Gastown and Chinatown will be altered slowly, carefully, in order to respectfully preserve their historical and cultural significance. One will not see sweeping new developments such as those at False Creek South and Citygate. Instead, these areas will evolve, with the key philosophy being preservation and restoration.

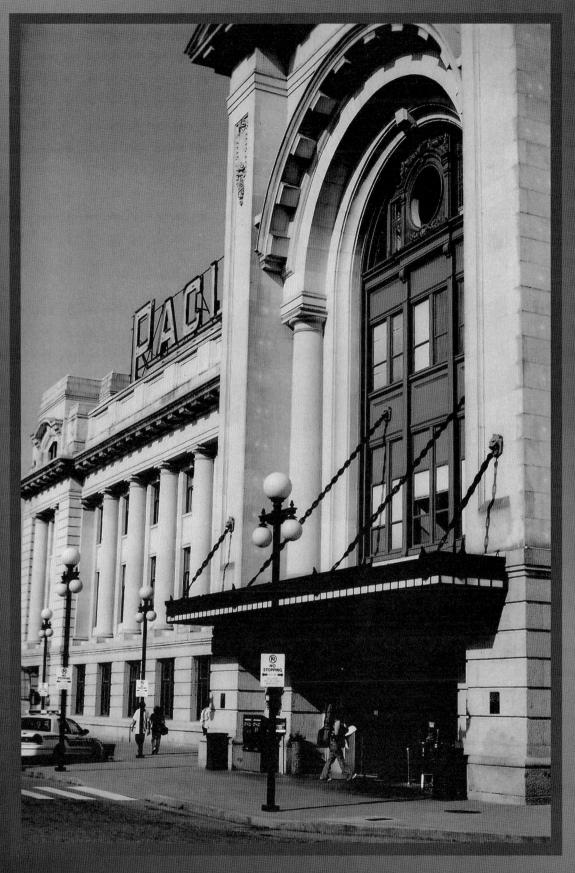

Address: 1150 Station

Completed: 1915

Use: Bus / Rail Terminal

Floors: 3

Address: 1455 Quebec
Completed: 1986

Use: Education / Tourism
Architect: Bruno Freschi

Floors: 7
Height: 47 metres (155 feet)

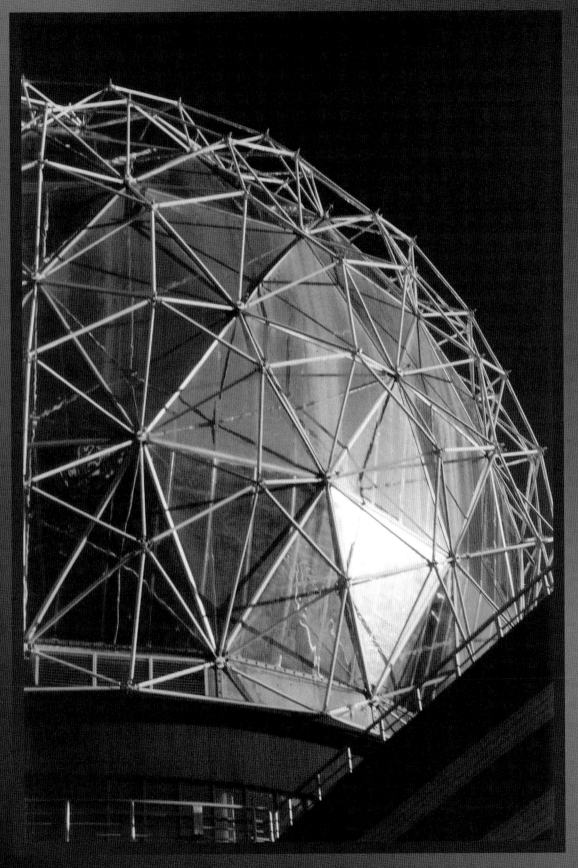

This fine example of a geodesic dome, patented in 1954 by inventor R. Buckminster Fuller, served as Expo Centre during the 1986 World Exposition (Expo 86). Today, as Science World, it is home to hundreds of interactive exhibits focusing on science and technology, and includes an IMAX theatre.

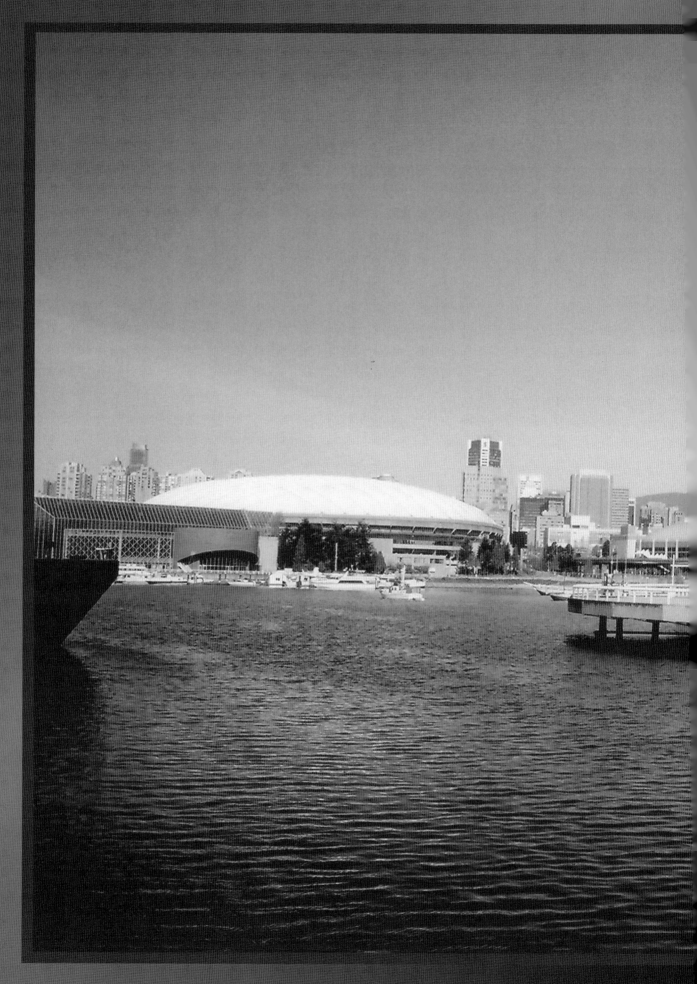

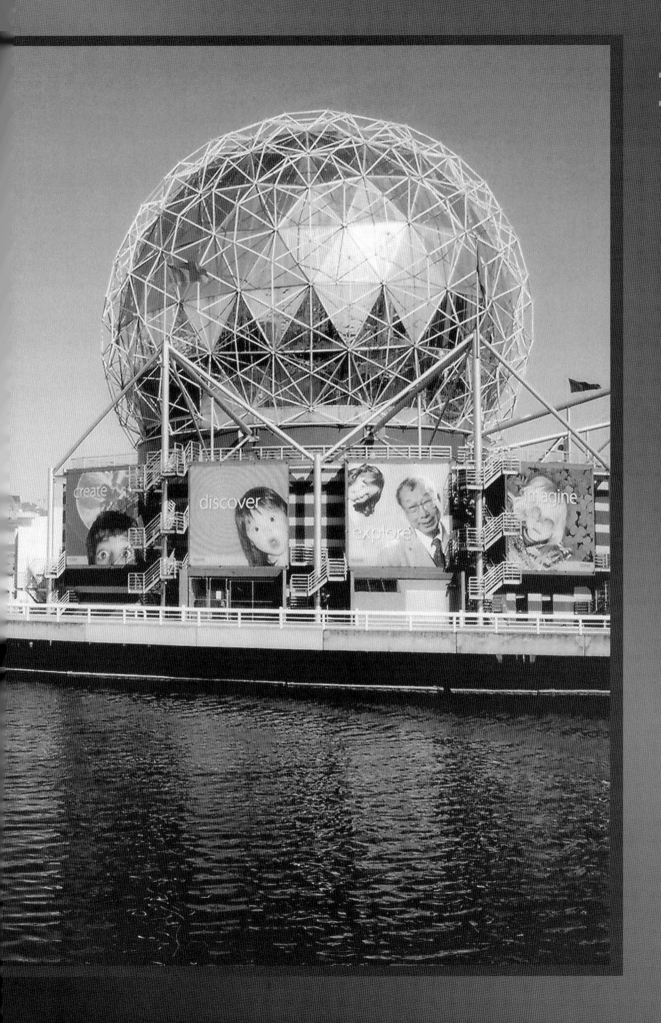

Address: 183 Terminal Use: Offices Floors: 14
Completed: 1995 Architect: Musson Cattel Mackey Height: 58 metres (191 feet)

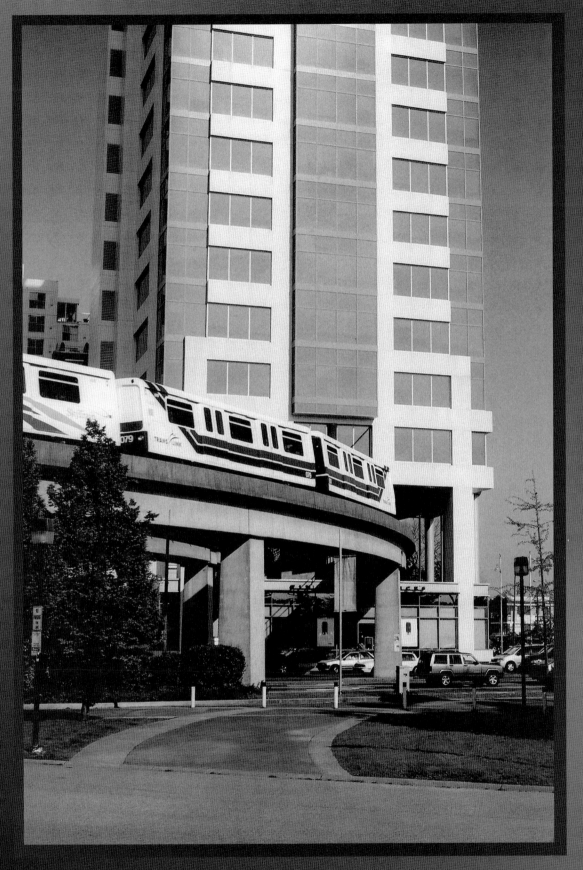

VanCity Centre incorporates a SkyTrain station on the second level – a concept that looks to the future with convenient public transit being integrated into new developments. The 14-storey building also anchors the Citygate area, a project guided by the city's urban planning vision.

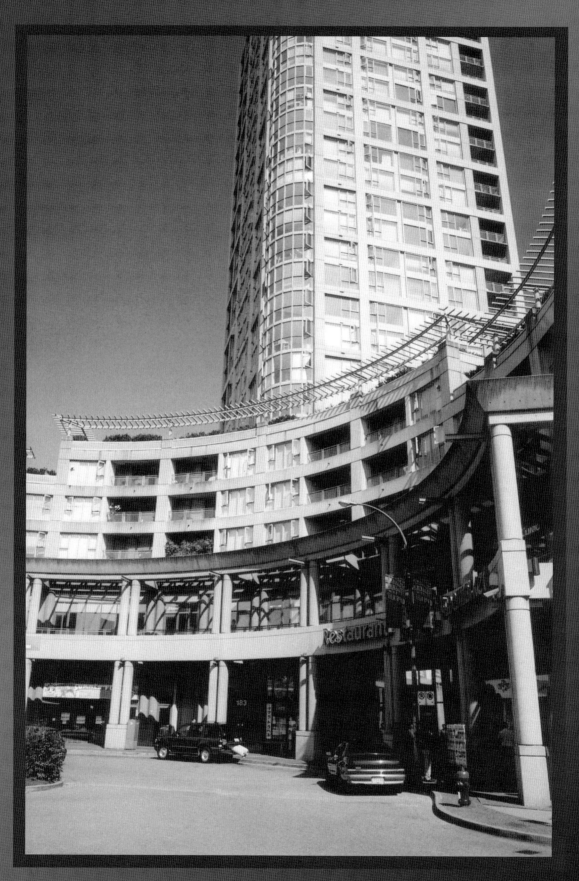

International Village consists of a six-storey retail / residential wing with two residential towers (25 and 31 storeys), to be completed in 2006. The 8.5-hectare (21-acre) development also includes a park, movie theatre and specialty shopping mall. A school and daycare will complete the project.

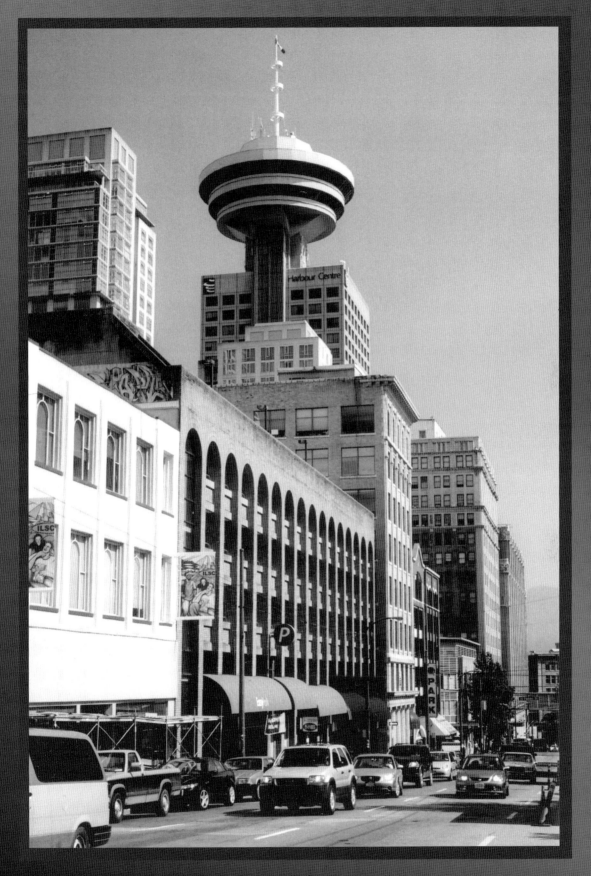

Homer Street, on the downtown's eastern edge, serves as a transition between the office towers and the heritage buildings of downtown east and Chinatown. Large-scale redevelopment has not touched this area — the buildings remain as they have been for generations.

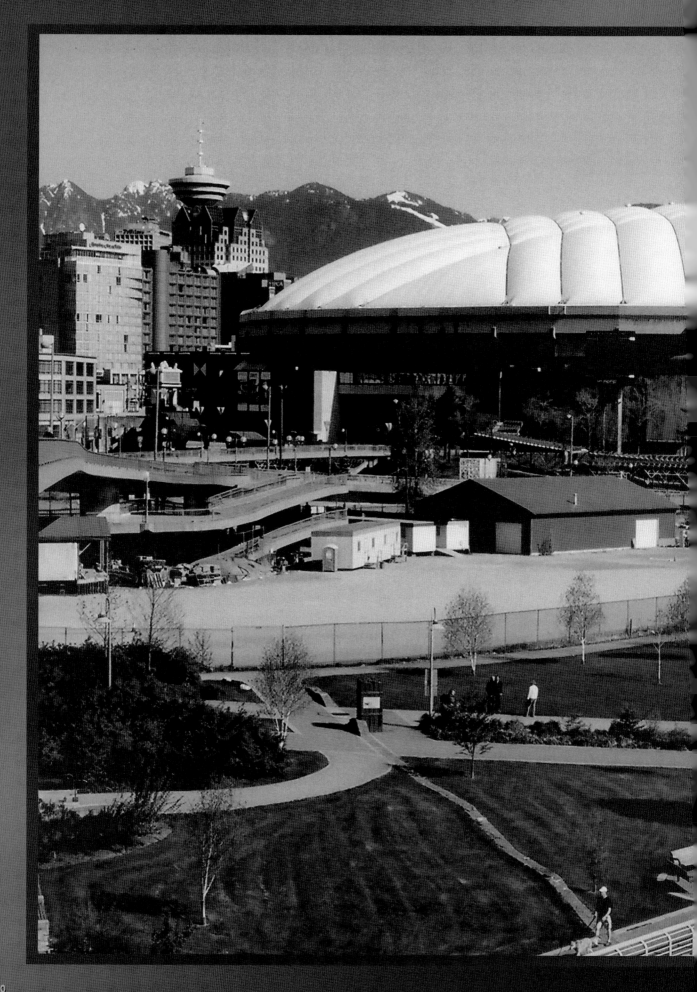

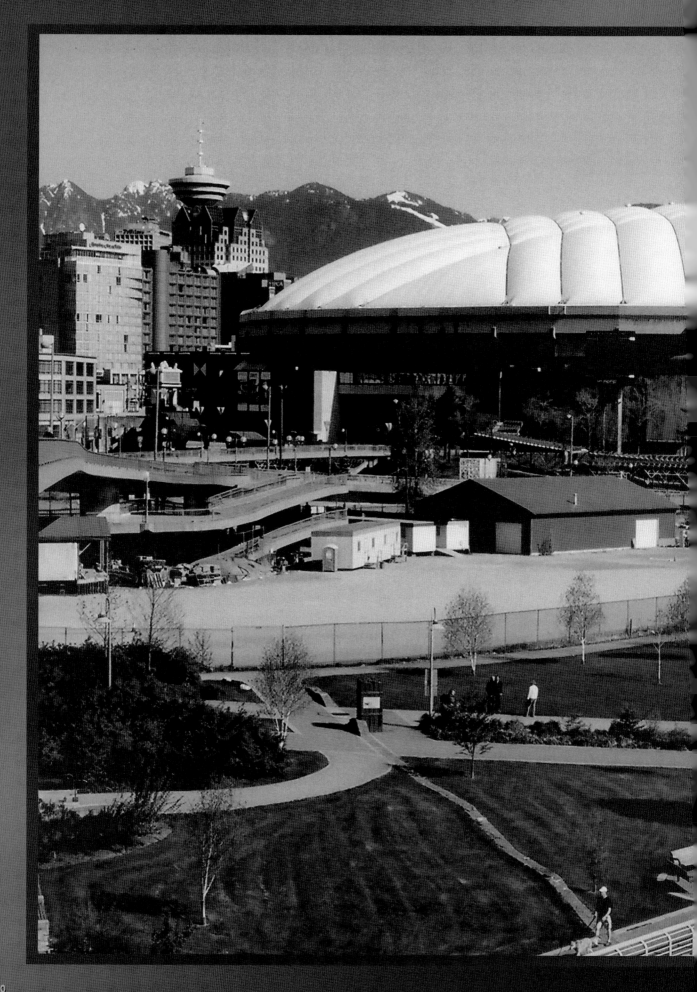

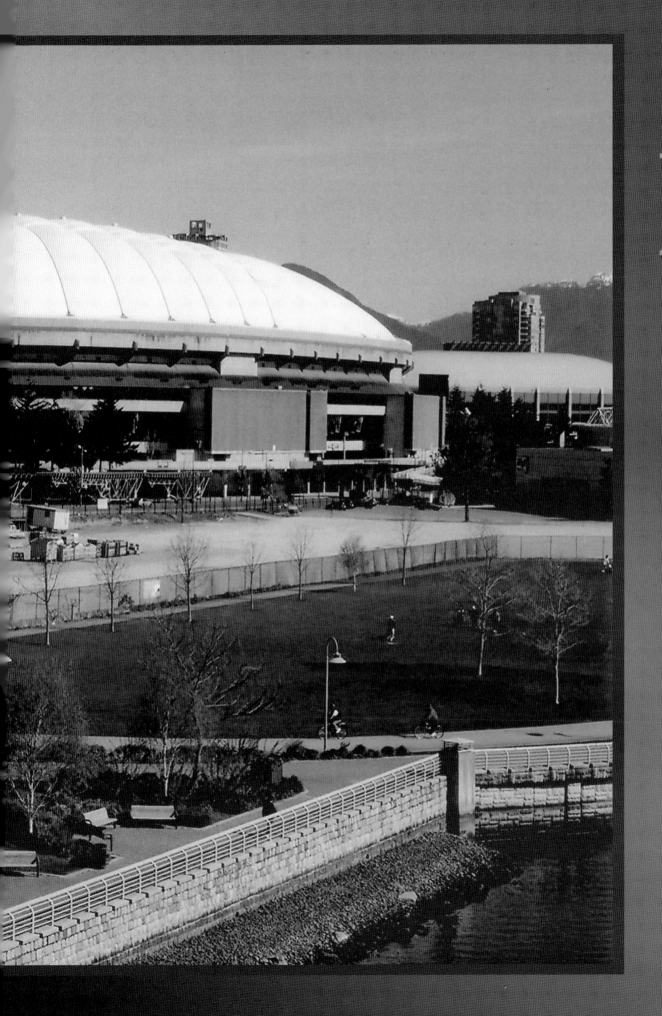

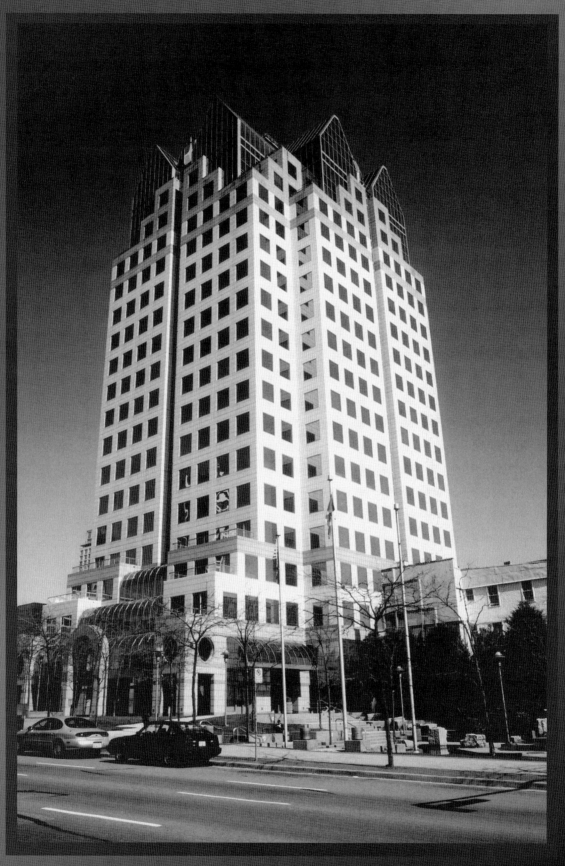

Address: 333 Dunsmuir Use: Offices Floors: 19
Completed: 1992 Architect: Musson Cattell Mackey Height: 81 metres (265 feet)

The postmodern BC Hydro tower, reflected on the glass of the adjacent building, is fully occupied by the 1100 employees of the public utility. The entry plaza features a water sculpture, clock tower and seating area.

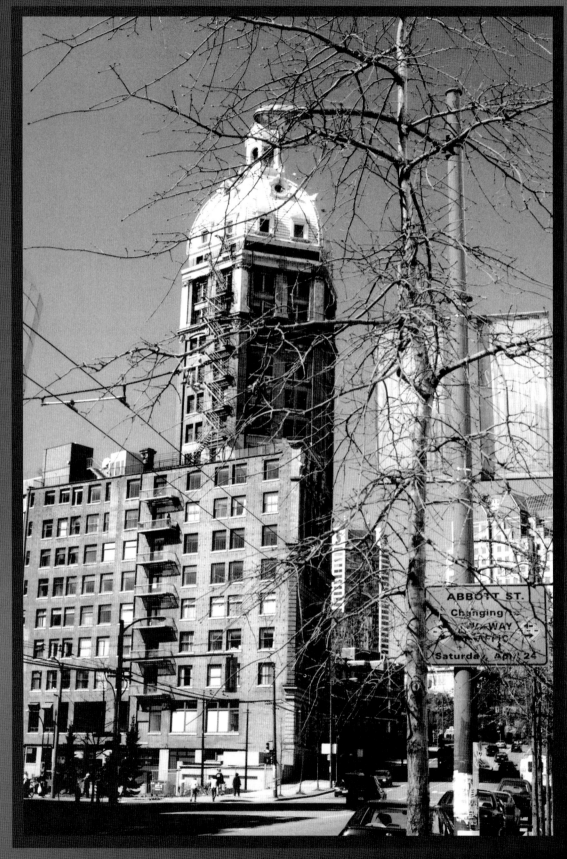

sun tower

Address: 100 West Pender Use: Offices Floors: 17

Completed: 1912 Architect: W.T. Whiteway Height: 82 metres (270 feet).

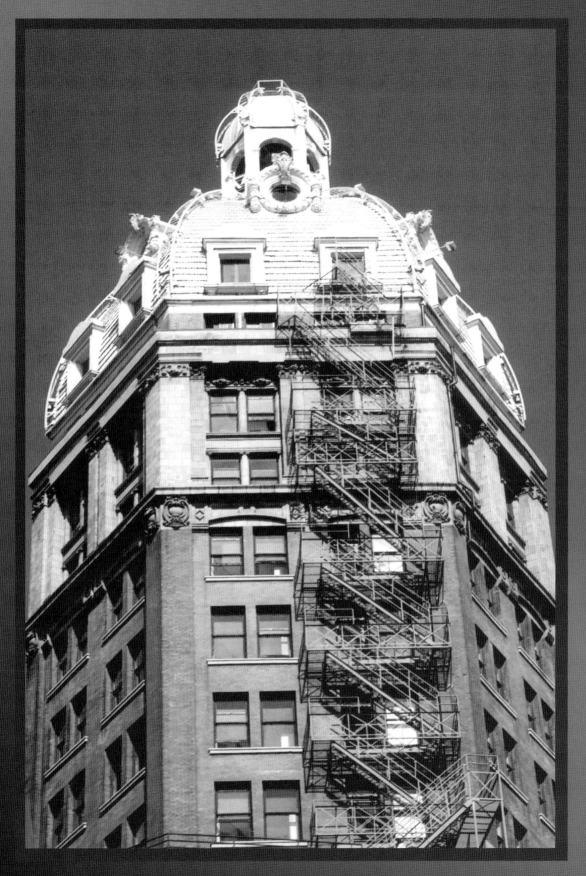

The Sun Tower, with its most prominent feature — the three-storey oxidized green copper roof — is one of the city's most important heritage buildings. Home to the *Vancouver Sun* newspaper until 1964, the building was renovated in 1989.

false creek

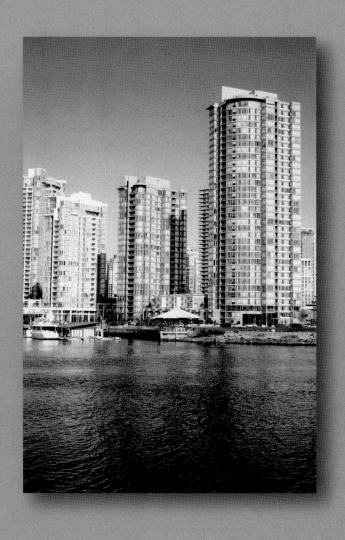

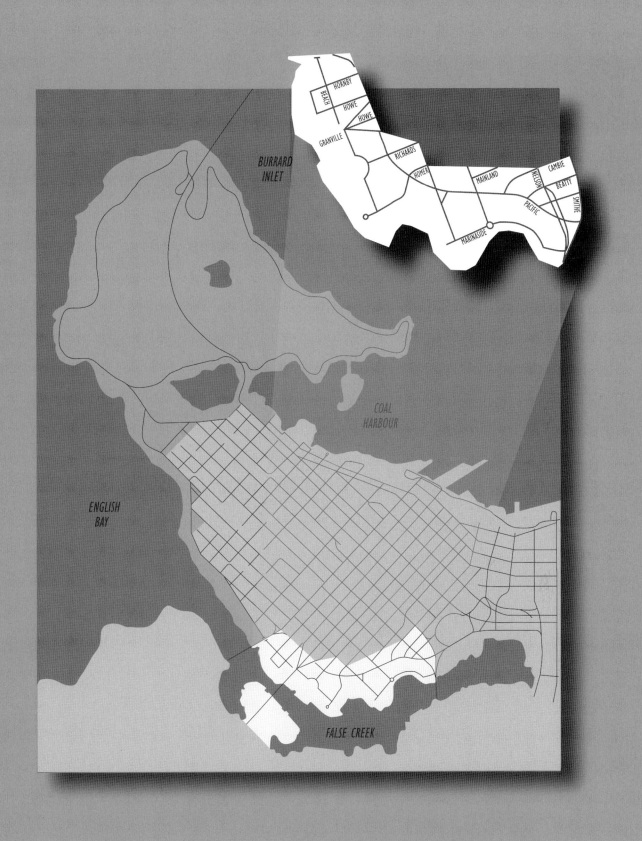

BURRARD
INLET

COAL
HARBOUR

ENGLISH
BAY

FALSE CREEK

BEACH
HORNBY
HOWE
HOWE
GRANVILLE
RICHARDS
HOMER
MAINLAND
NELSON
CAMBIE
BEATTY
PACIFIC
SMITHE
MARINASIDE

FALSE CREEK

The development on the north side of False Creek is the jewel of Vancouver; an over-whelming success story of modern urban planning. One can't help but be impressed when walking through the area, enjoying the public spaces, strolling the seawall or gazing up at the highrise residential towers. It became the template of what Vancouver has become.

A true community, False Creek was planned that way from the very start. People live, work and shop here, and send their children to local schools and daycare facilities. People enjoy the parks and community centre, with its theatre and programs.

One of the area's daycares, with the large David Lam park in the background, framed nicely by the new towers of the Beach neighbourhood.

The springboard to all of this, and indeed Vancouver's complete transformation, was the World Exposition of 1986 (Expo 86). This fair occupied the largely derelict industrial waterfront area on the north side of False Creek and was one of the most successful world's fairs ever. Legacy projects such as Canada Place, Science World, the Plaza of Nations as well as the SkyTrain elevated transit system have all proven to be great assets to the city. Once the fair was over, it was decided to design a new community on the site in an effort to attract more residents to the downtown peninsula. The lands on the north side were sold by the provincial government to a private developer, Li Ka-Shing, whose Concord Pacific Company is responsible for the area's 40 towers, four parks, schools, marinas and seawall. When completion occurs in 2010, 15,000 people will reside along this part of False Creek.

In the past, the shores of False Creek were the industrial heart of Vancouver, occupied by sawmills, a CPR rail yard and manufacturing plants. Originally the body of water was five times as large as it is today, but it was infilled to accommodate the needs of the railway and terminals. By the 1890s, the waters of False Creek were filled with log booms, barges, raw sewage and industrial waste. During the Second World War, activity accelerated to a furious pace, then declined sharply afterwards. Industry was moving out in search of cheaper land and by 1950 many thought False Creek should be filled in entirely. In the 1960s there was a push to have it cleaned up, and this was followed by the biggest land swap in the city's history. CPR, the provincial government and the City rearranged their holdings. CPR's land on the north side went to the province and 35 hectares on the south shore went to the city. Then the decision had to be made: What

would become of False Creek? Many thought the only suitable use was secondary indus-try, but visionaries foresaw a mix of housing and public spaces. After the civic election in 1972, work began on reclaiming False Creek and to that end, industrial waste was cleaned up, a seawall was built and today's Granville Island (administered by the federal government) came into existence.

The roundhouse of False Creek is a building of major historical significance to Vancouver. It was the largest facility of its kind in British Columbia and is the city's oldest heritage building, constructed in 1888. Originally the roundhouse was a cluster of buildings whose function was to house and service the CPR steam locomotives in the rail yards of False Creek.

As the steam era drew to a close, the buildings were no longer needed. The roundhouse and the surrounding rail yards were abandoned as the CPR turned its sights to more prof-itable ventures.

When the provincial government purchased the rail yards in 1980, the roundhouse was slated for demolition. Fortunately, this only occurred in part. Residents and local train buffs rallied to save the historic structure. Four years later, the roundhouse was to be renovated in order to prepare it for duty as a pavilion for Expo 86. It proved to be a crowd favourite. After the close of the fair, the roundhouse was to have a new future..

As part of the False Creek development, the roundhouse became Roundhouse Arts and Recreation Centre, an arts-oriented community centre that serves not only area residents but all of Vancouver's citizens. The facility was completed in 1997 and includes a performance centre, exhibition hall, arts studios, gymnasium, café and various multi-purpose spaces. The centre also houses Engine 374, the first passenger train to enter Vancouver (on May 23, 1887), restored for Expo 86.

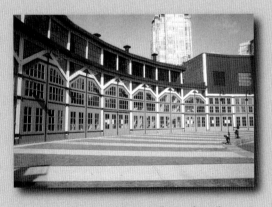

One of the best views of the roundhouse: from the court-yard where the old locomotive turntable is located.

The entrance to the community centre. The building's brick has been restored and the paving stones are coloured to match. Industrial art can be found in various places on the walls of the building.

From a design standpoint, it may be argued that the new buildings and towers of False Creek are too homogeneous. It is true that the colours, textures, styles and materials are common. Perhaps this is inevitable, considering the whole area was constructed by a single developer within a short timeframe. For this reason, it may be more appropriate to view the development as a whole, rather than as individual architectural styles, the way one would with the downtown core of Vancouver.

Despite the apparent lack of architectural diversity within False Creek, the area works well. Individuality gives way to consistency and whatever criticisms there may be, one has to admit that the development has achieved its goal of being a complete community with ample public access and amenities. Proof may be found by observing the number of people strolling the seawall, playing soccer in the park or just enjoying the fresh, new ambience of the area.

Two examples of amenities in the False Creek development, in the form of public art include a large steel sculpture (left) that pays homage to the areas's industrial past. The concrete mounting blocks have inscriptions that note important dates in the area's history. A piece resembling a bus shelter (right) has various industrial terms cut out of the metal. Public art such as this helps to make an area more engaging and visually stimulating.

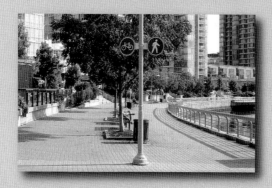

The seawall is a well-designed public space. Landscaping, benches, a consistent colour scheme and fixture styles, plus ample width make this an easy place for movement. Note the sign: Riders on the left, walkers on the right.

This photo shows a very atypically barren part of the False Creek seawall, but it illustrates an important concept. The sign directs pedestrians and cyclists to their appropriate areas and the surfacing materials reinforce this: interlocking bricks for people and pavement for riders.

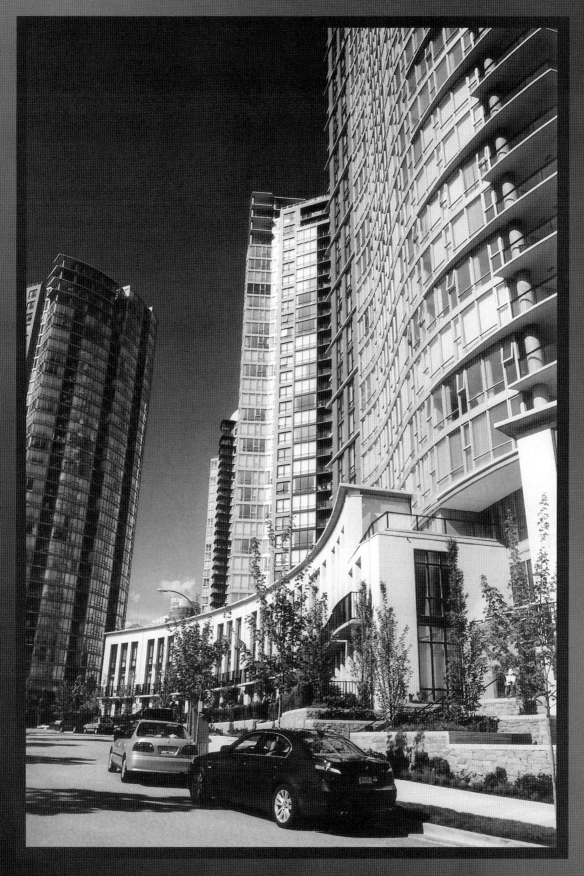

The Beach neighbourhood, just east of Granville Bridge, is the last major development at False Creek. When complete, there will be 15 residential towers on the 10-hectare (25-acre) site. Included in the project is George Wainborn Park, which will extend to the waterfront.

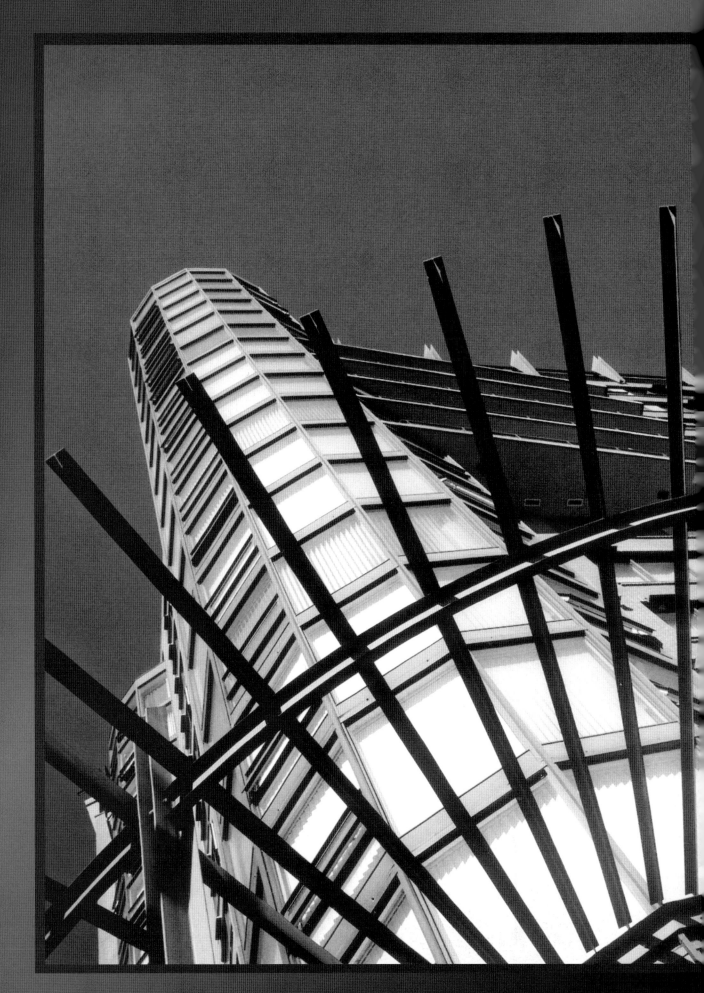

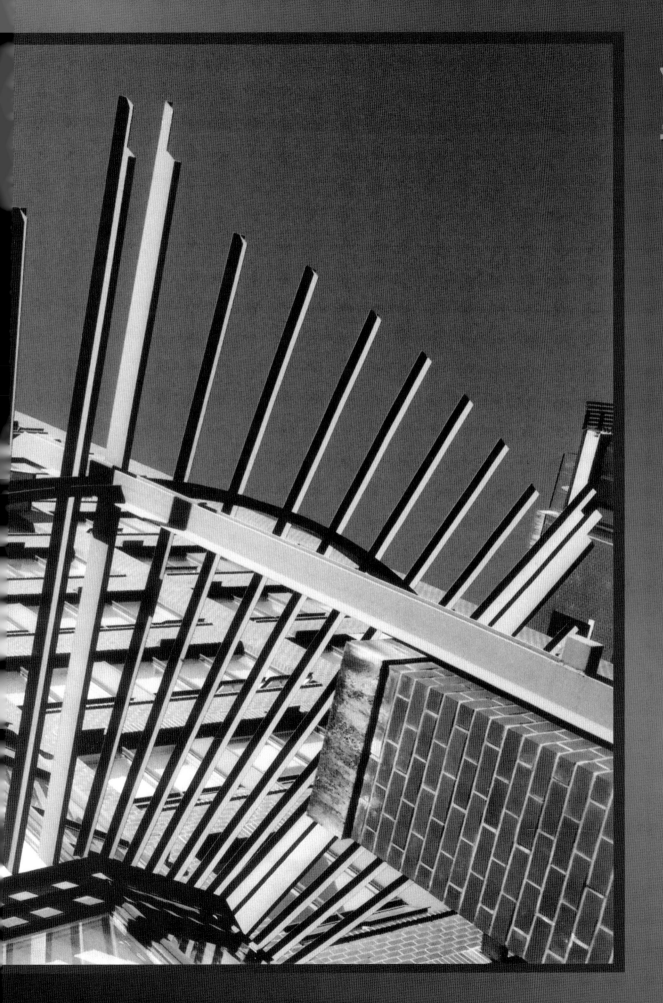

the pinnacle

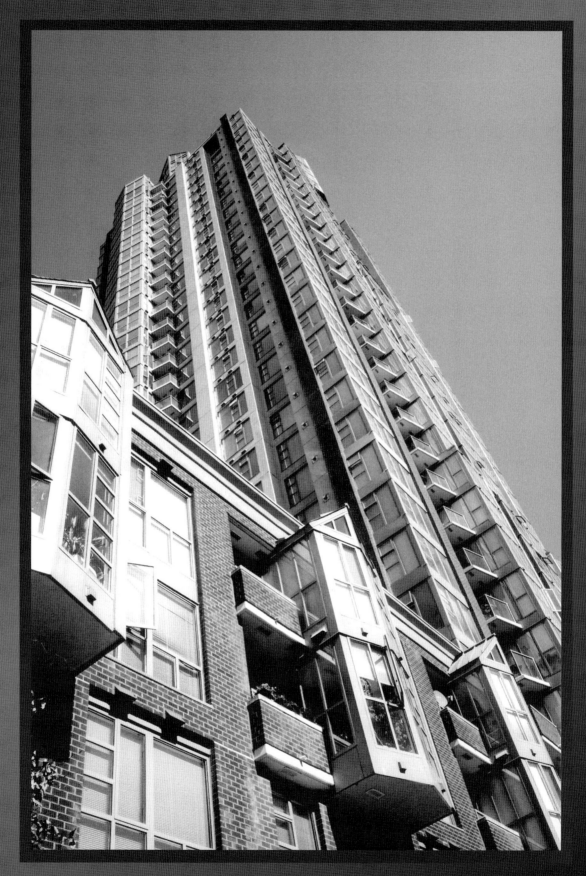

Address: 939 Homer Use: Residential Floors: 36
Completed: 1996 Developer: Pinnacle International Height: 106 metres (348 feet)

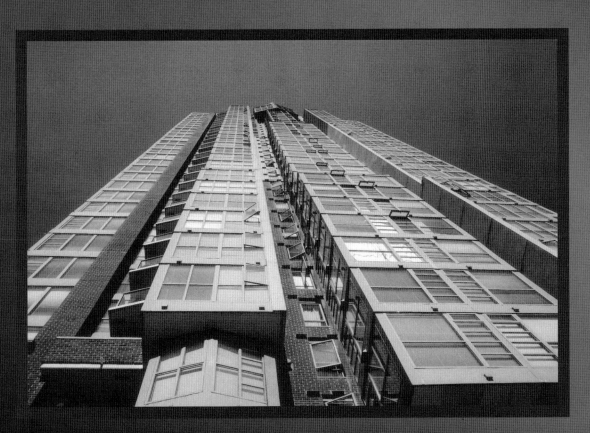

Pacific Avenue (top photo) serves as the transitional area between the restored warehouse district of Yaletown and False Creek. The Pinnacle (bottom photo) is typical of many new towers, using texture and depth to add character. Colours achieve the same, this building mixing teal with red brick.

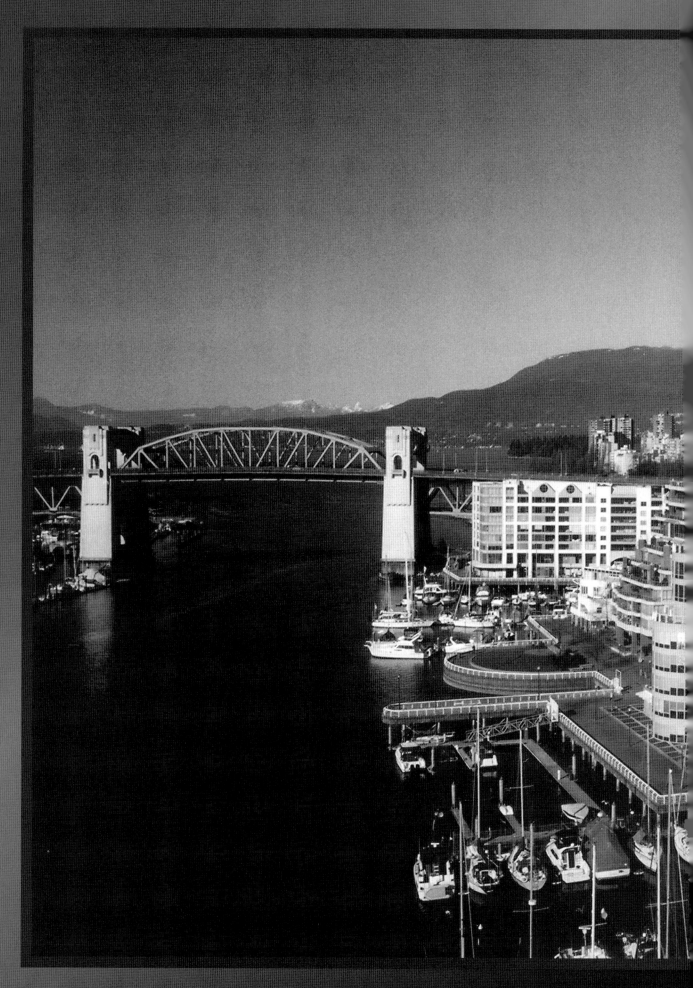

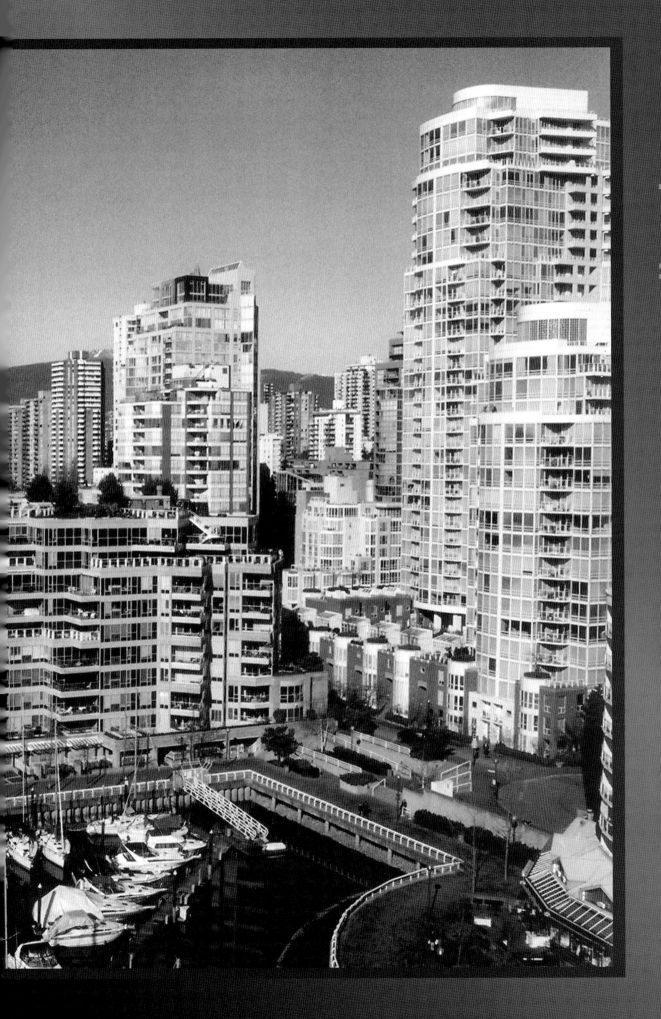

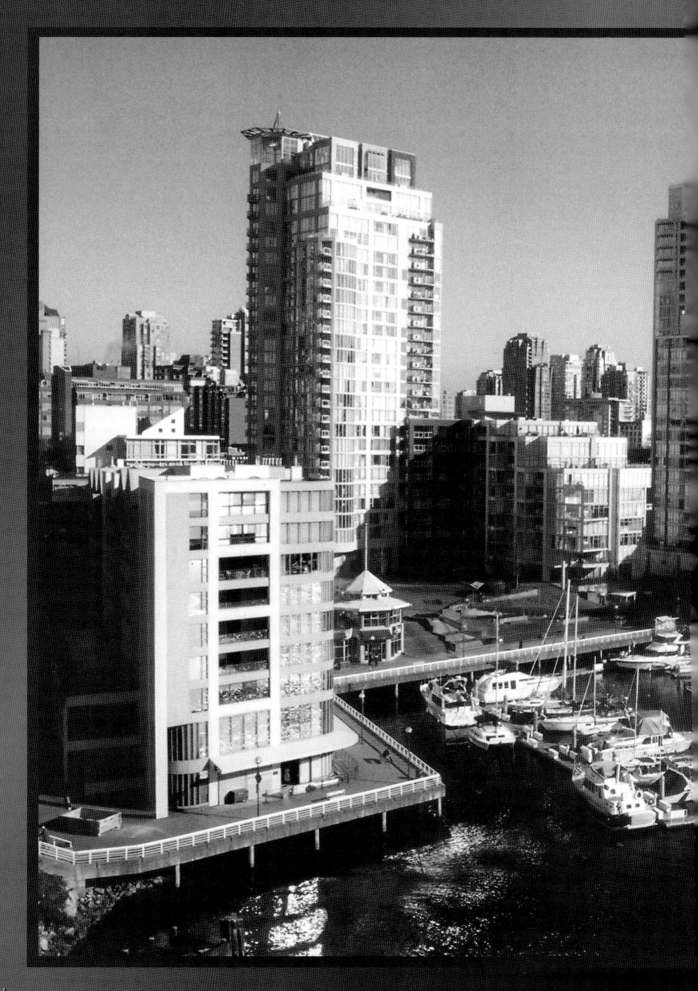

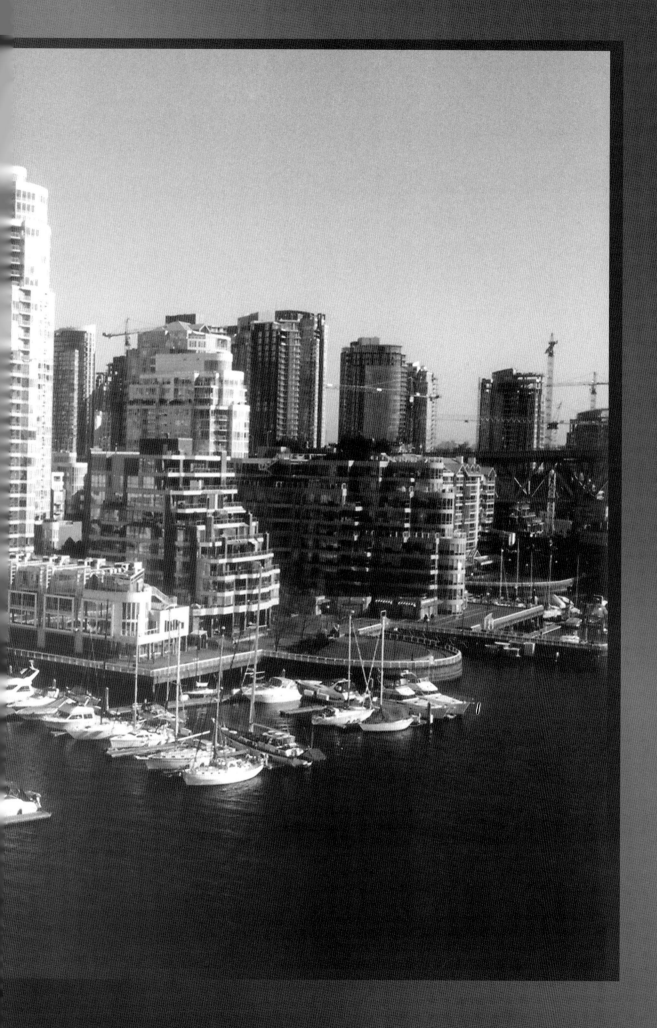

granville slopes

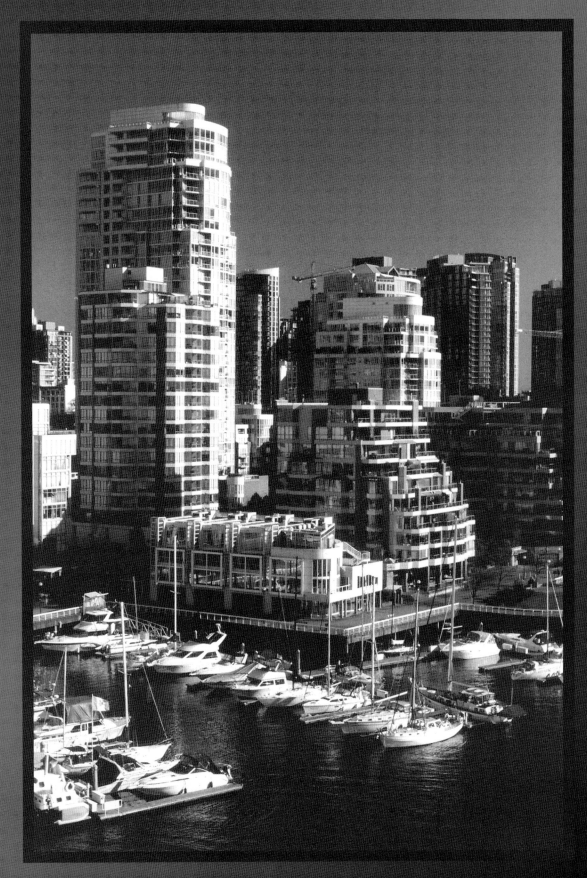

Located between the Burrard and Granville bridges, this area has been transformed into one of the city's highest density residential neighbourhoods. Construction occurred in the mid-to-late 1990s, and the development includes such amenities as a marina, seaside walk, restaurants and public plazas.

marinaside

A key urban planning element that is used to help keep large developments to a human scale is one- or two-level townhomes, which help to define the street edge. Towers are set back, reducing shadowing and giving the streets a more open, airy feel.

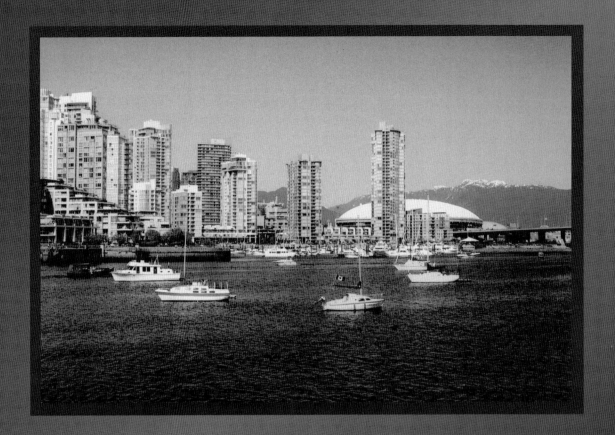

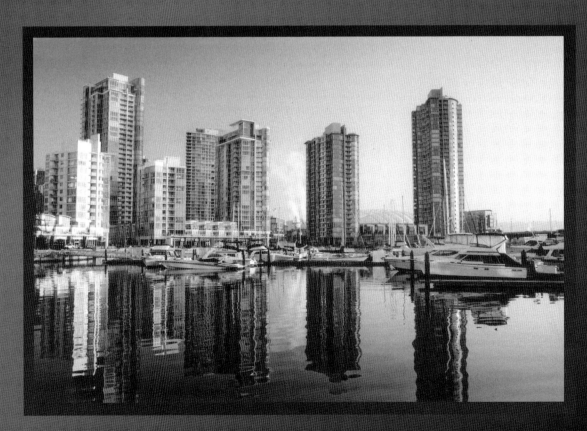

Point towers are used extensively in the False Creek development. The profile of the buildings is slender and the footprint on the site is small, preventing shadowing and preserving views. Marinaside is one of several False Creek neighbourhoods that blend seamlessly with one another.

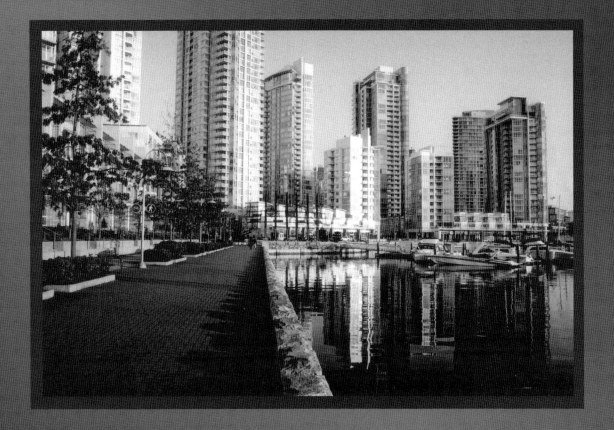

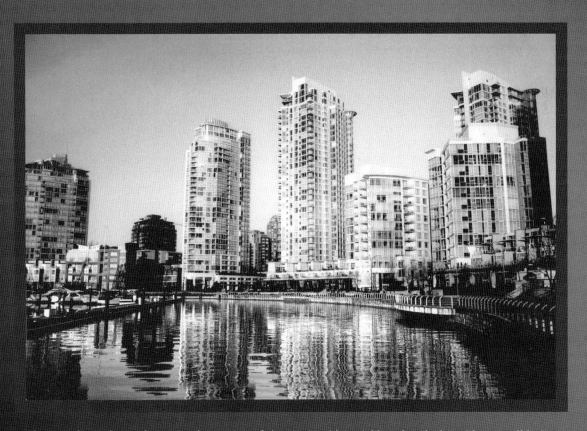

The top photo shows the westerly portion of the Marinaside neighbourhood, the wide seawall being an important feature. Below shows the view from the opposite perspective, near the Cambie Street Bridge, looking westward.

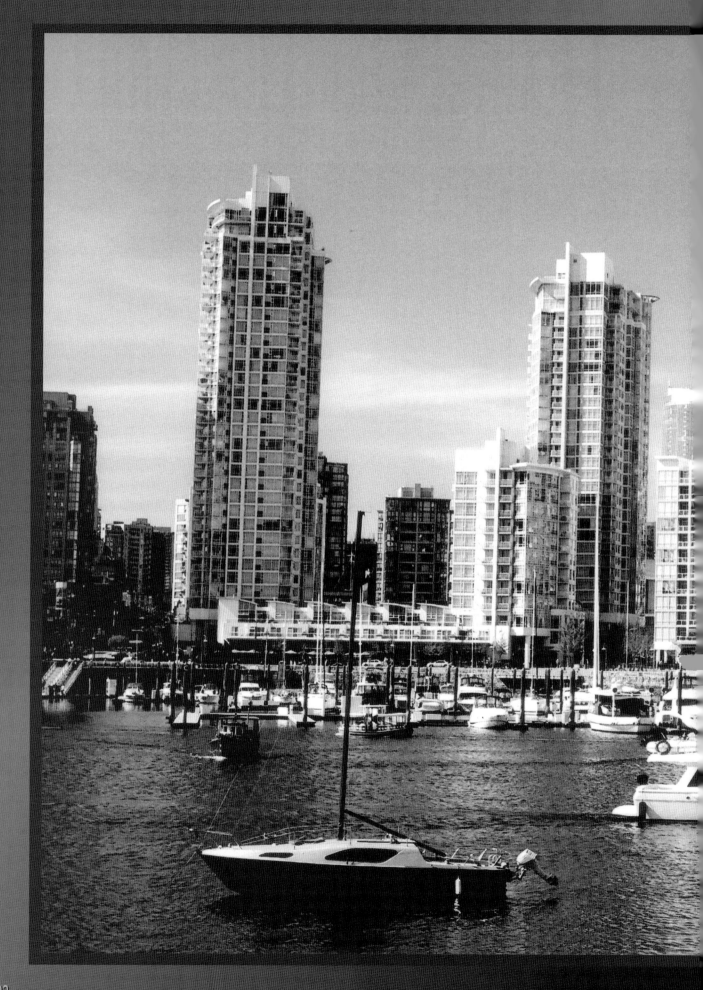

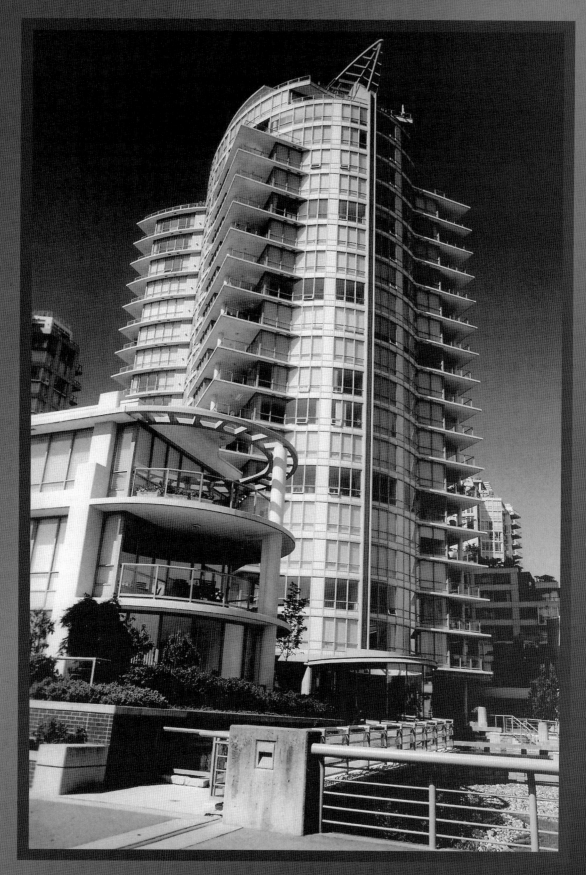

Address: 1328 Marinaside Use: Residential Floors: 22
Completed: 2003 Developer: Concord Pacific Height: 63 metres (208 feet)

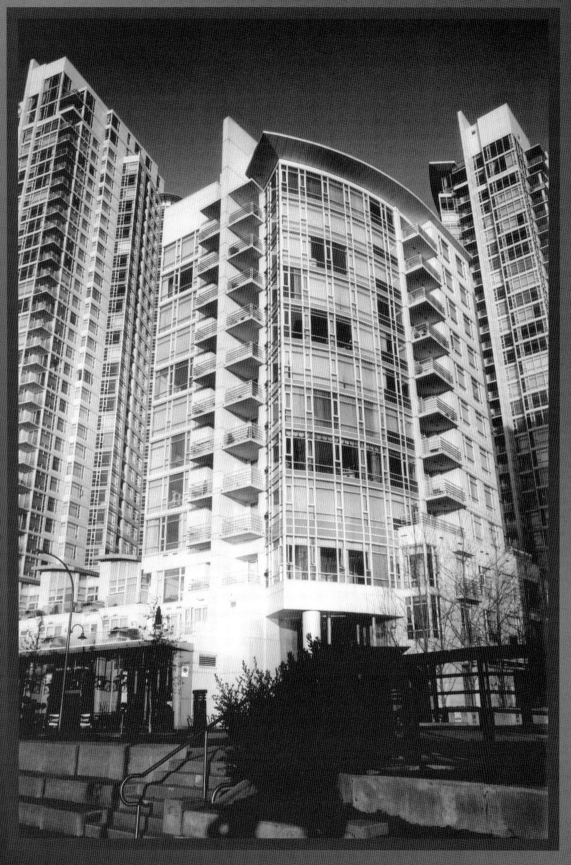

Address: 1111 Marinaside Use: Residential Floors: 12
Completed: 1999 Architect: James KM Cheng Height: 36 metres (171 feet)

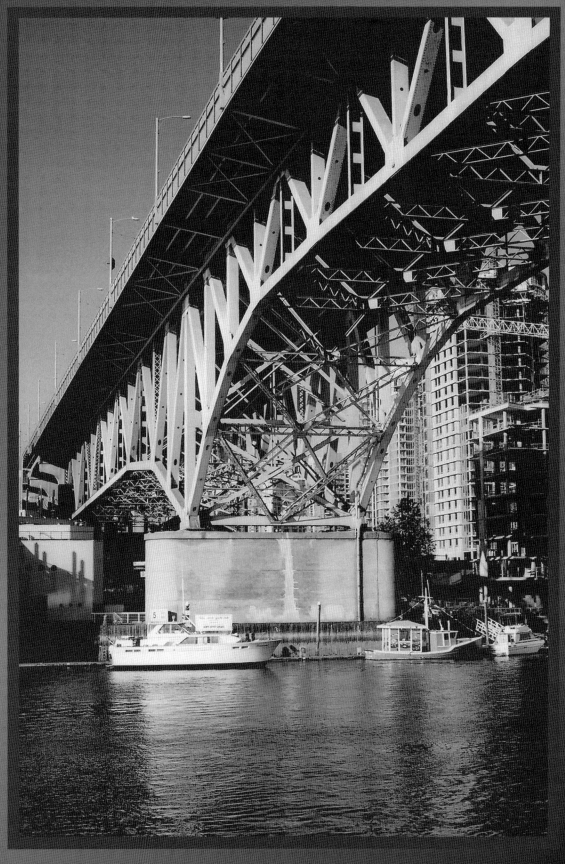

granville bridge

Completed: 1954 Engineer: John Grant Total Length: 1171 metres (3842 feet)
Structure: Steel Truss Cost: $16.5 million Spans: False Creek
 Concrete Viaducts

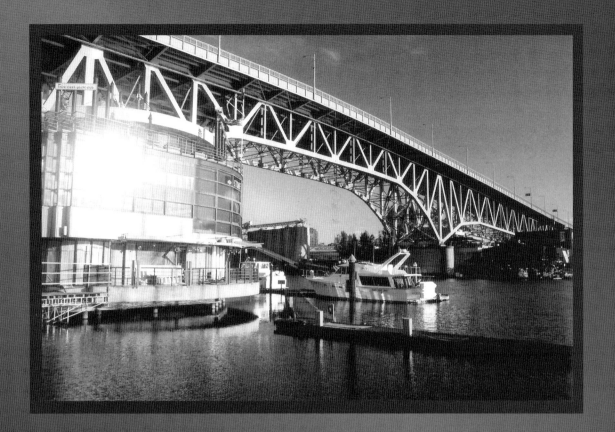

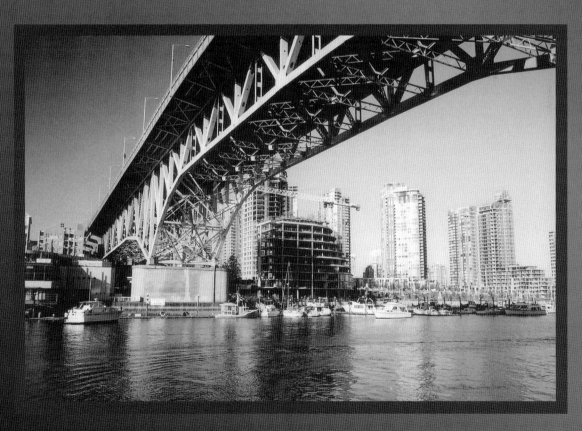

Granville Bridge is directly over Granville Island, adding to the area's industrial feel and providing interesting views. The seawall passes under both ends and continues along the False Creek development and English Bay.

227

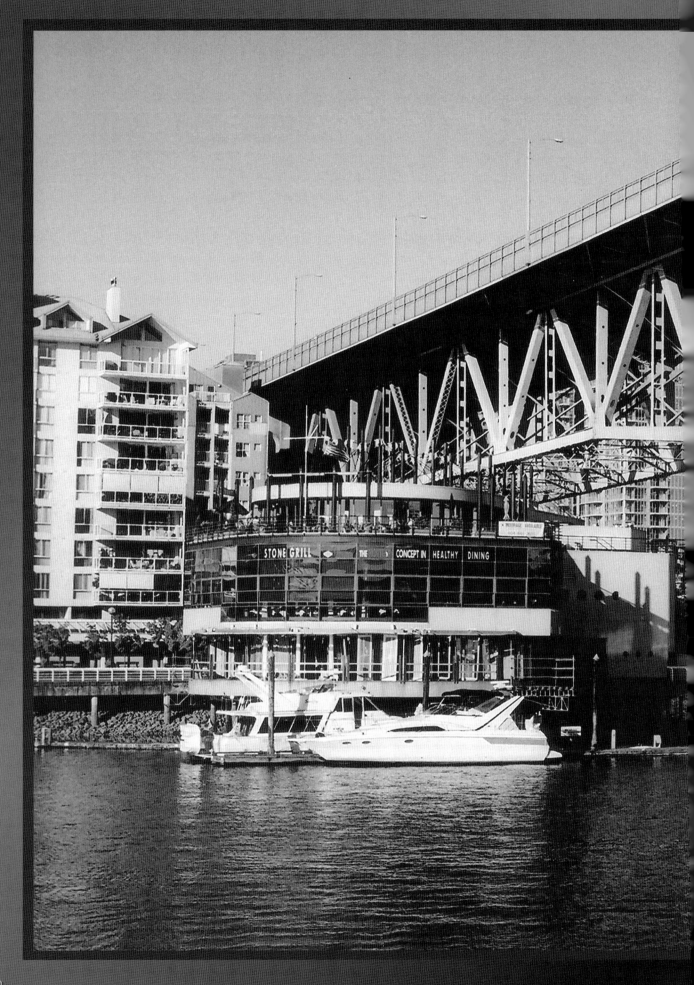

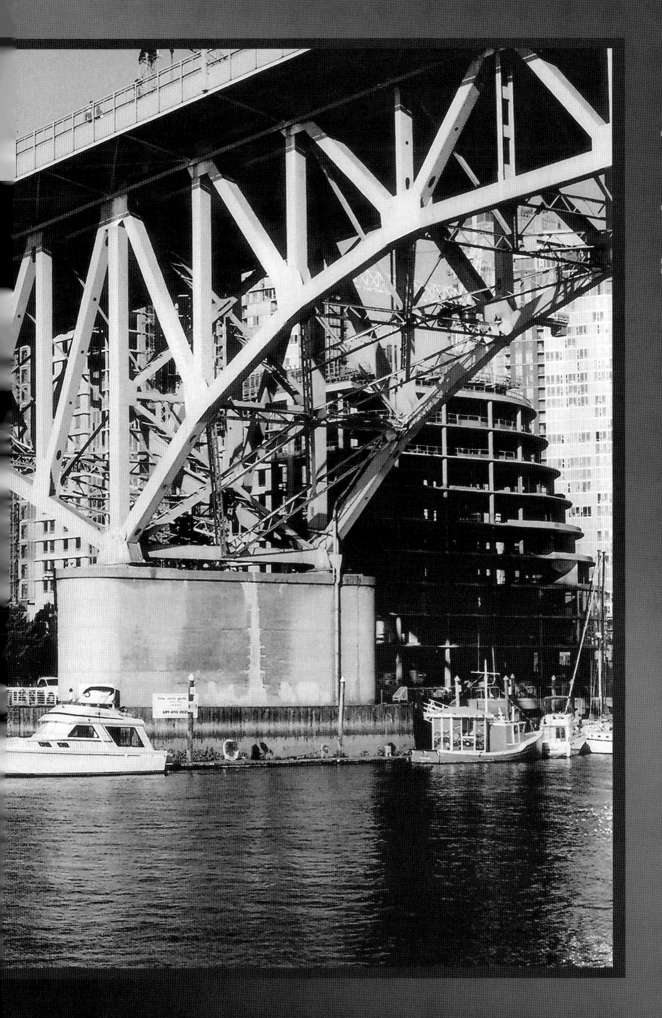

REFERENCES

Dream City: Vancouver and the Global Imagination, by Lance Berelowitz
Published by Douglas & McIntyre, 2005
#201 - 2323 Quebec St
Vancouver BC V5T 4S7
ISBC 1-55365-103-0

The Greater Vancouver Book, by Chuck Davis
Published by Linkman Press, 1997
15032 - 97th Ave
Surrey BC V3R 8J2
ISBN 1-896846-00-9

The Vancouver Achievement: Urban Planning and Design, by John Punter
Published by UBC Press 2003
2029 West Mall, University of British Columbia
Vancouver BC V6T 1Z2
ISBN 0-7748-0972-8

Arthur Erickson Architectural Corporation (2005, October). *Arthur Erickson Architect*.
Retrieved on various dates from August 2004 to August 2005, from
http://www.arthurerickson.com

Stout, Garrett (2004). *Emporis — Databases On Buildings and the Real Estate Industry*.
Retrieved on various dates from June 2004 to December 2005, from
http://www.emporis.com/en/wm/ci/bu/?id=100997

Buckland & Taylor Ltd. (2005). *Buckland & Taylor Bridge Engineering*.
Retrieved on various dates from June 2004 to June 2005, from
http://www.b-t.com/projects/granvile.htm

City of Vancouver (2005, January). *Welcome to the City of Vancouver*.
Retrieved on various dates from June 2004 to December 2005, from
http://www.vancouver.ca

Concord Pacific Group Inc. (1999). *Living Magazine*.
Retrieved on various dates from June 2004 to December 2005, from
http://www.concordpacific.com/livingmagazine/living1/volume1,_issue_1.html

Davis, Chuck (2004). *Vancouver History*.
Retrieved on various dates from August 2004 to December 2005, from
http://www.vancouverhistory.ca

Fairmont Hotels and Resorts (2006). *The Fairmont Hotel Vancouver*.
Retrieved on various dates from June 2004 to December 2005, from
http://www.fairmont.com/FA/en/CDA/home/hotels/abouthotel/CDhotelhistory

Greater Vancouver Regional District (2003). *Best Practices In Housing*.
Retrieved on various dates from June 2005 to December 2005, from
http://www.gvrd.bc.ca/growth/GOMDH/2003-vancouvermolehill.pdf

Janberg, Nicolas (2006). *Nicolas Janberg's Structurae*.
Retrieved on various dates from June 2004 to December 2005, from
http://www.en.structurae.de.geo.geoid/index.cfm?id=411

Roundhouse Community Arts and Recreation Centre (2006, January). *Roundhouse Community Arts and Recreation Centre*.
Retrieved on various dates from August 2004 to August 2005, from
http://www.roundhouse.ca

SkyscraperPage (2006). *SkyscraperPage.com*.
Retrieved on various dates from June 2004 to December 2005, from
http://www.skyscraperpage.com/diagrams/?c1

INDEX